Christian F. Feest,
who is now Professor of Anthropology
at the Johann-Wolfgang-Goethe U~~~~~~~~ in Frankfurt,
has previously served for 26 year~ ~~~~ he North and
Middle American collect~~~~~ ~~~~~~~~~~ für Völker-
kunde in Vienna. ~~~~~~~~~~~~~~~~~~ ~sed on Native
American arts ~~~~~~~~~~~~~~~~~~~~~ the history of ethno-
graphic ~~~~~~~~~~~~~~~~~~~nohistory of eastern North
Americ~ ~~ ~~~~ ~~ of the *European Review of Native
Amer*~ ~~~~~~ and the author of numerous articles
and ~~ ~~~~, including *Indians and Europe* (1987).

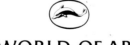

# WORLD OF ART

This famous series
provides the widest available
range of illustrated books on art in all its aspects.
If you would like to receive a complete list
of titles in print please write to:
THAMES AND HUDSON
30 Bloomsbury Street, London WC1B 3QP
In the United States please write to:
THAMES AND HUDSON INC.
500 Fifth Avenue, New York, New York 10110

*Christian F. Feest*

# NATIVE ARTS
## OF
# NORTH AMERICA

193 illustrations
20 in colour and 2 maps

# THAMES AND HUDSON

Any copy of this book issued by the publisher as a
paperback is sold subject to the condition that it
shall not by way of trade or otherwise be lent, re-
sold, hired out or otherwise circulated, without the
publisher's prior consent, in any form of binding or
cover other than that in which it is published and
without a similar condition including these words
being imposed on a subsequent purchaser.

© 1980 and 1992 Thames and Hudson Ltd,
London
Updated edition 1992

All rights reserved. No part of this publication may
be reproduced or transmitted in any form or by
any means, electronic or mechanical, including
photocopy, recording, or any information storage
and retrieval system, without permission in writing
from the publisher.

Printed and bound in Singapore by C.S. Graphics

# Contents

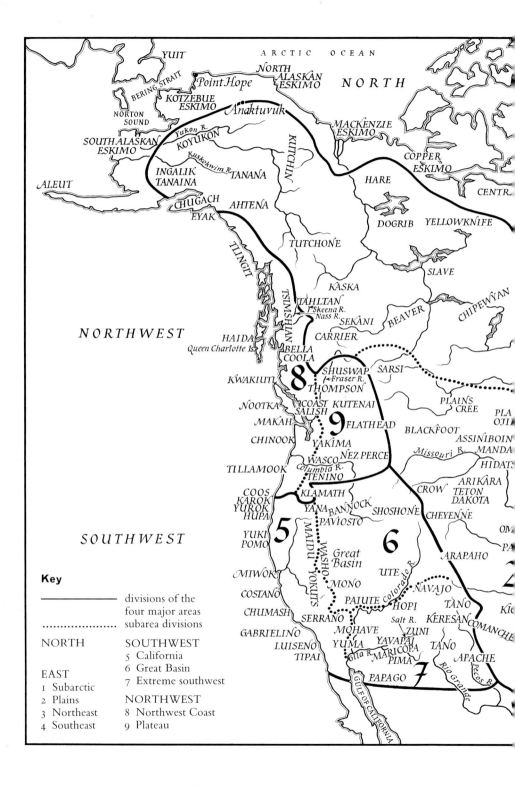

ARCTIC OCEAN

NORTH

YUIT
NORTH ALASKAN ESKIMO
Point Hope
KOTZEBUE ESKIMO
NORTON SOUND
Anaktuvuk
MACKENZIE ESKIMO
SOUTH ALASKAN ESKIMO
Yukon R.
KOYUKON
KUTCHIN
COPPER ESKIMO
ALEUT
INGALIK TANAINA
Kuskokwim R. TANANA
TANANA
HARE
CENTR.
CHUGACH
AHTENA
EYAK
DOGRIB
YELLOWKNIFE
TLINGIT
TUTCHONE
SLAVE
NORTHWEST
KASKA
TAHLTAN
Skeena R.
Nass R.
SEKANI
BEAVER
CHIPEWYAN
HAIDA
Queen Charlotte Is.
TSIMSHIAN
CARRIER
BELLA COOLA
SHUSWAP
SARSI
8
KWAKIUTL
Fraser R.
THOMPSON
PLAINS CREE
PLA OJI
NOOTKA
COAST SALISH
KUTENAI
9
FLATHEAD
BLACKFOOT
ASSINIBOIN
MAKAH
YAKIMA
NEZ PERCE
Missouri R.
MANDA
CHINOOK
WASCO
Columbia R.
TILLAMOOK
TENINO
HIDAT
COOS
KLAMATH
CROW
ARIKARA
TETON DAKOTA
KAROK
YUROK
HUPA
YANA
BANNOCK
PAVIOSTO
SHOSHONE
CHEYENNE
SOUTHWEST
YUKI
POMO
5
MAIDU
WASHO
Great Basin
6
OM
PA
MIWOK
MONO
UTE
ARAPAHO
COSTANO
YOKUTS
Colorado R.
CHUMASH
PAIUTE
NAVAJO
HOPI
TANO
KI
SERRANO
Salt R.
KERESAN
COMANCHE
GABRIELINO
MOHAVE
ZUNI
LUISENO
YUMA
YAVAPAI
TANO
APACHE
TIPAI
Gila R.
MARICOPA
PIMA
Rio Grande
Pecos R.
PAPAGO
7
GULF OF CALIFORNIA

**Key**

—————— divisions of the four major areas

················ subarea divisions

NORTH

EAST
1 Subarctic
2 Plains
3 Northeast
4 Southeast

SOUTHWEST
5 California
6 Great Basin
7 Extreme southwest

NORTHWEST
8 Northwest Coast
9 Plateau

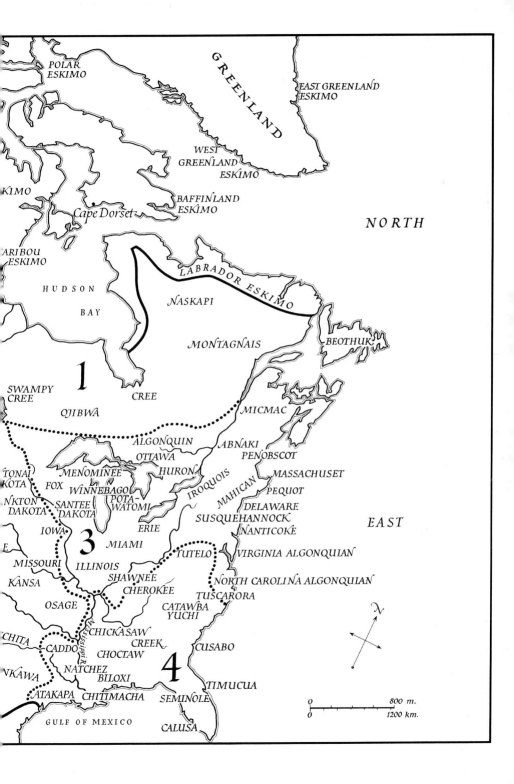

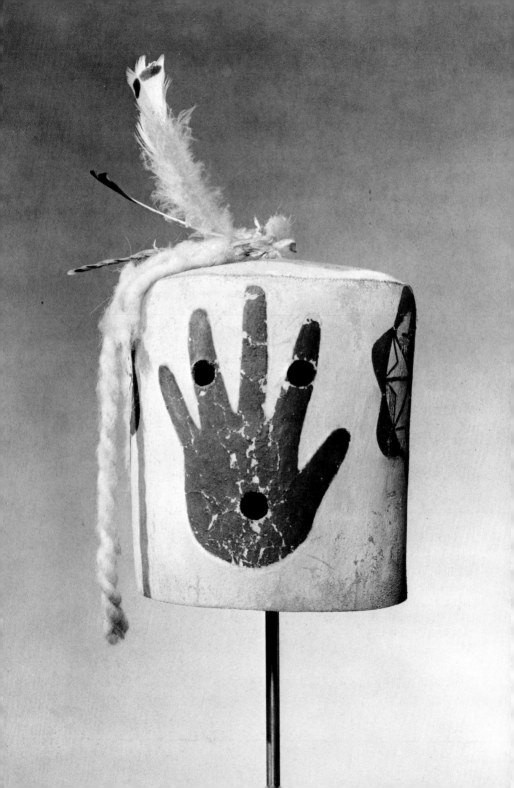

# From 'artificial curiosities' to art

None of the native languages of North America seem to contain a word that can be regarded as synonymous with the Western concept of art, which is usually seen as something separable from the rest of daily life. It might therefore be possible to argue that no art in the Western sense was produced by the aboriginal inhabitants of North America. Judging from the number of books devoted to, of museums exhibiting, and of dealers offering for sale items of 'North American Indian Art', however, we cannot simply let the matter rest there. The question that has to be answered first of all is how objects not conceived as art by their makers have come to be valued as art by their latter-day admirers. For a better appreciation of this transformation it is necessary to look briefly at the history of the encounter between Europe and the manufactures of the New World.

In 1520, when Albrecht Dürer saw the treasures that Cortés and his followers had brought back from Mexico, his admiration was spontaneous: 'And all the days of my life I have not seen anything that so gladdened my heart as these things did. For I saw among them wonderful, artificial things and marvelled at the subtle ingenuity of people in strange lands.' From Dürer's account it does not readily appear what fascinated him most, but we may safely assume that it was neither their unfamiliar style, nor their hidden meaning. Rather, it must have been the new media (like featherwork), the workmanship ('subtle ingenuity'), the value ('these things are all so precious that they are valued at a hundred thousand gulden'), the rarity, and the exoticism which was a major factor in the general German interest in America during the first half of the sixteenth century.

North American Indian artifacts, although made of less valuable materials than the Mexican artifacts seen by Dürer, nevertheless shared the same qualities of rarity and exoticism, and were therefore of considerable interest to early European collectors. Some, indeed, ended up in the same *Kunst- und Wunderkammern* – collections of art (in the sense of human ingenuity) and of marvels – that also contained the Mexican objects. Collections strongest on North America were found in Western and Northern Europe, while Middle

3 Hide kachina mask representing Anahoho. Zuni, c. 1890 (see pp. 31, 97–98).

and South America were best represented in Italy and Germany. They all included a broad range of rarities, both man-made (or 'artificial') and natural. North American ethnographic specimens clearly belonged to the former group, which were valued for their workmanship rather than for their aesthetic qualities. John Tradescant, in the 1656 catalogue of his objects from Virginia, New England, Canada, and Greenland (in the Museum Tradescantianum at South Lambeth, near the City of London) describes such 'artificialles' as 'utensils, household-stuffs, habits, instruments of war used by several nations, rare curiosities of art, etc.'

Other important seventeenth-century collections with North American artifacts included the *Kunstkammeret*, established in Copenhagen by King Frederick III in 1648, and the Royal Society of London collection begun at about the same time. The King Frederick collection later incorporated both the Museum Wormianum of Ole Worm and the *Gottorffische Kunst-Cammer* of Friedrich III, Duke of Holstein-Gottorp; the Royal Society collection was subsequently united with the British Museum and Sir Hans Sloane's magnificent wide-ranging group of ethnographic artifacts, which came from an area extending from the Carolinas to the Hudson Bay. Among the first artifacts collected from the Northwest Coast of North America were those brought back by Captain James Cook from his voyages to the Pacific. Many of them ended up in Sir Ashton Lever's museum established in the late eighteenth century, and after its final dissolution were scattered all over the world.

With the growth of the natural sciences, thanks largely to these very collections, 'natural curiosities' began to be approached in a more systematic manner and became important tools for scientific research. The same cannot be said for the ethnographic collections, which retained their classification as 'artificial curiosities' well into the nineteenth century. Exotic artifacts were sold by dealers in natural history, rather than on the art market, in part because their acquisition was incidental to the collecting of natural history specimens. A frequent criterion was their presumed historical or antiquarian interest: 'Montezuma's battle axe' (which turned out to be from Brazil rather than Mexico), 'Powhatan's mantle' (probably neither a mantle nor ever in the possession of the famous Virginia chief), or a 'Similitude of Pondiac the Indian Chief, cut in stone with his own hands' were valued highly on account of their fictitious attributions.

With the rise of ethnography as an academic study in the second half of the nineteenth century, these early artifacts ended up in separate, newly established ethnographic collections. With rare exceptions these collections were part of natural history museums, and the artifacts were still not regarded as art but as specimens. Complete series of objects, illustrating the

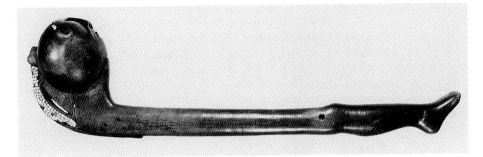

4 Wooden ball-headed club with inlays of shell and copper, probably collected
*c.* 1650 in the colony of New Sweden on the Delaware River. Two copies were
later made in Europe for the collections of the kings of Denmark and Sweden
(see also pp. 104, 179).

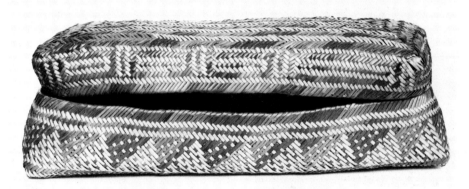

5 Double-woven cane basket from the collection of Sir Hans Sloane. South
Carolina, early 18th century (see also p. 107).

full range of forms, functions, and techniques, were more in demand than
aesthetically pleasing artifacts. Even when the term 'art', in its modern sense,
came to be applied to objects made by native North Americans (or by other
non-Western populations), it was commonly modified by adjectives like
'ornamental' or 'decorative' and seen as closer to craftsmanship than to
European 'high art'. Questions regarding the priority of representational or
ornamental art, or the content and meaning of designs, took precedence over
formal and stylistic matters. Since this 'primitive' art was seen as the product
of specific cultures, the approach tended to be particularistic. It was also
recognized that in tribal societies there was no art divorced from function,
and that individual creativity was of less importance than in European art.

Few anthropologists bothered to investigate the role of aesthetic ideas in
the tribal world at a time when this could have still been the subject of

fieldwork among the native populations of North America. With acculturation progressing at an ever increasing pace, many of the traditional functions performed by certain objects vanished, or were served by industrially manufactured products. A fair share of the now 'meaningless' artifacts ended up in museums, and with this final harvest the traditional collecting activity more or less came to an end as far as North America was concerned.

While only a limited number of objects continued to be produced for tribal use, the production of crafts for an outside market grew in importance. These 'ethnic' arts, which employed native technologies to satisfy foreign tastes, have a history almost as long as the history of the encounter of Western civilization with the tribal world. They were less restricted by traditional conventions and functions but had to meet the expectations of their White patrons. Depending on the structure of the market, there was a tremendous variation in the quality of what was offered for sale, from exquisite to very poor. Neither producers nor buyers considered these wares works of art. For their makers they were a source of cash income on the basis of traditional skills; for the tourists and visitors they were curios and mementoes of past adventures. (There is limited evidence for the influence of Black Americans on native American arts. Given the fact that slaves often fled their White masters to seek refuge among Indian tribes, it is surprising that only one classic case of stylistic transfer from African art to North American Indian art, a West African drum type found in use among the Choctaw of Louisiana around 1900, has so far come to notice.)

Around 1900, anthropologists in the American Southwest occasionally hired native informants to make drawings of native customs, especially religious ceremonies, which they were not allowed to observe themselves. At about the same time, a few liberal-minded teachers at government Indian Schools in the Southwest (particularly at San Ildefonso) and in Oklahoma (among the Kiowa) encouraged their students to draw and paint native subjects, even though this was contrary to the Federal policy of stifling all expressions of tribalism and traditionalism. These artists worked in the medium of painting, which a White public more readily recognized as potential art than beadwork or porcupine-quill appliqué; and they probably considered themselves to some extent artists in the Western sense.

Modern European and American artists were slow to discover native North American art, when compared with the relatively early interest which African objects had stimulated in Cubist art circles. In this case it was especially the émigré European Surrealists (such as Max Ernst) who saw in native American art the sources of renewal and deeper vision that they held to be representative of the 'primeval' world. These artists were especially

attracted to the art of the Northwest Coast because it was largely literary, and their intuitive acceptance of these works was in many ways more broadly based than the anthropologists' recognition of their particular aesthetic principles.

Other modern artists, such as the American John Sloan, were responsible for the greater acceptance of native American painting in wider American art circles. By 1920, for example, Sloan had learned about the native painters of San Ildefonso and arranged an exhibition of their works at the Society of Independent Artists in New York. Other shows of modern Indian painting followed during the next years. Finally, after a dramatic turn-around in Federal policy, a government-funded Indian Art School known as The Studio was opened in Santa Fe in 1932. In the emerging Pan-Indian painting tradition nobody could fail to recognize art.

The traditional artifacts slumbering in ethnographic museums, however, were still largely regarded only as specimens. An exception was the Denver Art Museum, which was the first museum to exhibit these objects as works of art (in 1925). From its collections came many of the art works shown during the 1931 Exposition of Indian Tribal Art, held in New York. Organized by John Sloan and Oliver LaFarge, the anthropologist, it considered itself 'the first exhibition of American Indian Art selected entirely with consideration of esthetic value' (even if the aesthetic standards were Euro-American rather than indigenous). By showing side by side traditional crafts and watercolours by modern artists, it identified both as part of the same tradition and thus elevated the ethnographic specimens to the status of art. The general public and most ethnographic museums probably could not have cared less, but an important beginning had been made.

Other milestones on the way to the recognition of native tribal crafts as art were an exhibition organized in 1939 for the Golden Gate Exhibition in San Francisco (the San Francisco World's Fair); and another one in 1941 at The Museum of Modern Art in New York. Frederic Douglas of the Denver Art Museum and René d'Harnoncourt, then the General Manager of The Museum of Modern Art, arranged the latter show and wrote the first classic account of native North American art to accompany it.

During the late 1940s and the 1950s the development was muted, partly because of a lack of public interest in native American affairs which corresponded to the official assimilationist policy of the period. Almost the only non-anthropologists who cared for the native material culture were the hobbyists who strove to emulate native life-styles by meticulously copying tribal products. Their efforts not only resulted in technological insights, but definitely contributed to an understanding of the aesthetic principles involved.

Since the early 1960s, the recognition of North American native art has become universal. Major shows in art museums and galleries, numerous art books, a specialized journal, but most of all the development of a market for tribal crafts, with prices *proving* them to be art, attest to the successful transformation.

In a significant parallel development, artists such as Fritz Scholder have begun to flee the ghetto of the modern Pan-Indian painting tradition. The Institute of American Indian Arts, established in 1962 at Santa Fe as a modern successor of The Studio, devotes itself to educating its students as Indians and artists, but not as Indian artists. While Pan-Indian painting is by no means dead, a new type of native artist has emerged who identifies himself as an Indian, but his art simply as art.

*Definitions and source material*

We are thus faced with at least four kinds of art, which differ in terms of the artist's self-evaluation, their producer-consumer relationship, and their function, meaning, and place in society. In current usage, the distinction between tribal, ethnic, Pan-Indian, and Indian mainstream art is generally neglected, even though it deserves to be made.

Tribal art was (and is) produced by members of tribal societies primarily for their own or their fellow members' use. In most tribes there were more or less gifted craftsmen working in one or more of the several traditional techniques; but as a rule there was no professional specialization in the arts beyond the sexual division of labour. Everybody was a potential artist, except in cases where religious paraphernalia was exclusively fashioned by ritual specialists, and in the Pacific Northwest-Coast area, where professional artists worked for the tribal aristocracy.

Tribal art was not made for its own sake, but to satisfy the material or spiritual needs of the tribesmen. Functionality had to be the overriding criterion for any product. This influenced not only the shape of an object, but often its decoration as well. The aesthetic component was not seen in isolation from the whole, much as religion in tribal societies was not a separable part of the total way of life (significantly, most native American languages seem to lack a word for religion as well). Forms and designs were executed according to the cumulative experience of generations, which left only limited freedom for individual expression.

Ethnic art was (and is) produced by members of tribal societies primarily for the use of members of other groups, in the case of North America mainly for White Americans. It is generally not thought of as art by its makers, who still live in a social context that does not recognize art as something separate. The technology of manufacture is largely traditional, though new kinds of

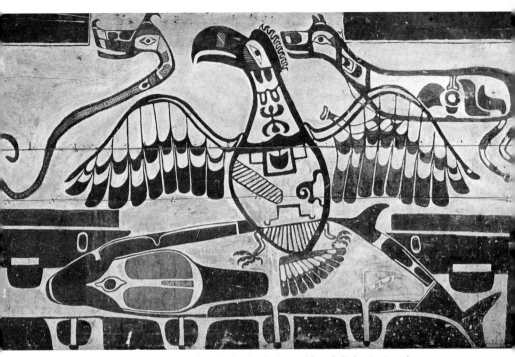

6 Painted wooden panel showing thunderbird, whale, wolf, and (lightning) snake. Nootka, c. 1850. These and other works were produced by professional artists to be displayed at potlatch feasts by the local aristocracy.

tools and raw materials received from the buyers' group may be used, in 7 some cases substantially changing the form the art takes; specialization begins to be the rule. The maker of ethnic art often does not know why his products are bought and what possible use the buyer may make of them. For himself they are first of all a source of income; in the long run they may become an important symbol of the makers' ethnic identity. Forms and decorations in ethnic art tend to be a mixture of native traditions and foreign expectations: sufficiently native to be recognized as exotic, and sufficiently foreign to be acceptable to the buyer. There are only a few transitional cases where tribal art has continued to be made, without changes, for an outside market.

Pan-Indian art is produced by native Americans who feel themselves no longer exclusively bound to the values and customs of their original tribal societies. They work for the art market of the dominant White society and consequently regard themselves as artists. While still drawing on the experience of their specific cultural background, their style is no longer 8 unique to the tribe, but is largely shaped by White expectations about

'Indian style'. Non-traditional media are the rule. This art is Pan-Indian because artists from widely different tribes produce remarkably similar works. It is ethnic art based on White definitions of ethnic boundaries.

Indian mainstream art is produced by artists who happen to be Indians. Like all other artists, they each have their personal heritage which may or may not find expression in their art. While the subject matter of their art is sometimes related to their ancestry or ethnic classification, their style is not. Because it is furthest removed from tribal art, Indian mainstream art is excluded from the scope of the present book.

There are many ways to approach the native arts of North America. One of the most common questions when facing tribal arts in particular is that of meaning. The question is perfectly legitimate, but makes sense only when one is dealing with works originating from a specific tribe. Since there is no general 'Indian' culture, there can be no universal explanation of meaning. For a full understanding of the meaning of a particular tribe's art, a highly detailed analysis of the ethnographic data is necessary, but this cannot be supplied in a brief survey of the vast field of native American art such as this. Moreover, vitally important information is today often impossible to recover. This is true of both prehistoric and early historic art. (It should be borne in mind that American prehistory ended only with first European contact, which began in the early sixteenth century.)

The question of function poses lesser problems, but adds little to an appreciation of forms, styles, and aesthetics in general. While both meaning and function impose certain limitations on the development of form and design, they do not determine it.

If forms are the visible embodiment of a group's aesthetic standards, it may be worthwhile simply to look. Unfamiliar styles can be absorbed without reference to meaning and function, in exactly the same way in which children assimilate the aesthetic standards of their own culture. A less subjective approach to the same goal consists of analysing the formal principles defining a style. Although successful attempts along these lines have shown the practicability and ultimate benefit of such analyses, all too few attempts have so far been made.

This book will try to survey the styles expressed in the native arts of North America from prehistoric times to the present, and to explore some of their historical dimensions. This cannot be done by using the usual 'culture area' approach, which defines, for example, native Northwest-Coast art as the sum total of all the art produced on the Northwest Coast. Such a proposition is not only circular reasoning, it also tends to belittle the influence of techniques and media on styles, and consequently to treat a broad spectrum

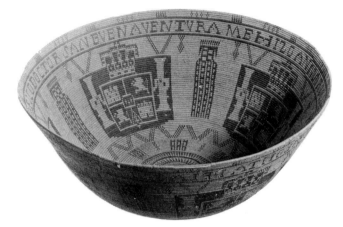

7 Coiled basket with Spanish inscription and royal coat of arms. Ventureño Chumash, 1822 (see also p. 111).

8 *Kiowa Moving Camp*. Mural painting on west wall of U.S. Post Office, Anadarko, Oklahoma, by Stephen Mopope. Kiowa, 1937 (see also p. 100).

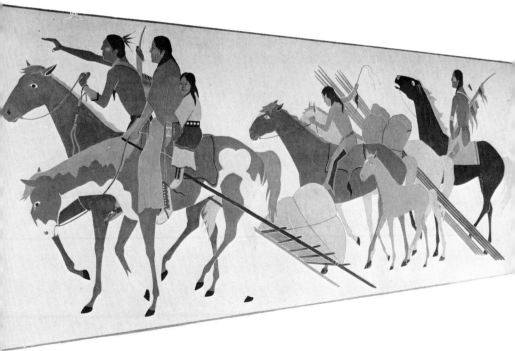

of heterogeneous styles as a single 'art'. For profound technical reasons, the art of basketry produces different styles from the art of wood carving, and painting may not be directly comparable to quillwork. Only by comparing what may fruitfully be compared will styles become apparent and definable. Once this has been done, comparisons on a higher level should be attempted.

Styles can be envisioned as sets of (generally implicit) rules which bind the maker of an object to certain conventions. Somebody who knows the rules and has the technical ability to apply them in his work may be regarded as a competent artisan. The knowledge of the rules alone will guarantee a satisfactory result, but not necessarily a work of art. In a narrowly defined traditional form of expression, the artist will make utmost use of whatever is not spelled out in the rules, combining known parts into new wholes within the framework of the permissible. Stylistic innovation is caused by breaking the rules: usually such transgressions would identify the artist as an incompetent craftsman. If, however, the majority of the consumers accept the rule-breaking as an improvement of traditional forms, rules will be reformulated. There are extremely few accounts of the native North American criteria for the judgment of works of art, but the few that exist bear out these observations.

A few cautionary words are necessary about the sources on which our appreciation of the native arts is based. Obviously not all artifacts that were ever made are available for our study, and we must bear in mind that the sample contained in today's museums and private collections may well be in some ways biased.

In the case of prehistoric art, many kinds of artifacts did not survive to be excavated at all, owing to the decay of organic materials in the soil. Some of the most functional pieces will never be found because they were simply worn out by their original owners. Others, such as many items of a ceremonial nature, were purposely destroyed after use. The ethnographic evidence tells us that this happened with several types of masks, with ceremonial sand painting, and with some pottery vessels. And, of course, we have access only to such objects as have been excavated and reported. Much certainly remains to be found.

The bias of the available ethnographic material is even harder to control. We have already seen that collections until very recently were not accumulated on the basis of aesthetic considerations. Collectors always had their personal reasons for acquiring specific classes of objects. In seventeenth-century Virginia, three individuals accumulated ethnographic collections: William Strachey, Secretary of the colony in its early days, bought bags made of silk grass from the Indians because of the possible commercial use of the fibre; the Reverend Alexander Whittaker sent to England the image of a

native god, 'ill-favour'dly carved', as an example of the heathens' delusion – and at the same time to rid the 'savages' of their devilish idol; and later in the century, the Indian trader William Byrd sent a complete Indian costume to one of his English friends 'for your boy to play with'.

When systematic collections were attempted, as during Captain Cook's third voyage (1776–78), the typical rather than the extraordinary was sought. An inspection of his collection from the Northwest Coast of America reveals that a sizeable number of items had already been broken and partly repaired by the natives. Reluctant to part with their still useful artifacts, they were glad to get rid of the damaged ones. Other collections are simply reflections of the taste of the collector rather than true samples of what the Indians regarded as good and beautiful. With the rise of tourist arts, further distortions occurred: there are more moosehair-embroidered cigar boxes, Eskimo-engraved cribbage boards, or Haida argillite pipes in White ownership today than objects that would better reflect traditional aesthetics.

Besides these collection problems, systematic destruction took place. Eighteenth-century missionaries burned piles of ceremonial paraphernalia, and White presumption in general led to the loss of many unique documents of culture and art; vandalistic effacement of rock art is just one contemporary example. How many invaluable objects were irretrievably lost in White collections because of a lack of proper attention is unknown; but old catalogues generally make sad reading.

In addition, the documentation for museum specimens is often inadequate if not misleading or downright wrong. Previous owners or collectors may not have kept records of their acquisitions or they may have mixed up their notes. Museums themselves are often to blame for faulty record keeping, or for trading objects but not the documentation. Moreover, the artifacts themselves may have been traded between tribes before their sale to non-Indians, who thought they were buying from the maker. None of this helps to assure correct tribal and age attributions. With rising prices in the market for native arts there has been a strong trend to date objects older than they really are. And even among professionals, a weakly substantiated body of lore about tribal characteristics dims the view of reality. All too often the motto is 'If it looks good, we can always find a label for it'.

Despite recent advances, the study is still in its infancy. But it seems that at least the right questions are now being asked, which will contribute to the exploration and adequate appreciation of the native arts of North America.

# The makers

At the time of first European contact, roughly one thousand tribes speaking a couple of hundred different languages inhabited the area between the Arctic Ocean and the Mexican borderlands. In their economic base they ranged from simple hunters and gatherers to irrigation farmers, in their social complexity from loosely structured bands consisting of a few related families to stratified societies and centralized chiefdoms. It is obvious that there must have been considerable variation in their needs and opportunities for material culture, and consequently aesthetic ideas, to develop.

Since the organization of this survey is not based on ethnic or regional principles, it is necessary to preface it with some notes on the geographical and historical background of the arts and their makers. For ease of reference, only four major areas embracing ten subareas will be distinguished.

*The North*

Except for the region around Bering Strait, which had been a thoroughfare for the migration of the first Americans during the final stages of the Pleistocene (before 18000 BC), the northernmost parts of the New World were uninhabited until rather late in prehistory. But as the glaciers receded, groups of hunters slowly moved east into Arctic Canada and reached Greenland during the third millennium BC. A distinctly Eskimoid culture had its beginnings some time after 2000 BC in the Bering Strait area. It first spread south into the Aleutian Islands and southwestern Alaska, where it became ancestral to the historic Aleut and the Yupik-speaking Eskimo. Somewhat later another eastward expansion of more specialized sea- and land-hunting groups reached Greenland around the time of Christ (Dorset Eskimo). Under continuing Asiatic stimuli two partly contemporaneous and territorially overlapping cultural traditions developed in northwestern Alaska: Choris-Norton-Near Ipiutak (*c.* 1000 BC to AD 500) and Northern Maritime (from 300 BC, subdivided into Okvik, Old Bering Sea, Birnirk, Punuk, and Thule phases). After AD 1000, Thule culture spread to Greenland in the east and to Norton Sound in the west, establishing a more or less uniform basis for the cultures of the historic Inupik-speaking Eskimo.

Cultural differences between the Aleut and southwestern Alaska Eskimo on one hand, and the descendants of the Thule Eskimo on the other, have

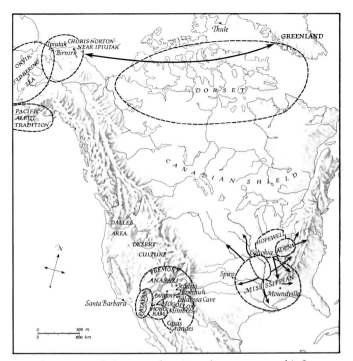

9 Prehistoric North America, showing culture groups and influences

been reinforced by differences in the environment. Higher temperature and precipitation in the western Alaskan and Aleutian tundra support a more plentiful flora and fauna, which in turn support higher populations. Survival in the treeless and freezing cold continental and northeastern tundra, on the other hand, depends very much on a specialized exploitation of the available resources (primarily sea mammals) by small groups. Caribou hunting is only of seasonal importance, except for such inland oriented groups as the Caribou Eskimo. Wood is available only in small quantities, as driftwood; and so bone and walrus ivory, besides skins, became the major raw materials.

157

Because Eskimos lived on both sides of Bering Strait, they acted as brokers and also as a filter for cultural exchange between Asia and America. Their relationship with their native American neighbours was often less than cordial, but evidence of mutual influences exist, especially on the northern Pacific Coast. First contacts with Europeans date from the Norse colony in Greenland between the eleventh and fifteenth centuries. In the early eighteenth century the Danes established a firm foothold in western Greenland, while the Russian presence made itself felt on the Aleutian chain

and in western Alaska. Whereas profound changes occurred in these early centres of contact, the rest of the Arctic was not drawn into the White American sphere of influence until much later. For many Canadian Eskimo groups, the transition from traditional to modern life came about rather abruptly after the Second World War.

10

*The East*

North America east of the Rocky Mountains and south of the Arctic is neither topographically nor ethnographically a uniform region. The Subarctic forests stretching across Canada, the dry steppe of the Plains, the grasslands of the prairies, and the woodlands east of the Mississippi extending from the temperate to the borders of the tropic zone, all offer different ecological potentials for human exploitation.

But with no major natural barriers (except the Appalachian Mountains) to impede the movement of populations and the exchange of ideas, the tribes living in this vast area have come to share much of their heritage. With the exception of the western part of the Subarctic (which has equally important ties with the North and Northwest), the East is inhabited by speakers of languages belonging to only two language groups: Macro-Algonquian and Caddoan-Iroquoian-Siouan. The differentiation of these two groups must have required thousands of years and probably took place without outside influence.

The earliest inhabitants entering the East towards the end of the Ice Age were small bands of Paleo-Indian nomadic big-game hunters depending on a specialized technology in their exploitation of the Pleistocene fauna. Changing climatic conditions and the extinction of some of the animals (like mammoth, mastodon, fossil bison), on which they depended, forced these hunters to modify their way of life. Since the environmental changes did not occur simultaneously, the beginning of the ensuing Archaic period was a gradual process, beginning around 8000 BC in the woodlands (ending after 1000 BC) and around 5000 BC on the Plains (ending around 1000 BC). Much of the Subarctic region was still covered by glaciers, and therefore entered into human history only during the Archaic period. A balanced utilization of the environment, entailing an increasingly versatile technology and supporting growing populations, is characteristic of this stage. Gathering and fishing supplemented hunting and, depending on the local ecological conditions, could even lead to a less nomadic life-style. This is particularly true of the woodlands, where pottery and an elaborate burial cult reflect this stability and foreshadow the Woodland period, while other regions such as the Subarctic and the Texas plains retained the Archaic pattern into historic times.

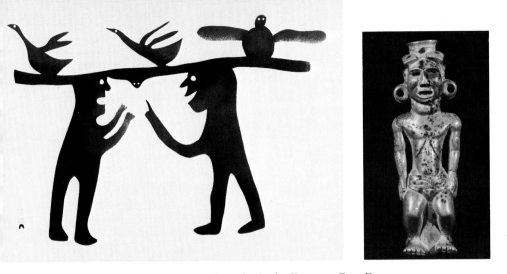

10 *Two Men Discussing Coming Hunt.* Stencil print by Kavavoa. Cape Dorset, Baffinland Eskimo, 1961 (see also p. 100).

11 Human effigy pipe, stone. Adena Mound, Ross County, Ohio; Adena, c. 800–100 BC (see also p. 158).

The first dramatic developments of the Woodland period occurred in the Northeast and were probably indigenous, associated with the so-called 'mound-builder' cultures. Both the Adena culture, flourishing in the Ohio    *11* valley after 800 BC, and the related Hopewell culture, which originated 500 years later in central Illinois but found its greatest refinement in Ohio, are distinguished by the presence of immense artificial earthworks, many of them mounds placed over the graves of persons of high status. Grave goods associated with the burials attest to a considerable development of the arts and to a sophisticated social and political organization. Cultivated plants, some imported from tropical America, others the product of local domestication, may have had a stabilizing influence on the economy but did not dramatically alter the subsistence pattern based on hunting, gathering, and fishing. Influences from the Ohio valley spread over most of the Northeast and Southeast as well as the eastern parts of the Plains. After AD 400, as the Hopewell influence diminished in the Northeast, a new cultural tradition evolved in the Mississippi valley, combining the heritage of the burial-mound period with stimuli from Mexican and Central American sources. Exotic materials, truncated temple mounds, and powerful death imagery centred around the 'Southern Cult' are its hallmark. Intensive corn cultivation became the mainstay of the economy, supplying a firm base on which the arts, associated with an elaborate ceremonialism, thrived. Mississippian manifestations centred in the Southeast, where tribes

23

like the Natchez retained some of their flavour into early historic times, but are also discernible in the Plains and to a lesser extent in the Northeast.

Except for the Calusa, unusual because they were a stratified society of sedentary fishermen, the historic tribes of the Southeast depended to a greater extent upon horticulture than other groups in the East. While many of the coastal tribes were early victims of the onslaught of European colonization, the people of the interior initially profited from trade and other not too massive contacts with the Spaniards, English, and French. The Muskogean Choctaw, Chickasaw, Creek, Seminole (this being a recent amalgamation of Creek and other tribes), and the Iroquoian Cherokee together became known as the 'Five Civilized Tribes', who partly through their sizeable mixed-blood element had managed to assimilate many of the features of White American society and culture. Under the pressure of the advancing frontier they were nevertheless forcibly removed to Indian Territory in present-day Oklahoma during the 1820s and 1830s. Only fractions of the Cherokee, Seminole, and Choctaw remained near their old homes in North Carolina, Florida, and Mississippi. Very few old ethnographic specimens are available to document the traditional arts of the Southeast, and equally few native crafts survived into the twentieth century.

All the tribes of the Northeast grew corn and other crops; nevertheless, hunting, fishing, and gathering remained of at least equal importance. Complexity of political organization ranged from largely independent 'towns' through tribal confederations to centralized chiefdoms. The famous League of the Iroquois, consisting of five related tribes (Mohawk, Cayuga, Onondaga, Oneida, Seneca) and which, after the admission of the Tuscarora, was also referred to as the 'Six Nations', rose to become a major military and political factor in the Northeast, while some of the coastal Algonquian tribes quickly declined in number and consequence. Northeastern tribes were less affected by the government's removal policy, and more groups managed to stay behind. Many groups, particularly in the Great Lakes region, retained a traditional life-style well into the nineteenth century in spite of, and not unchanged by, a long period of intensive contact with Whites. Sources for their art and its history are therefore much better than those in the Southeast. Some traditions, like Iroquois carving, remain unbroken to this day.

Many popular notions about Indians were shaped in the nineteenth century, when the bison-hunting horsemen of the Plains resisted the advance of the White frontier. Yet much of what has come to be regarded as typical of native American life in general and the Plains in particular was the indirect result of White contact. In early historic times, the Plains area was primarily inhabited by sedentary agriculturists whose habitat centred on the long grass

prairies and along the river courses of the short grass steppe. Bison hunting was only a seasonal event, because there were no adequate means to follow the migrations of the herds through the arid country. The arrival of the horse, which the Spaniards had introduced into the Southwest in the mid sixteenth century, brought a basic change in this respect. From all directions, tribes moved into the high Plains country, some drawn by the desire to have their share of the bountiful bison, others driven by tribal groups who had acquired military superiority along with firearms from the French and English. The combination of guns and horses led to a nomadic and competitive way of life, giving the roving and raiding bands a clear advantage over the sedentary farming tribes. The fur trade, whose centre shifted into the Plains area during the nineteenth century, brought increased prosperity and a new flowering of the arts. More works from the classic period of Plains art have been preserved than from any other part of the East, owing to the same extensive nineteenth-century contacts that made 'Plains Indians' and 'Indians' become almost synonymous.

From this apogee it was only a short way to almost total ruin. The near 30 extinction of the bison spelled doom for an economy so largely dependent upon this single resource, while defeat at the hands of the American army signalled the end of political autonomy and the old social order. Since the late nineteenth century, cultural Pan-Indianism, developing together with reservation life, has had a major influence on the renaissance of some traditional arts.

The tribes of the Subarctic had always been nomadic hunters of the moose, caribou, and other animals of the northern forests. Their life-style did not permit great numbers of people to stay together for long, nor to carry with them too many possessions. All groups in the area were greatly affected by the fur trade, initiated by the Whites in early colonial times, and which intensified the already existing atomistic tendencies of the native societies. The desire to gain access to the goods of the trader was very strong, though it often resulted in economic dependence. Even tribes like the Ojibwa, who had been semi-sedentary fishermen on the north shore of Lake Superior, pushed north and west in search of furs and thus helped to spread northeastern elements and styles.

Although much of this applies to all peoples of the Subarctic, there were some differences. In general, the eastern Subarctic is better known, and museum collections from this area span a longer period of time. It was inhabited by Algonquian tribes who shared much of their heritage with their sedentary relatives of the Northeast. The Athapaskan tribes of the western Subarctic, on the other hand, had roots associating them with the North 12 rather than the East. During the nineteenth century, some of them also

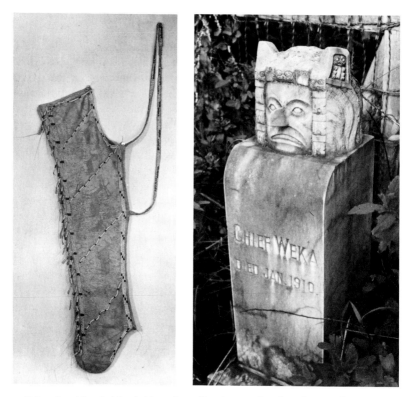

12 Painted and beaded buckskin quiver. Tanaina, *c.* 1840 (see also p. 58).

13 Tombstone of Chief Weka with carving in stone of frontal-headdress type (cp. ill. 24). Kitwancool, Gitksan Tsimshian, *c.* 1910.

established closer ties with the Northwest Coast; these are clearly reflected in their arts.

## The Northwest

Striking contrasts exist between that narrow strip of land known as the Northwest Coast, hemmed in between the Pacific Ocean and the steep Coastal ranges, and the Plateau area which extends behind those ranges as far as the Rocky Mountains. The Coast is humid, warmed by the Japanese Current, and covered with rain forest; the Plateau is dry, in some parts even arid, and quite cold in the winter. In the south the Columbia and Fraser Rivers, and in the north the Skeena and Nass, break their way through the mountains to form the major avenues of contact between Plateau and Coast.

The earliest inhabitants of the Northwest (like those in the rest of mountainous western North America) were rather unspecialized hunters

26

and gatherers. While the Coastal area was submerged for several thousand years by rising sea levels, the Plateau was influenced by the specialized Desert culture of the Great Basin in the south. Later, new inspirations seem to have come from the East and North. By 1000 BC, the people of the Coast exhibited an adaptation to the maritime environment not unlike that of their Eskimoid neighbours to the north, with sea-mammal hunting a major economic activity. In due course this way of life was altered, apparently by the influx of new populations from the Plateau, who brought with them both specialized methods to exploit the riverine resources and superior stone tools, which led to a rise in the art of carving. While stone carving remained important in the interior, it was almost abandoned on the Coast in favour of sculpture in the abundantly available wood. Late prehistoric sites, like the Makah village of Ozette (which was covered by a mud slide preserving a tremendous amount of organic materials), afford insights into the richness and quality of this artistic tradition.

Among the earlier inhabitants of the Coast were the Tlingit and Haida in the north, distant relatives of the Athapaskan tribes of the western Subarctic; the Wakashan-speaking Kwakiutl and Nootka on Vancouver Island and the adjacent mainland; and the Penutian-speaking Chinook on the lower Columbia River. The Penutian Tsimshian, the Salishan Bellacoola, and the Salish tribes on the lower Fraser River and in the State of Washington were among the later immigrants.

The historic tribes of the Northwest Coast were able to secure a stable and even abundant supply of food by intercepting the regular runs of salmon to the up-river spawning grounds, as well as by catching herring, halibut, and other fish, both in the rivers and on the ocean. Whaling, practised by some groups like the Nootka, was important more for the prestige it carried than for economic reasons. These fishermen lived a sedentary life in villages consisting of large wooden houses inhabited either by clans or kindreds. The secure food supply enabled them to develop an elaborate ceremonialism, especially during the economically less important winter months, and it sustained a complex social organization based on marked class distinctions between a hereditary nobility, the common people, and a small slave population. Accumulation of wealth and status in the leading families is a key theme of Northwest-Coast culture. Special occasions for the validation of inherited rights, and for the display and redistribution of property, centred around the potlatch feasts, or lavish present-givings, which were held in winter when all the food was gathered in, and which were accompanied by songs, dances, and drama dealing with the grandeur of the host's family and ancestry. The Northwest Coast is the only area in North America where heraldic and ceremonial carving and painting was in the hands of *13*

professional artists who could be supported by the upper class from the economic surplus.

The first Europeans encountered on the Northwest Coast were Russians, probing south from Siberia and later establishing a colony in Alaska. A thriving trade in sea-otter furs began, following Captain Cook's visit of 1778, which brought ships from many nations to the Coast and added to the wealth and prosperity of the tribes well into the second half of the nineteenth century. Later, however, declining trade and White encroachment led to a breakdown of the old culture among most tribes. Especially in Oregon and Washington, many groups were crushed by disease and other consequences of White contact. In British Columbia and Alaska, however, larger populations survived to see a recent revival of some of the rich cultural heritage.

Developments in the Plateau area were less spectacular. Salmon was important for the food economy, but could not become a basis for sedentary life: its catch was one seasonal activity among others, such as root digging and hunting. The local resources plus the heterogeneity of the tribes (mainly Penutian-speakers in the south and Salishan-speakers in the north) contributed to some diversity within the region which, however, lacked the social, artistic, and cultural complexity of the Northwest Coast.

During the historic period, the Plateau tribes were situated between, and influenced by, two areas of dramatic cultural development: the Plains and the Northwest Coast. Plateau groups like the Flathead, Kutenai, and Nez Perce adopted some of the trappings of Plains culture along with the horse, while slavery was introduced from the Coast. Though the Plateau area during this period lacked the exquisite arts of the neighbouring regions – even its stone carving was not equal to the wood carving of the Coast – it is of particular significance as a cultural turntable between the north, east, south, and west.

*The Southwest*

Southwestern North America is dominated by mountains and deserts. Between the Rocky Mountains in the east and the Sierra Nevada in the west, the arid Great Basin offers little to invite human occupation. To the south, the Rockies level out into a plateau area which is drained by the Colorado River into the Gulf of California, and by the Rio Grande into the Gulf of Mexico, and ultimately drops off into the Gila Desert of southern Arizona. Only west of the Sierra is the climate less extreme. Although there are dry spots in California too, most of the state is blessed with an agreeable Mediterranean-type climate. On the other hand, there are also more

mountains (the Coastal Ranges) and consequently the human habitat is divided into many small zones and ecological niches.

The earliest inhabitants of western North America in general were apparently rather unspecialized hunters and gatherers, with big-game hunting important only in marginal areas. As the Southwest became more and more desiccated after the end of Pleistocene (after 10000 BC), its inhabitants had to specialize in order to survive. Around 8000 BC, the Desert culture arose in the Great Basin as a specialized gathering culture in which hunting was of only secondary importance. Three thousand years later this new way of life had spread to the Southwestern plateaux and deserts; its adaptations in California were more local and less specialized. The success of

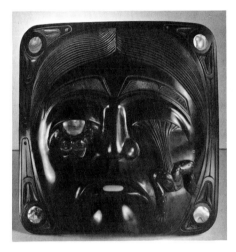

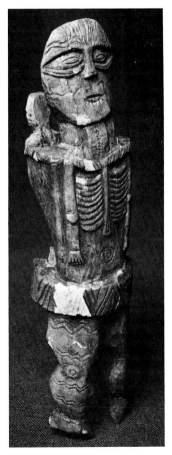

14 *The Volcano Woman*. Argillite carving by Henry White based on the myth of The Weeping Pole of Tanu (see also p. 162). Haida, 1976.

15 Carved elk antler figure showing ribs in typical X-ray style (cp. ill. 153). Columbia River (see also p. 189).

these adaptations is borne out by the fact that both in the Great Basin and in California no major changes in basic subsistence patterns occurred until historic times, even though local populations did change.

Only the extreme Southwest saw further developments, partly spurred by Mexican influences. Its prehistory, over the 1800 years prior to the arrival of the Spaniards, is dominated by the interplay of three local traditions: the Mogollon of the Arizona–New Mexico border area, the Anasazi of the northern Southwest, and the Hohokam of the southern desert. What distinguished them from their neighbours was the emergence of a sedentary life-style based on irrigation farming. Corn (maize) had first been introduced into the Mogollon area from Mexico before 2000 BC (with squash and beans following a thousand years later), but was only grown supplementary to the gathering of wild plants.

The beginnings of the Hohokam tradition around 300 BC point to Mexican inspirations of a more decisive nature. A sophisticated system of canal irrigation with ditches over ten miles long made farming possible in the deserts of the Gila and Salt River valleys. Pottery making and textile technology are also thought to have derived from southern sources at the same time. Whether the early Hohokam people were peaceful colonists from Mexico establishing a northern outpost, or local people strongly influenced by their Mexican neighbours, is still in dispute.

The Hohokam tradition affected groups to the east and north until after AD 1000; later, after AD 1200, the Hohokam themselves came under the influence of the Anasazi. Pueblo-like architecture (multi-storey buildings made of stone or adobe, with walled rooms, accommodating several units or families) and polychrome pottery enriched the local culture for about 200 years. It is generally assumed that the Pima and Papago are the historic heirs of this tradition.

Mogollon definitely represents a local development. Owing to better ecological conditions, irrigation farming was never as vital here as elsewhere in the Southwest. Fired pottery may have been received directly from Mexico or from the Hohokam, but exotic elements are less common than in the desert area. During the first millennium AD, Mogollon played an important part in the rise of the Anasazi tradition; later the situation was reversed and Mogollon found itself on the receiving end. The Mogollon-Anasazi blend manifested itself in the late period of Casas Grandes in Chihuahua, a former Mexican outpost on the borders of the Southwest, and may have provided the cultural mould for the historic Zuni.

At a time when both the Hohokam and Mogollon were already potters, the Anasazi were still in their Basketmaker stage (AD 300–700), a transitional period between a local version of the Desert culture and the emergence of the

fully developed Pueblo culture. Some corn was grown, but pottery does not appear before AD 400. Another 300 years later, the transition from pit house earth lodges to the characteristic architecture of stone or adobe marks the beginning of the Pueblo stage, which lasted into historic times. It is now usually divided into four periods coinciding with (*a*) the development of irrigation and architecture, AD 700–900; (*b*) the expansion of its sphere of influence, 900–1100; (*c*) the reduction of its territory and concentration of its population after a long and severe drought had forced them to give up their settlements in the north, 1100–1300; and finally, (*d*) up to the coming of the Spaniards in the sixteenth century. There had always been local diversity within the huge Anasazi realm; in historic times this was largely reduced to a distinction between the western pueblos (Hopi, Zuni, Acoma) and the eastern pueblos along the upper Rio Grande.

*87*
*95*

Sharing basically the same culture (Pueblo architecture, irrigation farming, priestly religion, theocratic government), the Pueblo tribes consisted of representatives of four different language groups: Uto-Aztecan, Tano-Kiowa, Zuni (distantly related to the Penutian family of California), and Keresan. Spanish-Pueblo relations were marked by a strong native resistance against enforced acculturation. The Pueblo revolt of 1680 actually expelled the Spaniards from the Southwest, but twelve years later they returned to reconquer their lost possessions, and to Christianize the Rio Grande tribes under military pressure. They could not, however, prevent the Pueblo tribes from secretly adhering to their traditional religion; in many respects, the Pueblo groups have since retained much of their old culture.

*3*

Along the northern frontier of the Anasazi, the Fremont culture of Utah also grew out of Mogollon stimuli on a Desert culture base. It developed largely independently of the Anasazi, and left no identifiable historic heirs. The Yuman tribes of the Colorado River, on the other hand, are probably the descendants of the prehistoric Patayan tradition which had absorbed both Hohokam and Anasazi influences.

Most tribes of the Southwestern heartlands had their roots within the region; but the Athapaskan-speaking Navajo and Apache were intruders, whose arrival did not significantly precede that of the Spaniards. Originally hunters and gatherers, many of them learned some farming from their new Pueblo neighbours and adapted other Southwestern traits to their culture. This, and the adoption of the sheep introduced by the Spaniards, attest to the remarkable ability of the Navajo to integrate foreign elements without losing their cultural distinctiveness. Today the Navajo have the largest population of all North American tribes.

Owing to the dry climate, many objects made of organic materials have been preserved in prehistoric contexts. Therefore, more about the material

16 Carved wooden staff
decorated with feathers. Pomo,
c. 1900.

culture and the arts of the pre-European populations of the Southwest is
known than about any other area in North America. The secrecy with which
Pueblo religious life is surrounded has, however, limited White access to the
important field of religious art in this area.

The Uto-Aztecan inhabitants of the Great Basin illustrate an efficient
adaptation of the Desert culture pattern to their inhospitable habitat.
Exploitation of the meagre resources required a loose social organization
coupled with a nomadic life-style. Neither contributed to the development
of the arts.

The tribes of California were in a somewhat better position. Especially on
16 the Coast, the combination of fishing, gathering, and hunting supported
some of the highest population densities in native North America. Overall
characteristics of the region are its extreme local diversity, both in terms of
linguistic affiliation and culture, and the small size of most social and political
units. Spanish influences were strongest around the missions of southern and
central California. In the nineteenth century, the massive surge of White
immigration following the Gold Rush led to genocide all over the State. The
majority of native societies had ceased to function in a traditional way by
1900.

32

# Native traditions and the European impact

A general feature of tribal societies is the division of labour by gender. Though the assignment of any specific task to either males or females is not universal, certain basic trends exist. Worldwide, work in stone, bone, horn, shell, wood, and metal tends to fall to the men, while the preparation of skins and leather, needlework, weaving, basketry, and pottery are activities performed by males in some societies and by females in others. In North America, this second group was assigned to the women, with the exception of Pueblo weaving and embroidery. (Other exceptions are the frequent female participation in work in bark and, perhaps related to this, the leading role of women in Pawnee wood carving.) Two further rules also have a bearing on the arts. One is that, in process consisting of several different steps, all tended to be done by the same gender; for example, if women made the pottery, it was usually painted by women. The second rule suggests that wherever professional specialization occurred, tasks were performed by males; since professionalism was rare in native North America, this applied primarily to heraldic painting and carving on the Northwest Coast, as well as to the art of ritual specialists elsewhere, who were generally males anyway.

From all this, distinctive male and female styles can be expected to have evolved, depending on the media used. This expectation is increased if the constraints of the different technologies on matters of design are taken into account. In broad outlines, the facts support this contention. If we discount most of the floral or realistic designs in bead and quill appliqué and basketry as post-European, female styles on the whole are distinguished by a greater inclination towards abstract, geometric designs, while male styles often exhibit distinctly realistic tendencies.

A classic example of this dichotomy is Plains Indian skin painting, one of the few arts produced by men and women concurrently in the same tribes, using identical techniques but different styles. Otherwise, technologically unrelated arts, such as Tlingit male painting and female basketry, or Navajo male dry painting and traditional female weaving, have to be compared to exemplify the difference.

*18, 17*

More interesting than cases conforming to the rule (which is often simply the result of female dominance in basketry with its inherent limitations on the nature of designs) are the exceptions, which have three possible causes:

*102*

evolutionary trends, technological limitations, and stylistic borrowing across gender lines.

Looking at the question of abstract versus representational design from an evolutionary point of view, there is evidence pointing to a priority of abstract styles in some cases where dated sequences can be established. This is true of all the female arts that developed beyond abstraction, and also of a few male arts. In Alaskan Eskimo ivory engraving, a whole series of abstract styles appeared before the late pictorial style of the nineteenth century. Similarly, the oldest styles of Great Basin rock art are thought to have been the simple 'pit-and-groove' (circular grooves with small shallow holes) and a later curvilinear abstract style; both predate the earliest representational examples of petroglyphs in the area. This is not to say that abstract art invariably preceded realistic art (in sculpture, Okvik, Thule, and Punuk forms clearly show examples of both traditions, as do the eastern Adena and Hopewell traditions), but it does indicate a general trend from abstraction to representation.

Technological limitations may be the major reason for the abstract nature of designs in Pueblo male weaving. By using a technique which in many

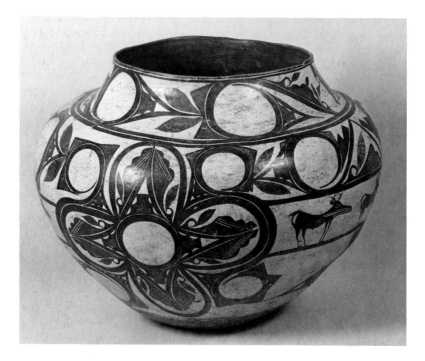

important respects derives from basketry, the weavers were restricted to more or less abstract patterns. Embroidery designs are less limited from a technical point of view; their possible evolution from brocading, however, explains their continued abstract and rectilinear nature which seems to have given way only in the nineteenth century to the adoption of less stylized floral motifs.

A similar conservatism of design is seen in early Southwestern pottery painting, which represents a continuation of abstract/rectilinear basketry design traditions, even though this new medium allowed a much greater freedom of forms. The first development here, after several centuries of pottery painting, was the addition of curvilinear elements, to be followed even later by representational motifs. The prevalence of mythological or ceremonial subjects on Mimbres realistically painted pottery, for example, *74* may indicate a male influence on this second development. The same is true of Hopewell pottery in the East, whose bird designs possibly derive from older versions in male arts (such as engraved stone tablets).

Stylistic borrowing across sex lines is well documented in several instances during the historic period. Pictorial quill- and beadwork of the Plains is

17 Polychrome painted storage jar. Attributed to Arroh-a-och, a male transvestite artist. Zuni, *c.* 1850 (see also p. 86).

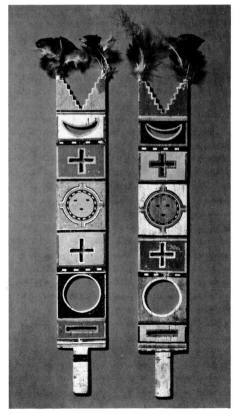

18 Pair of painted and cut-out wooden dance wands showing symbols of the sun, moon, clouds, and rain. Zuni, collected by F.H. Cushing before 1884 (see also p. 82).

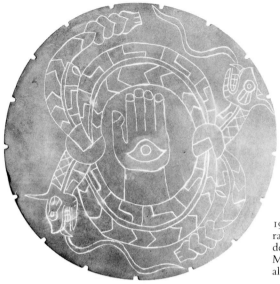

19 Stone disc with engraved
rattlesnake and hand-and-eye
design. Moundville, Alabama;
Mississippian, c. 1200–1500 (see
also p. 64).

heavily indebted to male painting styles; the woven sand-painting rugs by
Navajo women faithfully copy a male art form in textile (it is interesting that
it was a *male* pioneer weaver of sand-painting rugs, Hosteen Klah, who
contributed to the final breakthrough of this style); and in Chilkat weaving,
the women work from pattern boards painted by the men.

Those representational designs in textiles and basketry that are
undoubtedly pre-European also appear to be related to male arts and
activities: human figures on Wasco sally bags find their correspondence in
wood carving; whaling scenes on Nootka basketry relate to an exclusively
male activity; and the representational designs on twined textiles (as well as
in quill appliqué) of the Great Lakes area feature almost exclusively images of
supernatural beings, such as the thunderbird or the underwater panther, and
thus parallel Mimbres pottery.

Examples of male styles deliberately borrowing from female arts are less
common. Indications are present in Southwestern mural painting, which at
different stages of its evolution seems to have borrowed elements from
pottery design. On a simpler level, the incised decorations found on elk-horn
purses and related objects from northwestern California are based on
principles similar to those encountered in basketry design.

Irrespective of the artists' gender there is a notable regional distinction
between graphic and painted styles, which may be regarded as separate
traditions. If changes caused by the European impact are excluded, the East
emerges as a typically graphic region, while genuine painting traditions are

36

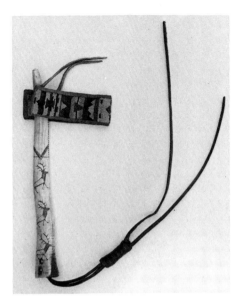

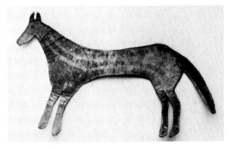

20 Elk horn quirt engraved with elk motifs. Shoshone, *c.* 1880 (see also p. 64).

21 Cut-out rawhide horse effigy. Cheyenne, *c.* 1880.

best represented in the Southwest. Many two-dimensional arts of the East are indeed based on engraving or define forms by simple lines (outlines or silhouettes). Pottery is almost exclusively engraved; rock art is either engraved or executed in a monochrome graphic style; engraving is the standard form for the decoration of bark, bone, shell, and even wood; in *20* pictographic skin painting, forms are outlined and do not necessarily need colour; in the painting of parfleches (containers made of folded rawhide, for carrying dried meat for example), outlines are drawn first, colour is filled in later; all over the East we find abundant use of cut-out forms, including *21* textile appliqué; and even when pigment is used it is not applied by means of a brush but with a stylus.

Southwestern pottery, by contrast, is almost always painted; rock art, especially of later periods, is often painted; in mural painting, areas are painted first, and outline added as a final touch; Hohokam shell etching, although resulting in graphic forms, is basically a painting technique. Here, except for early rock art and metalwork, engraving is rare, and so is appliqué; the use of mosaics rather than cut-outs typifies the Southwestern preference for additive complexity as opposed to graphic abstraction (and this includes sand painting, as an impermanent form of mosaic). Finally, in Southwestern *22* painting brushes are used.

By the same standards, the North is also overwhelmingly graphic. The Northwest, however, combines features of graphic and painting traditions. Brushes are used, but in two-dimensional painting the outlines are drawn

37

first, and formlines are constructed from cut-out templates. The formal complexity of the classic northern Northwest-Coast style is much greater than that encountered in most Eastern graphic styles; the style is also found in engraved representations, but these clearly derive from the painted versions and not vice versa.

From a developmental point of view, graphic styles are older than painted styles, which represent an advanced stage in the evolution of artistic expression and technology. This is true of Southwestern painting, which spans an enormous time-scale, beginning about 2000 years ago, and also of Northwestern painting, whose development, however, cannot be traced as far back, owing to the perishable nature of paintings on wood and skin.

Another important distinction between graphic and painted styles is the presence or absence of polychromy. The Southwestern sequence shows that polychrome pottery painting is a rather late phenomenon which originated in the Anasazi tradition after about AD 1100. In rock art it may be earlier, as exemplified by the Pecos River style of Texas, but, significantly, polychrome rock art (and mural painting) is an almost exclusively Southwestern phenomenon.

The history of Southwestern pottery indicates that the development of colour use led from monochrome to bichrome to polychrome patterns. Not all arts were affected by this trend at the same time, nor did all Southwestern groups participate equally in it. Basketry and weaving, for example, remained very conservative in this respect; the pottery of several Rio Grande pueblos shows a similar reluctance to accept polychrome and sometimes even bichrome decoration.

The data for the East are less satisfactory, and the prehistoric evidence is not conclusive. Some polychromy may have existed in the Mississippian phase of the Southeast, but it did not extend to pottery decoration. Polychrome painting on shields and parfleches may ultimately derive from this source, although a Southwestern origin is more likely (see the similarity of shield design patterns, the use of negative space in parfleche designs, and the Southwestern origin of Plains dry painting, pp. 54–55, 56, 101). Otherwise the East is predominantly a monochrome and bichrome area, with red and dark colour combinations on naturally light backgrounds. This occurred most frequently in early specimens of painting, quillwork, basketry, and twining. On the northern Northwest Coast, and in the adjacent parts of the southwestern Arctic, polychrome painting seems to have been traditional. The classic two-dimensional style is based on the use of black, red and blue on a natural background, while masks, totem poles, and wooden hats of the Aleuts display an even wider range of colours. It does not, however, seem to have been an old feature of central and southern parts of the Coast.

22 Leather shield with highly stylized symbolic painting. Cochiti, collected by
A.F. Bandelier before 1883 (see also p. 58).

23 Mountain sheep horn bowl, partly engraved, partly sculptured. Haida,
collected by Captain A. Jacobsen in 1882 (see also p. 187).

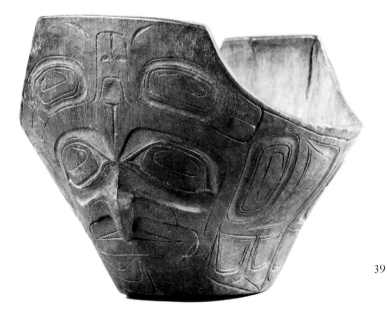

According to past research, influences that may have contributed to some of these developments may have entered North America in pre-European times from three directions. That man came to the Americas from Siberia across Bering Strait cannot be reasonably doubted; even some continuation of Old World influences on North America over the Eskimo bridge spanning Bering Strait can be taken for granted. It is, however, an unlikely explanation for the presence of polychrome painting in the northern Pacific area.

The theory of trans-Pacific contact between eastern Asia and the Northwest Coast has always had staunch supporters. It is largely based on an assortment of similar motifs found on both sides of the Pacific. Such contacts were certainly possible but remain to be substantiated beyond reasonable doubt.

The third direction is from Mexico. Again, there is little argument about the fact that both the Southwest and the Southeast were affected by influences from the south. On the other hand, it may be too easy to explain every development in these areas as having been inspired by Mexican ideas. The origin of mural painting in the northern parts of the Southwest, rather than anywhere closer to the centres of Mexican civilization, is an important example. Similarly, polychrome pottery painting apparently did not enter the Southwest among the Hohokam or Mogollon, but seems to have originated in the Anasazi tradition.

While external influences do have their place in the history of the native arts of North America, they should not detract from the overriding importance of indigenous developments.

In historic times, there were short 'golden periods' of tribal art, which occurred after the White man's technological and economic stimulus had invigorated tribal life, but before his relentless pressure for space and resources doomed hundreds of tribes to social decay and even extinction. Although the more dramatic developments can thus be seen as the direct result of external influences, an ever increasing body of data has led in recent years to a recognition of evolutionary changes within indigenous traditions, both prehistoric and historic. The rise, fall, and resurrection of American Indian art cannot, however, be understood without continual reference to the social, economic, and technological changes caused by the impact of European contact. The rapidity and thoroughness of this transformation is unparalleled by any of the changes and developments that occurred before Columbus. It attests to the strength and endurance of the native societies that their visual arts have nevertheless retained a remarkable distinctiveness.

The first and most important changes resulted from the exposure to new tools and materials imported by Europeans. Iron tools traded from Siberia in

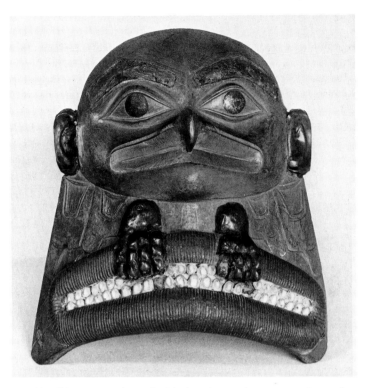

24 Frontal headdress, painted wood with sheet iron and copper overlay, and opercula inlay. Yakutat-Tlingit, collected during the Malaspina expedition of 1791 (see also p. 174).

prehistoric times had had a significant influence on the carving and engraving styles of the western Arctic and perhaps even of the Northwest Coast, although the amount of metal so received was probably very small. The almost unlimited supply of iron tools following European colonization, on the other hand, necessarily led to even greater changes. Wherever wood had been carved before, the size, quality, and quantity of the carving increased. This is true of the Alaskan Eskimo, who turned increasingly to mask making during the nineteenth century, of the Northwest-Coast peoples, whose monumental totem poles are largely the result of the new tools, and of the Iroquois, whose masks, the 'False-faces', could now be more exquisitely carved (indeed, they may even have been post-European in origin). Even the Pueblos, whose past record of carving had been mediocre, started to mass-produce their Kachina dolls in more elaborate forms.

In the East, the development of monumental wood sculpture was probably stunted by the disintegrative influence of intensive White contact

from the mid sixteenth century; but the Northwest-Coast tribes enjoyed the advantages of the superior tools for another hundred years without such interference.

Metal tools also had an effect on work in stone. They contributed to the rise of argillite and catlinite carving and of modern Eskimo soapstone sculpture, as well as to the refinement of lapidary art in the Southwest. Nowhere, however, did they inspire monumental art in stone. Similarly, in basket weaving, wooden splint basketry is unthinkable without metal tools. All kinds of needlework were boosted by the introduction of steel needles and scissors; true embroidery was a major innovation derived from it. Everywhere the advantages of the new implements led to enhanced delicacy.

Much of the time that had formerly been spent on the procurement and preparation of skins, beads, fibres and dyes could now be devoted to their decoration. In the East, trade cloth and ribbons initiated the evolution of *141* ribbon appliqué, while the easy availability of glass beads in many colours spurred their lavish use and ultimately promoted polychromy. On the Northwest Coast, mother-of-pearl buttons stimulated the creation of elaborate 'button-blankets'. Commercial yarns and dyes also increased the range of the native palette. The preference for bright colours, once they became available, proves that the pastel quality of some of the work in native dyes was the result of technological limitations rather than of aesthetic considerations. The recent adoption of acrylic fibres and colours by native artists and craftsmen continues the tradition of choosing the newest and most suitable raw materials.

Whole new technologies were less frequently accepted. Silversmithing – most advanced in the Southwest, and in less complex forms elsewhere – is a major exception. Among textile techniques, knitting, crochet, and hole-and-slot heddle weaving represent less revolutionary changes, since in most cases they merely improved upon existing methods.

None of the new tools, trade goods and technologies contributed as such to a significant Europeanization of styles. They were integrated into the repertoire of native artistic expression to produce objects of indubitably traditional character.

Stylistic acculturation required more intensive interaction between Indians and Whites than trade. In its most thoroughgoing forms it probably resulted from formal education or intermarriage. Silk-thread embroidery, for example, is almost completely European, not only in technique but also in design, among the Cherokee (with their sizeable mixed population) and among the Canadian Métis. Similarly, the floral patterns of the Northeast apparently owe a major debt to mission schools, in which young native women were trained in the latest European styles, sometimes already

42

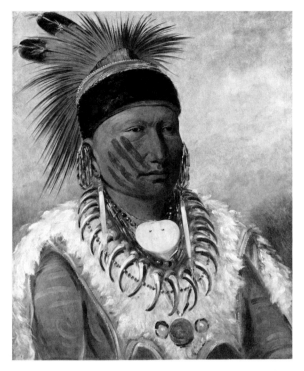

25 *The White Cloud (Iowa)* by George Catlin, showing hand-shaped face painting (cp. ill. 3; see also pp. 52, 97–98).

adapted to the use of traditional materials such as porcupine quills and moosehair.

In general, however, stylistic acculturation was selective. Only those foreign features that were compatible with traditional design found easy acceptance: floral patterns prospered where curvilinear designs had been the rule. And if, as seems likely, certain late nineteenth-century Plains beadwork patterns were derived from oriental rugs, this could happen only because these were similar to the traditional rectilinear style.

More difficult is the explanation of stylistic acculturation in Plains skin painting. In one individual case, that of the Mandan chief Mató-topé, stylistic changes have been explained as resulting from contacts with White artists such as Catlin or Bodmer; but such contacts cannot be documented, or even regarded as likely, for the majority of mid nineteenth-century Plains Indian painters whose style was nevertheless moving in the direction of White models. Perhaps the exposure to book illustrations and other examples of Western art seen on the frontier was responsible for the general 25

26

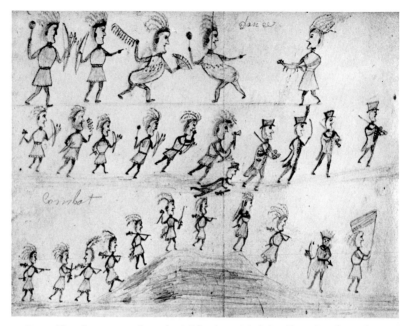

26 *Dance* (showing a scene from the Midewin or Medicine Dance) and *Combat*.
Pencil drawings pasted into a book of drawings from the mission school at Arbre
Croche, Michigan. Ottawa, *c.* 1845 (see also p. 61).

trend. In later decades, the influence of the Indian prisoners returning from
Fort Marion, which after 1875 had become the first informal native art
school, and of others who had experienced comparable situations, reinforced
this trend.

Related to this process may be the widespread efflorescence of pictorial
design under White influence. In Plains skin painting and Pueblo
embroidery it is once more only an intensification of features already
present; in Plains bead and quill appliqué it represents a transfer from
matured pictorial painting; in Northeastern quill embroidery on bark it
grows out of the floral style; in Navajo weaving and western basketry the
reasons are less clear. It even appears in modern Northwest-Coast print
making, where artists like Vernon Stephens produce pictorial art under a
thin veil of classic northern Northwest-Coast style.

Whatever the specific reasons might have been, the universality of the
trend was backed by the transition from tribal to ethnic art. Because of
White preferences for realistic designs, successful tourist art had to be largely
pictorial. This is true of two-dimensional designs as well as of sculpture.

27

44

Most forms of effigy basketry were made only for sale; ceramic sculpture in the Southwest has traditional roots, but became especially popular when a new market developed after 1880; and at least certain types of catlinite pipes (including those showing drinking scenes, and perhaps also those of an erotic content) partly reflect the demands of White customers.

Indirectly, the White American impact on the native tribes resulted in heightened intertribal stylistic exchanges. The resettlement of Eastern tribes in Oklahoma, and the northwestward spread of the Ojibwa in connection with the fur trade, contributed to the expansion of styles, just as at a later date the confinement to reservations fostered the emergence of Pan-Indian traits on the Plains.

Finally, some basic changes in the arts have to be mentioned, which derive from the economic and socio-political influence exerted by Whites in the New World. Initially, the European presence in America tended to stimulate native economies. As long as the colonists depended partly upon the indigenous population for necessary supplies, and native productivity was increased by new exploitative techniques of European origin (horses, guns,

27 Figural beaded vest with elk motifs, lazy stitch on buckskin. Northern Cheyenne, c. 1890 (see also p. 146).

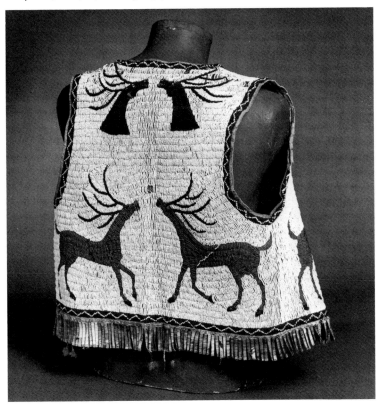

steel traps, shepherding), the tribes clearly stood to gain from their new neighbours. Even in the fur trade where the traders reaped the highest profit, the net inflow of capital and goods contributed to the rising wealth of the natives. At least part of this surplus wealth was converted into art, since more time was available for the production of lavishly decorated clothing and ornaments, and for an elaboration of ceremonial life. Both secular and religious art flourished in these golden periods, through which most tribes passed at various times.

It was during this period of buoyancy for the tribal arts that ethnic arts originated. For the artist, this meant not only additional income, but also the possibility of a greater freedom of expression. Many of the traditional and ceremonial constraints of tribal arts could be disregarded when working for White customers. Poor quality for easy gain and creative exploration of new directions were but two facets of the same trend.

In the long run, the White presence proved to have less beneficial results. As the Whites assumed political domination over the tribal people and imposed their administration on their affairs, the old way of life could no longer be maintained. Some tribes were swamped by the tide of White settlement, others were pushed from the better lands and confined to reservations. Economic disasters, whether caused by the extermination of the bison, the end of the fur trade, or the transfer of tribal lands to individual ownership, contributed to the destruction of the traditional cultures. White legislators and bureaucrats took it upon themselves to suffocate all outward signs of traditionalism by prohibiting important institutions such as the potlatch of the Northwest Coast, or the sun dance of the Plains, an important ritual featuring self-torture of the participants.

All this, of course, reduced the vitality of tribal art, but made ethnic art more important than ever before. Pottery was less in demand for cooking vessels (since metal pots and pans were cheap to buy), and only the tourists showed continued interest in native curios made of clay. Without potlatching, no more totem poles were erected by some tribes; but poorly carved models sold remarkably well. After industrially made textiles had replaced the old Navajo wearing blankets, the Indian traders could still sell Navajo rugs to the city dwellers back East. Art, which had been an indivisible part of a way of life, veered towards being an economic opportunity. The pride of good craftsmanship was sometimes muted under these circumstances, but it was not completely gone.

A few White people knew that native artists could do better than mass-producing pottery 'rain gods' ('Do you have a God?', asked the advertisement offering these clay figurines for sale). It was largely their foresight and exertions that stopped the general decline by creating a new

market for higher quality products and by cultivating especially gifted artists, such as Datsolalee, the Washo basket maker, or Nampeyo, the Hopi potter. Both innovative experiments and revivals of traditional techniques and styles were invited to raise the ethnic arts beyond the level of mere routine.

Today, ethnic art (alongside Pan-Indian art, which grew out of the same movement) has become the established form of traditional native American art. The White market is at last willing to pay the artists the prices their work deserves, and the artists have accepted their role as producers of native art for non-traditional use and non-tribal buyers. There has been both continuity and change in the history of the native arts under White influence. In general, the changes seem to outweigh the continuities, but they must be regarded as the price paid for the survival of the arts.

*28*

28 *Koshare Promotion Ceremony*. Painting on pottery by Sofia and Rafael Medina. Zia, *c.* 1975.

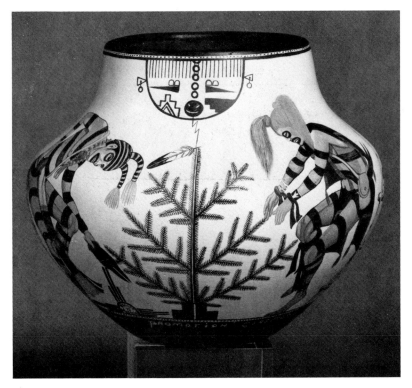

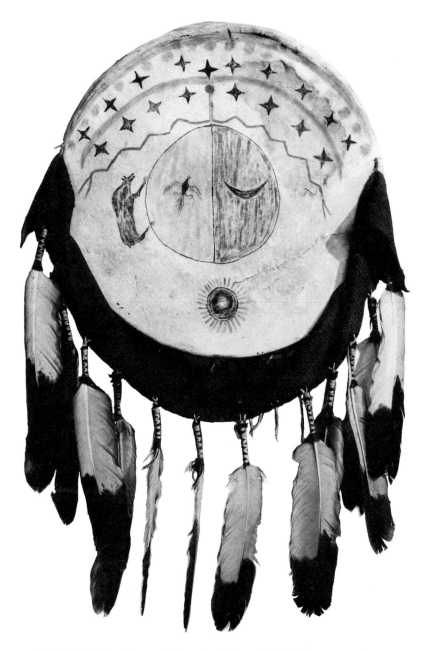

29 Hide shield with visionary designs (including celestial phenomena and zoomorphic spirits) used in the sun dance. Shoshone, *c.* 1890 (see p. 54).

# Introduction

For a concept of form to reach visible realization, the application of specific techniques to a specific medium is necessary, just as a specific language is needed for the formulation of verbal utterances. Techniques determine styles no more than meaning or function, but inasmuch as they represent the vehicle for expression, they often exert an obvious, limiting influence on the possible solution of problems of design. This is what makes literal translations – from one medium, or language, to another – so difficult. The strength of this influence differs according to the techniques employed, and it generally decreases with the improvement of technologies in general.

The distinction between two- and three-dimensional arts is basic: the creation of sculptural forms poses problems vastly different from those in the creation of surface designs. Because every three-dimensional object also has a surface, two-dimensional forms or principles may enter into its design. The addition of two-dimensional forms (as in painted pottery) simply increases the formal complexity of the object. The application of two-dimensional *principles*, however (as in some forms of Northwest-Coast carving, where the formline system was applied to curved surfaces – see pp. 166–70), clearly modifies the principles of three-dimensional form. In two-dimensional art, only three-dimensional additions of form (such as feathers or scalp locks dangling from painted shields or beaded shirts) are found in native North American art; the application of three-dimensional principles, such as the use of perspective or shading to indicate spatial depth, seems to have been unknown in the tribal arts, but was later learned from White sources.

Among two-dimensional techniques, painting and linear or graphic style (incised, engraved, or drawn) must be distinguished from the textile arts. In the latter, surfaces are decorated either by structural means in the process of their manufacture (weaving, basketry) or by the addition of decorative material to the surface of the finished textile (needlework). Limitations are much more pronounced in structural designs, which, however, were the major form of textile art in pre-European times. In painting (as defined for the purpose of this book) pigment is applied with a stylus or brush, while in engraving, matter is removed from the surface to achieve contrasts between line and background. Painting, of course, allows the use of different colours (including polychromy), which is generally lacking in engraving except when the two techniques are combined.

# Painting and engraving

Within the field of painting and engraving, the media used are of special significance. It certainly makes a difference whether one has to apply these techniques to a soft skin or a piece of hard ivory. It also matters whether painted surfaces are more or less flat or spherical (since, in most examples of pottery painting, even 'straight' lines are curved).

The choice of medium is primarily dependent upon availability. Thus, skin painting dominates on the Plains, ivory engraving in the Arctic, wood was the favourite material of Northwest-Coast painters and engravers, and pottery painting is the major form in the Southwest, just as bark engraving is in the Subarctic. These are rarely the only forms of art in a given area, because usually at least one other medium was available. The universal material is stone, a factor that adds to the importance of rock art for stylistic comparisons across environmental zones. But it is a difficult medium to work with and consequently very rarely became the primary medium for painting and engraving, with the possible exceptions of California and the Great Basin.

*Skin painting of the East*

The two-dimensional artistic techniques of the East found their highest development in skin painting. Most of the data relate to the Plains area in the nineteenth century, but there is evidence of its importance in the Southeast, Northeast, and eastern Subarctic as well. While several stylistic traditions can be distinguished, the basic techniques of skin painting are the same. First the tanned skin or (untanned) rawhide was partly or fully treated with a clear sizing made of cactus juice, hide scrapings, or horn glue, which preserved the original colour of the hide and consequently appeared light after the untreated skin became dirty. Next, designs were outlined by scratching the contours into the soft skin, and finally colour could be added, by means of a stylus made of porous bone or wood; brushes, made of antelope hair, are a late development reflecting White influences. Most pigments were of mineral origin (red, dark brown, and yellow being the most popular); vegetal paints were occasionally employed, while pigments received in trade from White sources (such as Chinese vermilion) became increasingly important. Some rawhide paintings were varnished with sizing after the design had been completed.

30 Quilled and painted man's shirt, showing humans represented with a geometric trunk outline, head attached. Northern Sioux, 1800–50.

The first tradition may be termed pictographic. It was devoted to the stylized representation of historic events by male artists, and embraced two subtraditions. One of these is actually a form of picture writing, used for calendrical records ('winter counts') or to register gifts or booty obtained on military expeditions. Aesthetic considerations are less important than the information contained in these highly stylized pictures, which resemble those found on engraved birch-bark records.

The second subtradition incorporates pictographic elements in scenic compositions which are usually biographical or historical. Most surviving examples are bison robes and shirts from the northern Plains. They date from the late eighteenth to the late nineteenth century, a period in which changes due to White stimuli overshadow intertribal differences. Because of the importance of warfare for the prestige and social standing of the Plains Indians, scenic skin painting depicts primarily rather static figures of men and horses engaged in combat. Human beings are represented in one of several ways: geometric trunk outline with head attached, rather than 30 included in the continuous outline; common head and trunk outline, partly closed by attached legs; open or closed outline including head, trunk, and legs. Except for late forms, arms are always attached. Legs are consistently shown from the side. Faces are shown frontally and are either blank or exhibit highly conventionalized features; more attention is given to details of hairstyle, attire and equipment. Spatial depth is ignored (with no horizons or

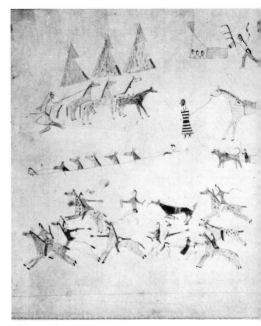

31 *Self-portrait* by Buffalo Meat, one of the Indian
prisoners at Fort Marion. Cheyenne, *c.* 1878.
Note attempts to represent spatial depth.

perspective), colours have no tonal variation and are without naturalistic
intent. There is a tendency to arrange scenes in horizontal groups, but almost
no overall composition.

One of the most outstanding artists of this genre was the Mandan chief
Mató-tópe, whose works, dating from the second quarter of the nineteenth
century, show the early influence of White painters (such as George Catlin
and Carl Bodmer), without the stylistic uncertainty so common in such
contacts (as, for example, in sixteenth-century Mexican picture writing, a
very similar medium). Representative of the late nineteenth-century tourist-
oriented style, which marks the end of traditional scenic skin painting, are
the paintings of the Shoshone artist Katsikodi. His crowded compositions
depicting scenes of hunting and camp life were made with the help of stencil
patterns and aniline paints. Stylistically, they resemble the ledger art
discussed in the next paragraph. In the same vein is a set of Ojibwa skin
paintings apparently made for sale by a single artist around 1860.
Unfortunately, these are almost the only remaining scenic skin paintings
from the Northeast.

Around 1860, Plains Indian artists began to apply their changing scenic
style to paper. Ledger books were filled with crayon and ink drawings of war

69
25

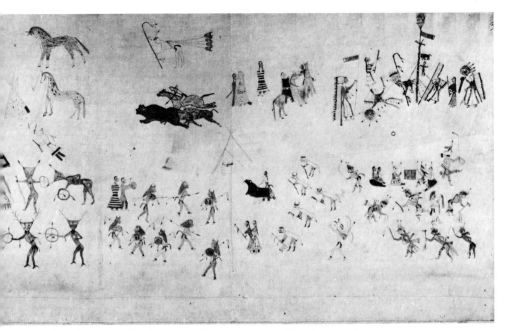

32 Painting on muslin showing raiding and warfare, bison hunt, and various ceremonies including (in top right-hand corner) the sun dance. Teton Dakota, Standing Rock Reservation, c. 1890.

exploits and, increasingly, of other incidents of traditional life, without losing their biographical character. The size of the paper, smaller than skins, necessitated the shift from groups of related scenes to individual scenes. Stylistic changes included the growing dominance of faces shown in profile, first attempts to depict eyes and frontal views of horses. Whereas the style *31* remained basically flat, overlapping and horizons were accepted as conventions to indicate spatial depth. In particular, Indian prisoners like those brought to Fort Marion in 1875 could experiment with the new medium and refine their style. Soon a White market developed for this type of ethnic art, and this helped to reinforce its colourful, semi-traditional style. At the same time, the artists began to sign their pictures.

As suitable skins were becoming increasingly rare, scenic painting was also done on imported muslin and other fabrics. Here the style and content of *32* ledger art could be combined with the linear arrangement of scenes found in earlier skin painting.

The second tradition of Eastern skin painting could be termed visionary, because the subject matter derives from visionary encounters with the supernatural. One might easily suppose that these paintings, based on emotional experiences, would be more expressive and individualistic.

53

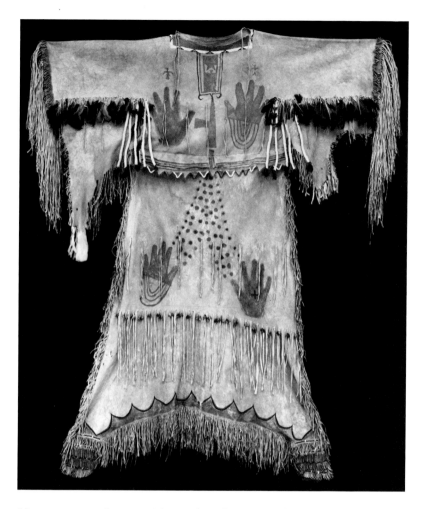

However, not only were visions culturally patterned, but so were the formal principles determining the arrangement of pictorial elements in a given space.

29     Shields and shield covers were an important vehicle for visionary painting. The circular shape limited the possibilities for composition – only two basic types underlie all shield designs: bisection by a line or band, and a central circle surrounded by a frame, which was often divided into quarters. The dividing lines were either overtly marked or indicated by representational paintings. The design of circular drum heads follows similar rules. During the Ghost Dance movement of the late nineteenth century – a nationalistic reawakening of Plains culture in the face of military and social

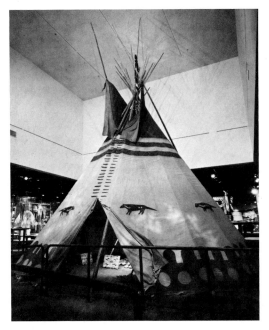

33 Ghost Dance dress (back view), painted with protective designs. Arapaho, acquired from the wife of Black Coyote in 1901.

34 Otter tipi, showing animals with heart-line (cp. ill. 17). Blackfoot, 20th century.

defeat – many of the features of shield painting, which included many protective designs, were transferred to skin or muslin shirts and dresses, *33* which were likewise thought to guard the wearer against his enemies' weapons. Compositions showing birds and other animals, crescents, traditional four-pointed stars as well as the five-pointed stars of the American flag, tend towards lateral symmetry. Often the background is divided into two horizontal colour areas, continuing both the composition of the bisected shield type and the tradition of Dakota war shirts.

Many designs found on the covers of tipis fall into the category of *34* visionary painting. Since the right to use a certain design, originally received from a supernatural being, was passed on within a certain group, some tipi designs acquired a heraldic function. Compositional types are limited in number and differ to some extent between tribes.

Symbolic painting, the third tradition, is usually referred to as a female art. While this is generally true of rawhide painting, there are exceptions: just as women sometimes executed tipi designs sketched by a man, so men occasionally painted symbolic robes. These differ in style from both pictographic and visionary painting, in that designs that had originally been representational were often conventionalized beyond recognition. With some important exceptions, most examples again stem from the Plains area.

69    One type of symbolic robe, worn by men, is decorated with one or more concentric circles of diamond-shaped 'feathers'. Sometimes this sun motif, as it is usually called, is surrounded by a more or less rectangular frame with groups of feathers in its corners; these may also appear without the frame. In several cases this symbolic painting is combined with pictographic scenes; in others, the feather circle is split in two and reinterpreted as two calumets.

35    A second type, worn by women, is commonly called a 'box-and-border' robe. The border outlines the skin on which it is painted in a conventionalized fashion, but it is never rectangular. Early Dakota examples indicate that it may represent a stylized profile view of a bison; in later pieces, mostly from the bordering tribes (for example, Ute and Arapaho), its shape is hexagonal. The box motif here is purely ornamental, and is related to designs found on rawhide containers.

Besides these two major types, there are other variants of symbolically painted robes from the Plains whose distribution and symbolism is even less fully understood. Some of them, which date from the eighteenth century,
70    bear a certain similarity to four robes, presumably collected among the Illinois, whose stylized designs are largely made up of narrow, triangular forms, indented on one long side or relieved by negative filler designs. They cannot be regarded as precursors of the box-and-border type, but must be seen as representing different branches of a much larger group.

36    Parfleches and other rawhide containers were also painted with symbolic designs by the women (and less commonly with visionary designs by men). Straight and curved edges were used to outline the patterns, whose original meanings have been forgotten, and since reinterpreted. Owing to the greater number of well-documented items, stylistic variations between different tribes are much better understood here (for example, strict rectilinearity among the Crow and their western neighbours as against combined rectilinear and rounded forms elsewhere). A limited number of elements (triangles, rectangles, diamonds, hourglass shapes, lines, dots) are arranged according to certain compositional rules. The design covers more than half the pictorial space and creates analogous negative forms.

A distinctive subtradition of symbolic painting is best represented in the largely ornamental decoration of skin objects in the eastern Subarctic.
37    Naskapi style, of which the greatest number of specimens survive, is found on coats, leggings, moccasins, mittens, caps, bags, and a single square robe. Painting is in yellow, red, and blue/green, rarely black, and includes groups of parallel lines and bands, triangles with paired incurves ('bracket' or 'double curves'), leaf shapes, and other curvilinear elements. Individual design groups may be enclosed by rectangular or trapezoidal frames. Hatching and crosshatching, rare in parfleche painting, are common here.

56

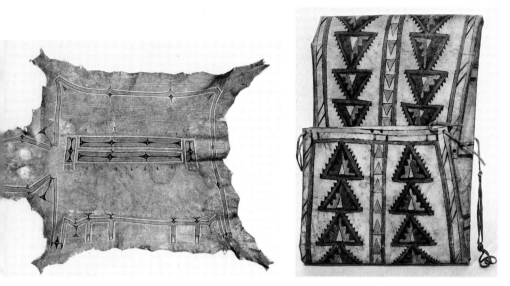

35 Painted bison robe with box-and-border design. Santee Dakota, collected in 1856 from two Wahpeton and Wahpekute chiefs, Taoyateduta (Little Crow) and Zitkayaduta.

36 Parfleche painted with conventionalized symbolic designs. Probably Blackfoot, c. 1880.

37 Tailored coat (back view), painted with curvilinear (double curves) and rectilinear designs. Naskapi, collected in 1825.

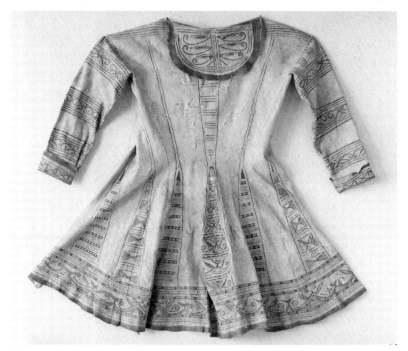

*38*    Cree ornamental painting shares some of the characteristics typical of the
Naskapi, but seems originally to have lacked the curvilinear elements, except
*39*    for circles which are usually quartered. During the nineteenth century,
however, curved forms gradually displaced angular ones, and the style
became increasingly floral.

*Other skin-painting traditions*

Outside the realm of the Eastern painting traditions, skin painting was
practised in three areas. Northwest-Coast skin painting conforms to the rules
of the local overall two-dimensional style which is discussed on pp. 71–77. A
*12*    minor tradition is represented on some Tanaina quivers which are painted
with hunting scenes in red. Both hunters and animals are shown in profile, in
solid colour, and in stylized movement. These pictures have borders
consisting of dots, dashes, and triangles, which reappear without repre-
sentational motifs on the skin dresses of other Athapaskan groups of the
western Subarctic. The style bears some resemblance to the ivory engravings
of the North Alaskan Eskimos and to rock art.

Polychrome skin painting of the Apache (except that of some eastern,
Plains-like groups) was used primarily for ceremonial purposes. Motifs
therefore have an overt religious significance. Representational elements are
*40*    stylized, but only rarely conventionalized as in picture writing, and tend to
be rectilinear. Compositions are based on a vertical primary axis and a
*89*    horizontal secondary one, and in this they resemble Navajo dry painting.
Otherwise the style resembles that of the few extant examples of Pueblo skin
painting rather than those of the Eastern traditions. A version of it occurs on
Apache rawhide playing-cards adapted from Spanish models.

Shield painting of the Rio Grande pueblos is essentially similar to that of
the Plains, except that it is less expressive and even more conventionalized.
*22*    Western Pueblo shields, on the other hand, are stylistically related to Pueblo
painting on wood.

*Bark sgraffito*

Many of the purposes served by skin on the Plains are served by bark in the
Subarctic. Birch bark is the most frequently used material. Most common
are containers of various shapes, fashioned from bark by cutting, folding,
and sewing it with root splints. In the eastern part of the Subarctic the grain
of the bark runs at right angles to the rim of the vessel; from the Cree
westward it runs parallel to the rim. Generally the winter bark of the birch is
preferred, in which a thin, dark brown layer conceals the lighter coloured
inner layers. Designs are developed by scraping or scratching to produce
negative (light on dark) images; or, if templates (themselves cut out of bark)

58

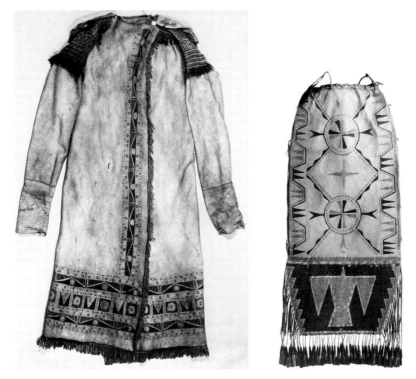

38 Painted coat with shoulder-pieces of woven quillwork. Cree style, early 19th century (see also p. 118).

39 Painted skin pouch with netted fringe of porcupine quills. Northern Great Lakes, 18th century (see also p. 116).

40 Polychrome painted skin. Apache, late 19th century.

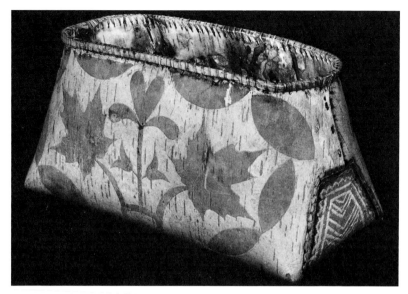

41 Birch-bark container for maple sugar with scratched design. Ottawa, collected in 1851–53.

are used, the dark layer is scratched off around the stencil, which results in a positive (dark on light) image. Template work gives cleaner contours but allows less variation.

At least five styles may be discerned. A simple geometric style dominates among the Athapaskan tribes of the western Subarctic. Crudely scratched lines or bands of triangles alternating with straight lines are the rule. In the central area (Waswanipi Cree, Ojibwa), these geometric arrangements become more complex. Zigzag bands, dotted lines, and chevrons appear together with lateral symmetry, and each side of the container becomes a separate design unit. Among other groups of the central area (Algonquin, Tete-de-Boule Cree, Lake St John Montagnais), the use of templates is characteristic. Zigzag bands retreat to the borders, and figural elements take up most of the design. Floral motifs, ranging from stylized to luxuriant and always growing out of a baseline, are much more frequent (and apparently older) than static representations of animals in profile view, artifacts, or humans freely floating in the pictorial space. Symmetrical forms (achieved by folding the template) and symmetrical compositions are the rule.

A complex ornamental style combining rectilinear and curvilinear elements is found among the Penobscot and Malecite: C shapes (often in pairs to form double curves), rounded zigzag bands, diamonds, and stepped lines are as typical as crosshatching and doubling of lines. Later, this style was also applied to bent wooden splint boxes. The fifth style is known mainly

*41*

60

from Micmac and Malecite examples and is distinguished by lively representations of animals and scenes from daily life. Figures are shown in movement and are highly spontaneous.

The suggestion that these scratched designs on bark are related to the incised parfleche decoration of the northern Plains and Plateau area can now be refuted, as this type of parfleche decoration seems more likely to have derived from Spanish leatherworking techniques.

*Incised decoration on bark and wood*

Whereas in bark sgraffito the dark outer layer of birch bark is selectively removed, the Ojibwa and Menominee use the inner (cambium) side to produce line drawings by cutting into the soft layer with a pointed tool. The resulting contrast in colour increases with age. Most of these birch bark engravings had mnemonic and pictographic functions, and it might be argued that they should not be discussed in aesthetic terms at all, especially since the bark has a short life-span, and copies frequently had to be made. The majority of these pictographic bark records relate to the doctrine and 42 ceremonies of the Midewin or "medicine society", who joined in regular ceremonies to protect the health of their members. Song texts consist of a strictly linear arrangement of pictograms; other records are sequentially ordered representations of historical or ritual events.

Since the incised lines often lack sufficient contrast, there is a tendency to double contours and to use crosshatching for outlines or solid areas. Otherwise the drawings are strictly linear and pictographically abstracted. Too few old and reliably dated specimens survive to answer questions about stylistic trends. It nevertheless appears likely that some developments resulting from intensive contacts with Whites parallel changes in Plains Indian skin painting (from frontal to profile views, from outline drawings 26 to growing attention to detail).

Song texts were occasionally incised on wooden boards by the Ojibwa and Menominee, and also by the eastern Dakota, who did not use bark. Other types of wooden objects decorated with incised drawings are prescription sticks, prayer sticks, and weapons. The latter usually carry illustrations of war deeds or visionary experiences, but basically use the same style as the birch-bark engravings.

A different style of incised decoration is shared by the Ojibwa and eastern Dakota. It is non-pictographic and combines zigzag bands and bands of triangles with symbolic designs consisting of groups of lance heads, circles, 43 squares, hourglass shapes, and the like. This style is also found on clubs, but finds its most complex expression on lids of wooden boxes for storing feathers; these lids are themselves often stylized anthropomorphic cut-outs.

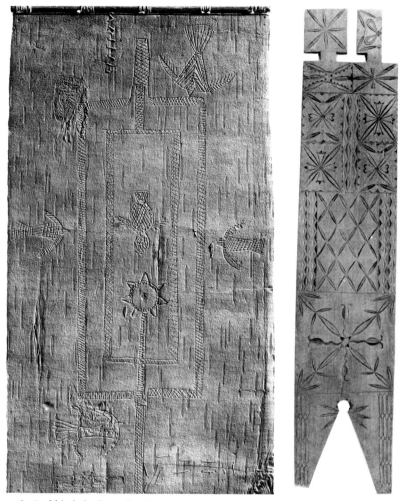

42 Incised birch-bark scroll with contents relating to the Midewin. Leech Lake, Minnesota. Ojibwa, collected by William Jones before 1905.

43 Engraved and painted wooden cut-out board. Santee Dakota, collected in 1856.

*Incised decoration on other materials*

Incised pottery, shell, bone, horn, and metal artifacts from the East afford insights into the prehistoric roots of this tradition – insights which cannot be gained from perishable bark and wooden items.

44    Adena- and Hopewell-engraved decorations on stone, bone, and metal reveal a decided trend towards ambiguous and ornamental forms. Curvilinear renderings of such typical motifs as birds of prey are smoothly

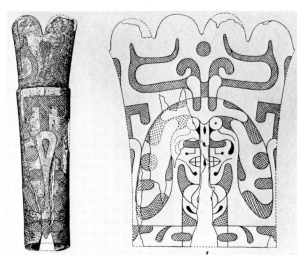

44 Portion of engraved human femur, showing superimposed faces with antler
headdress (see drawing on right). Hopewell Mound Group, Ohio; Hopewell,
c. 100 BC–AD 300.

45 Engraved shell gorget with eagle dancers wearing antler headdresses. Dallas
culture, Tennessee; Mississippian, c. 1300–1500.

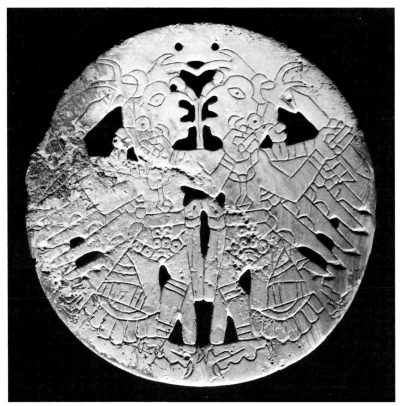

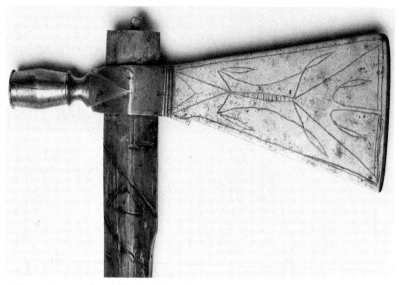

46 Iron pipe-tomahawk blade with rocker-engraved spider-web design associated with thunder and lightning. Hunkpapa Teton Dakota, Fort Randall, South Dakota, c. 1860.

drawn and almost fill the pictorial space. Those of later, Mississippian, origin (and especially those of its later phases) are more naturalistic, show dynamic movement and pay more attention to detail. In human figures, frontal views are regularly combined with faces and legs in profile. Among historic tribes of the East, on the other hand, incised decorations, such as those on elk antler quirt (riding whip) handles, are closer to contemporary styles of painting and engraving than to prehistoric antecedents.

Early examples of incised pottery date from the Hopewell period (c. 300 BC–c. AD 550). Stylized bird motifs are outlined by deep, incised lines, and the background is textured with a toothed rocker or roulette. During the Mississippian period, incisions become shallower, and the designs themselves, rather than the background, are often textured by hatching or crosshatching. The designs are characterized by flowing curves and include both representational elements and scroll work.

Incised designs remained typical of Eastern pottery (as exemplified by Iroquois work, both traditional and revived); but in the Southwest they could never compete with the popularity of painting. During the 1930s, however, potters of the Tewa pueblo of San Juan revived a prehistoric incised ware, while at Santa Clara experimentation was started with carved

64

47 Engraved pottery bottle. Prehistoric Caddo, Glendora, Louisiana; Mississippian, *c*. 1200–1600.

48 Carved redware vase by Margaret Tafoya. Santa Clara, 1962.

intaglios on polished black and red wares to which a sgraffito technique was *48* later added. Famous potters in this tradition include members of the Tafoya-Naranjo family, Joseph Lonewolf, Grace Medicine Flower of Santa Clara, and Rose Gonzales of San Ildefonso.

A further step in the development of incised pottery decoration was the use of wooden stamps, whose carved design was impressed into the clay while it was still soft. Previously the surface had been textured with impressions of textiles or cords, and by the use of rockers and roulettes. Whereas these techniques had a limited potential for artistic design, stamping made possible the repetition of single elements to form more elaborate patterns. Stamping occurred especially in the Southeast in both prehistoric and historic times. The same principle was used in post-European metalwork (see pp. 68–71), and, together with pigments, in the decoration of some wooden splint baskets in the Northeast.

An unusual method of decorating shell was developed by the Hohokam people. An acid solution derived from the juice of the giant cactus seems to have been used to etch shell, the pattern being produced by the application of *49* a 'resist' (as in resist dyeing) to the areas which were to be left unetched. This technique was abandoned some time before the historic period.

65

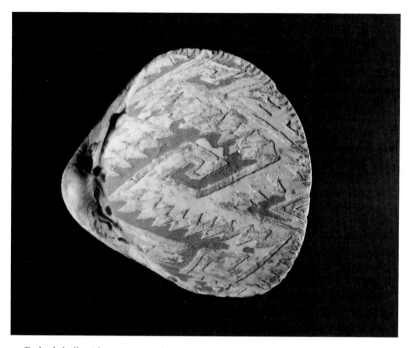

49 Etched shell with geometric design. Hohokam, Arizona, c. 1000–1200.

*Eskimo engraving on walrus ivory*

Archaeological finds document the existence of a distinctive Eskimoid engraving style in the latter part of the first millennium BC. Walrus ivory harpoon heads, and objects of uncertain function ('winged objects', for example), produced in the Okvik, Ipiutak, and Old Bering Sea cultures, exhibit smooth curvilinear forms combined with circle-and-dot motifs and acute angles. Lines are often doubled. Also typical are dashed lines and fine dentations produced by short cross-lines. Influences have been identified here from the Amur region (Old Bering Sea) and from the Scytho-Siberian animal style (Ipiutak, Punuk). Increasing rectilinearity and harder lines during Punuk times (after AD 600) result from the use of iron engraving tools. The trend continued into the Thule phase and can also be seen in late Pacific-Aleut manifestations. Towards the end of the Thule phase a new representational style of Eskimo engraving emerged, probably furthered by Russian stimuli; the evidence for an earlier Canadian origin of this style is disputed. Representational engraving finds its fullest development in Alaska

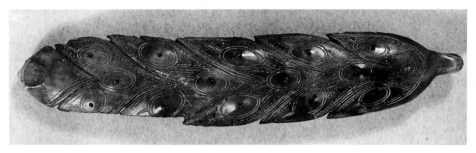

50 Engraved walrus-ivory object of unknown function. St Lawrence Island, Alaska; Old Bering Sea, *c*. 200–500.

51 Walrus-ivory arrowshaft straightener with three sculptured caribou heads and incised decoration in Old Engraving Style. North Alaskan Eskimo, *c*. 1850.

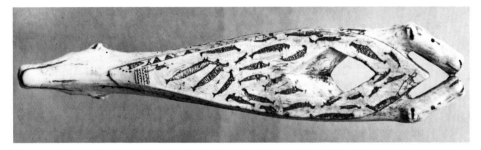

north of Norton Sound during the nineteenth century. Various items (particularly bow-drills and bag handles) are decorated with linear arrangements of engraved and blackened drawings consisting of horizontal and vertical lines, only rarely combined to form crosshatching. Village and hunting scenes, as well as herds of walrus and caribou, dominate and are occasionally accompanied by circle-and-dot motifs.

After 1870 this 'Old Engraving Style' is generally replaced by the 'Modified Engraving Style' in which lines are more regular and of uniform depth. Crosshatching increases in popularity while the formerly common stick-men figures disappear. A greater variety of items is decorated in this way, including pipes fashioned after Chukchee models and whole walrus tusks. The ethnic souvenir character of these objects is now obvious, although early authorities believed – wrongly – that this style represented an ancient pictographic tradition.

During the 1890s another new style, the 'Western Pictorial Engraving Style', rapidly gained ground. Shading was no longer mechanically determined by horizontal and vertical lines, but attempts were made to

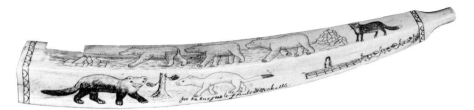

52 Walrus-ivory pipe with incised decoration in Western Pictorial Style by Joe Kakarook Austin (Kakavgook). St Michael, Alaska, c. 1905.

52  imitate the surface texture of the subject as closely as possible. Gross naturalism was promoted partly by the fact that engravers began to work from photographs. Artists like Happy Jack, or Guy and Joe Kakarook, started to sign their engravings. Also during the 1890s, cribbage boards were added to the list of objects decorated in this style and represent an important time marker.

Since about 1930 further modifications have led to a style in which the contrast between black lines and areas, and the use of zigzag lines for shading has become characteristic. As more creative artists turn to other media, the overall quality of Eskimo ivory engraving has declined.

*Historic two-dimensional metalwork*

In prehistoric times copper, found in its metallic (native) form and not smelted from ore, was used by many indigenous groups. Embossed and
53  engraved copper cut-outs were manufactured in several parts of the East. During the early colonial period, the Europeans' sheet copper superseded native copper as the major material for Indian metalwork. Silver ornaments of European make were also traded to the Indians, who did not at first imitate them. Only with the decline of the fur trade did several tribes of the East turn to silversmithing, adopting raw materials (coins and ingots), tools, and technology from the Whites.

The best-known Eastern silversmiths of the nineteenth century were the Iroquois, whose work continued the style of their colonial White precursors, although the adopted designs were often reinterpreted by native makers and
54  users. Elaborately stamped and engraved openwork brooches of various shapes (double and single heart, octagonal, simple and ornate circular, rhomboid, star, 'crown', and 'Masonic type') were the most popular, but earrings, bracelets, and other jewellery were also made.

Whereas Iroquoian silversmithing declined during the last third of the nineteenth century, the craft was adopted by several Plains tribes. Instead of

68

silver, German silver (an alloy of copper, nickel, and zinc) became the major medium of metalwork. The techniques remained essentially unchanged, with soldering being added in the mid twentieth century. On the southern Plains, designs derived from the symbolism of the Peyote cult (particularly the waterbird motif) were added to the simpler ornamental patterns such as circles, arcs and lozenges common in the whole area.

In the Southwest, the Navajo learned silversmithing from Mexican blacksmiths around 1860, but the new art did not become widespread until

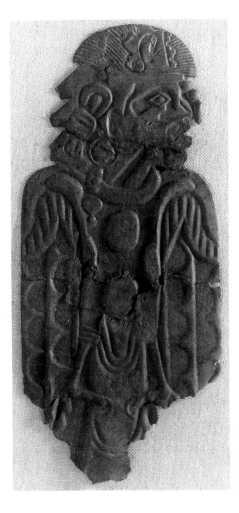

53 Embossed, cut-out copper plate (one of the so-called 'Wulfing plates'), showing elaborately dressed human being. Dunklin County, Missouri; Mississippian, c. 1200–1400 (see also p. 64).

54 Stamped openwork silver brooch of Masonic type. Iroquois, 19th century.

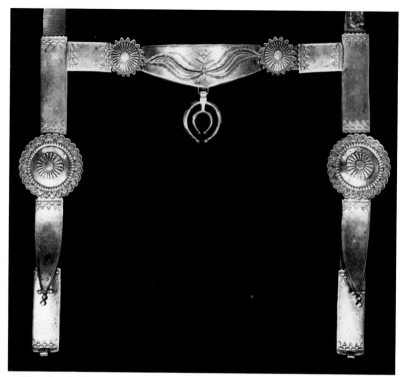

55 Silver headstall, embossed and stamped, with cast *naja* pendant. Navajo, *c.* 1900.
56 Silver bracelet with engraved bear design by Ray Stevens. Haida, 1978.

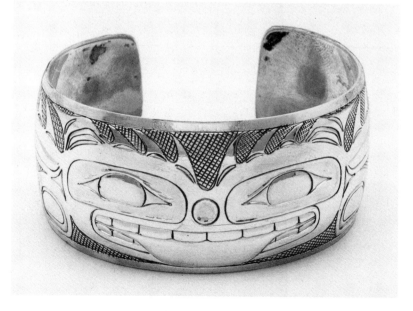

the late nineteenth century. Because the techniques here were more varied than among other native silversmiths and included casting, a greater variety of forms (many of them three-dimensional) could be produced. Stamping remained the major two-dimensional technique, with designs derived from Mexican leather-stamps. Predominantly curvilinear forms, which replaced 55 early rectilinear patterns, were often combined with embossing and were also applied to casts. The art spread to various Pueblo tribes before 1900, but distinctive styles developed only later, among the Zuni and Hopi.

The Russians introduced silver engraving to the Tlingit around 1800. Little is known about early native uses. Later in the century, artists in many Northwest-Coast tribes decorated silver bracelets and other objects, 56 following the canons of the local two-dimensional style. Because of the lack of colour contrast, crosshatching is more frequently employed here than in comparable wooden relief carving. Both on the Northwest Coast and in the Southwest, the use of gold is both rare and late.

*Painting and engraving of the northern Northwest Coast*

The two-dimensional painting and engraving tradition of the northern Northwest coast is based on the most complex and self-contained system of rules in native North America. This has led to a clarity of style that makes this art absolutely unmistakable. It occurs in painting, relief carving, and a combination of both. Wood is the primary medium, but the style has also 58 been applied to the decoration of skin, horn, bone, metal, and basketry. Objects so decorated may be two- or three-dimensional, but the same complex formal principles of organization always apply to the surface. In its classic perfection of the late nineteenth century, this style was common to the Tlingit, Haida, Tsimshian, Bella Coola, and Bellabella; its spread to the central Northwest Coast is a late phenomenon, even though some of its basic principles seem to be traditional in this area. The art is representational, but it 57 is stylized and symbolic rather than naturalistic. Northwest-Coast art is essentially decorative, although its function was the display of crests rightfully owned by certain kinship groups. This function of display certainly contributed in part to its conventionalization, which can be expressed in a number of rules of representation: compositional harmony based on a continuous formline, abstraction of standardized design units, and reorganization of the design elements around new, often disjunctive organizational principles.

The total harmonic use of the pictorial space is a major principle of composition. The forms depicted are consequently seen as subordinate to the pictorial space, even where the space is not completely filled.

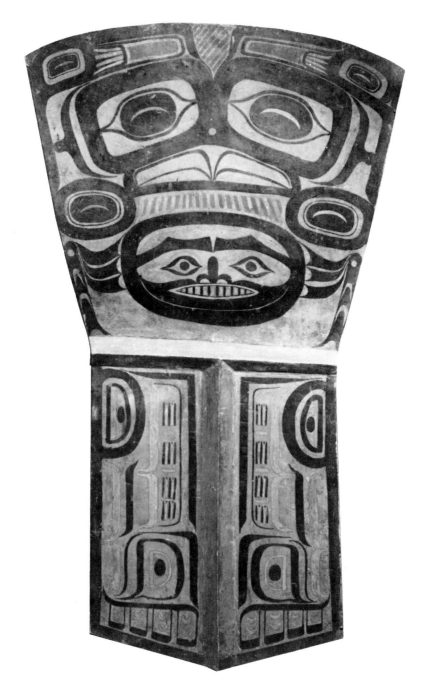

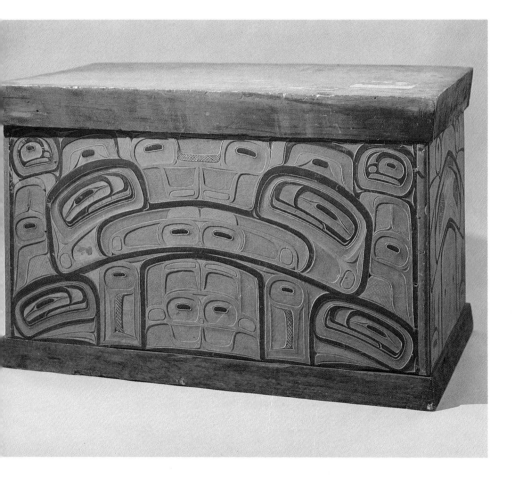

57 Painted copper emblem with heraldic designs in black, red, and green. Tlingit, collected by J. G. Swan before 1876.

58 Engraved and painted storage box showing the principles of the classic graphic style of the northern Northwest Coast. Haida, collected in 1864.

73

Forms – while derived from observable proportions and shapes – are reduced to a limited number of standardized units (ovoids, eyelids, eyebrows, fingers, U forms, plus subsidiary L and S forms). Subjects represented have certain features exaggerated (such as the teeth of the beaver); but explicit rules for identifying forms are of limited value since ambiguity is a fundamental trait of Northwest-Coast art. The technique of split representation of subjects aims to show their whole surface 'from the inside out' and simplifies the attainment of symmetry; double profile representation follows as a corollary. Anatomic realism is sacrificed to composition through the dislocation of elements. Less important details may even be ignored in the process of graphic reduction. Other details are given secondary meanings by successive modification, again in keeping with the tendency towards ambiguity. The classic examples of this modification are round or oval joint marks, which progressively change into eyes, faces, and secondary figures.

59 Engraved mountain sheep horn rattle. Coast Salish 1850–1900. Note the secondary bird forms developed from eyes and eyebrows.

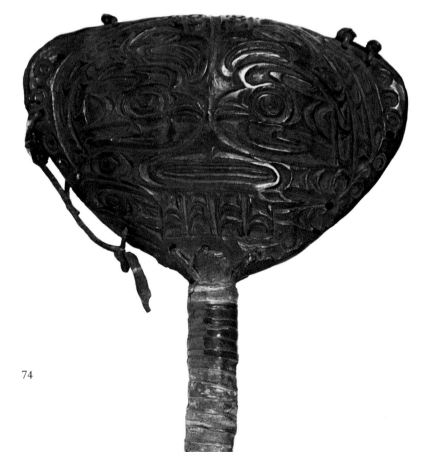

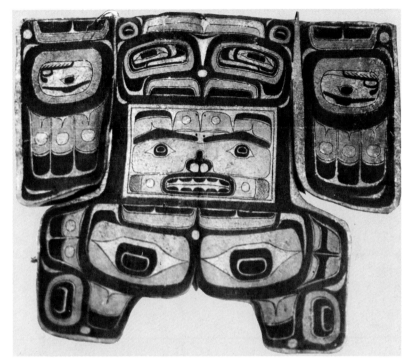

60 Painted skin breast plate with distinctive design and secondary faces derived from joint marks. Tlingit, 1800–50.

The degree in which the forms deviate from realistic representation varies considerably and can range from 'configurative' (recognizable outline shape, no filling of pictorial space) to 'expansive' (split representation, dislocation, and deformation help to fill the space, but subject can still be identified) to 'distributive' (complete remodelling, due to the avoidance of empty spaces, makes identification hard or impossible).

The backbone of composition is the formline structure. It consists of the standardized units noted above, all of which are executed as gently expanding and contracting lines. These lines merge into a continuous frame which defines the outline of the subject. In painting, the primary formlines are usually black (occasionally red); in relief carving, they are in the surface plane of the carved material. Secondary formlines (usually red and also on the surface) are always attached to the primary structure but may form secondary complexes, while tertiary forms (generally blue or green and always engraved) are enclosed by the primary and secondary formlines.

*60*

In the decoration of flat surfaces, formlines define the negative space between the principal design forms made by different bark templates. Formlines are generally curvilinear and derive their dynamic quality from the graduated shifts between the straight, curved, and angular pattern forms. To avoid too heavy concentrations of colour where formlines merge, they 61 either taper to a point or swell at the juncture; in the latter, the solid area is relieved by negative forms placed within it. Other methods of relieving such solid areas of colour include crosshatching and, less commonly, superimposed hatching. Otherwise all designs are painted with solid, unshaded colours.

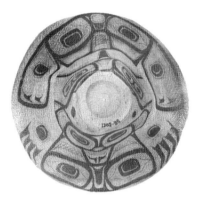

61 Spruce-root hat with distributive design painted over geometric twined 'self' design (see also p. 112). Tlingit, c. 1840.

62 Plaited cedar-bark mat with painted thunderbird motif. Kwakiutl, late 19th century (see also p. 117).

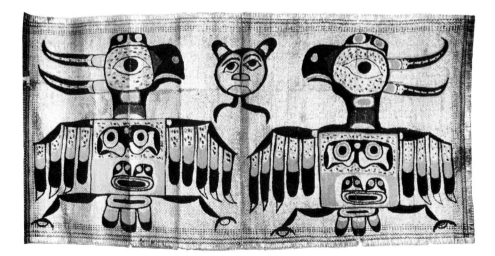

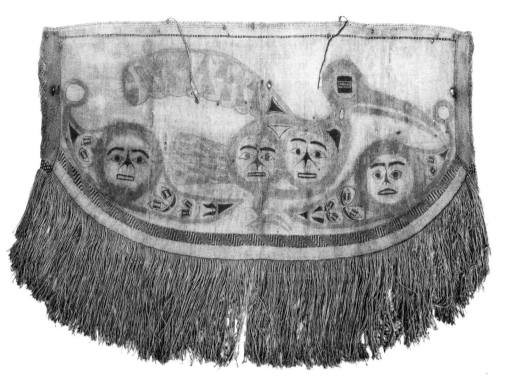

63 Twined and painted cedar-bark blanket with decorative twilled border. Nootka, collected by Captain Cook in 1778 (see also pp. 10, 127).

The formline structure is fairly evenly distributed over the pictorial space to achieve the desired balance of composition. Other basic principles of formal organization include horizontal symmetry and the avoidance of parallel lines (as exemplified both by non-concentricity and the continually changing width of the formlines).

A lesser degree of stylization, and of reliance on formline structures, is characteristic of the two-dimensional art of the central Northwest Coast. Here, asymmetrical compositions indicate a relaxation of formal constraints, as in Nootka painting. Parallel lines and circles, as well as rectilinearity, are no longer avoided. In relief carving, there is a strong resemblance between Nootka and Coast Salish work, the latter typically represented by carved wooden spindle whorls (disks attached to the spindle, making it revolve evenly). In an even simpler version, this style is found among the tribes of the lower Columbia River.

62

63, 6

64

65

## Other painting and engraving traditions on wood

Quite distinct from the classic style of the northern Northwest Coast are the visionary paintings of Coast Salish ritual specialists on the wooden planks used in their Spirit Canoe ceremony. Simple silhouettes of animals and men are accompanied by dotted lines. Equally distinctive are the painted wooden bowls of the Eskimo of southwestern Alaska. The use of lines of uneven width and of negative joint marks relieving dark areas are reminiscent of Northwest-Coast graphic style, but other features, including silhouette drawings, X-ray representation, and dashed lines, indicate the continued importance of an older Coastal tradition of painting. Some of these elements also appear on the polychrome painted wooden hats of the Aleuts, which are otherwise characterized by parallel bands and bold spirals. Northwest-Coast influences are more pronounced in the painting of Pacific Coast Eskimo groups, however, which exhibit stronger rectilinear tendencies.

66
67
68

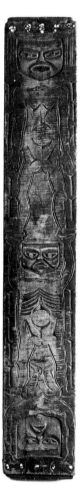

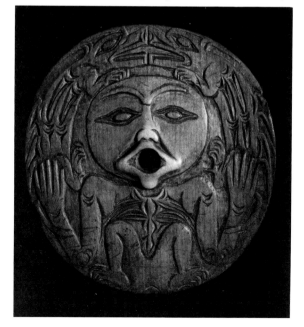

64 Engraved lid of wooden arrow box. Nootka, collected by Captain Cook in 1778.

65 Carved and engraved spindle whorl of maple wood. Cowichan (Coast Salish), 19th century.

66 Painted board used in Spirit Canoe ceremony. Duwamish (Coast Salish), late 19th century.

67 Painted wooden bowl with bone inlay, showing X-ray representation and lines of uneven width. Nuloktolok, South Alaskan Eskimo, collected in 1878.

68 Painted wooden hat with sea-lion whiskers and European glass beads. Aleut, 1800–50.

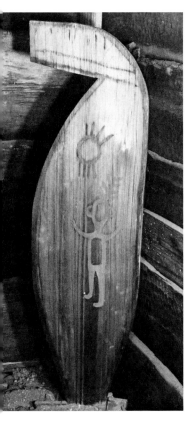

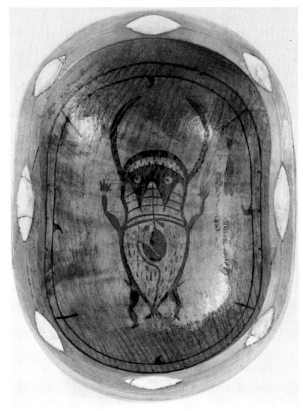

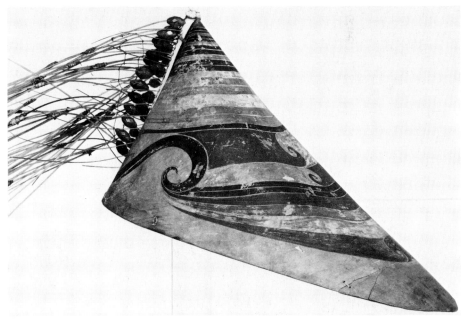

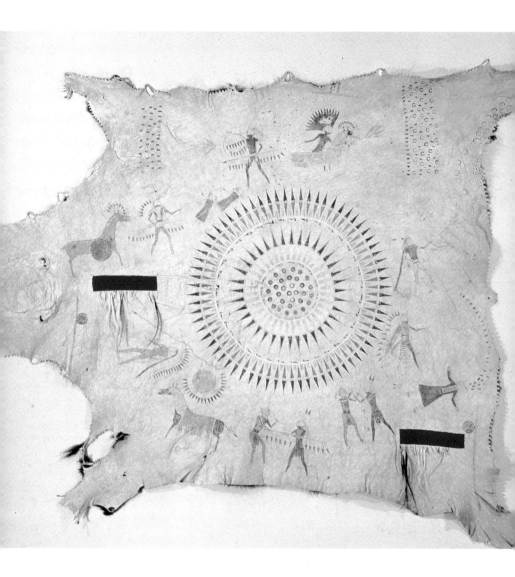

69 Painted bison robe; central sun motif surrounded by maker's war exploits. Attributed to Mató-topé, Mandan, collected in 1837 (see pp. 52, 56).

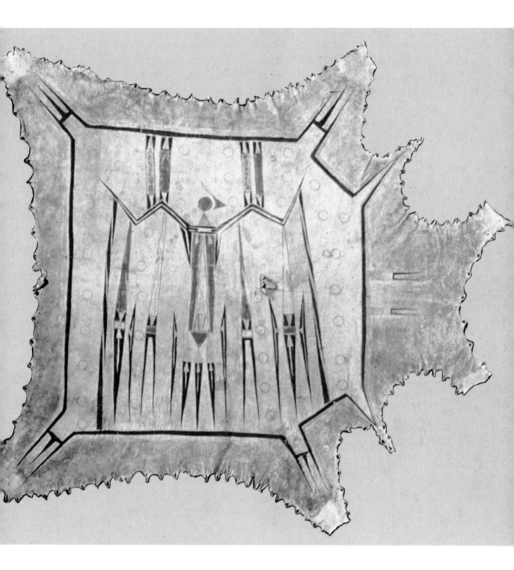

70 Painted bison robe with stylized representational designs of a type not encountered during the 19th century. Illinois (?), late 17th century (see p. 56).

In the Pueblo area of the Southwest, painting on wood differs radically from painting on pottery, a distinction which may be correlated with male and female workmanship. Symbolic representations of clouds, lightning, corn, feathers, and the like are combined with occasional anthropomorphic and zoomorphic elements on dance wands and tableta headdresses. The same style of polychrome painting with bold black outlines recurs on kachina dolls and also in Pueblo dry painting (see p. 102).

A strictly abstract and rectilinear style occurs in northern California. It is found on polychrome painted wooden bowstaffs, and on netted back ornaments, as well as on the incised and blackened elk antler purses of the area, and may best be compared with local basketry designs.

71 Netted back ornament (fastened to the hair) with painted designs derived from basketry decoration. Karok, late 19th century.

72 Carved and painted wooden cradle board (back view). Mohawk (Iroquois), c. 1850.

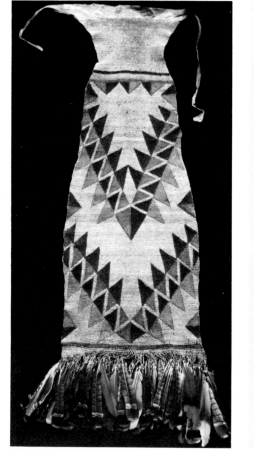
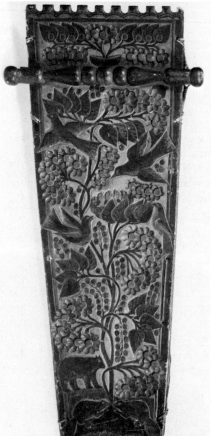

Outside the Northwest, wooden relief carving appears only in the East. Most of the examples available from the Northeast reveal overwhelming White influences in both style and technique. Thus, Iroquois cradleboards *72* feature brightly painted naturalistic relief carvings of plants and animals, which even indicate spatial depth by overlapping. Plains Indian cradleboards, on the other hand, carry traditional (female) designs obviously related to those found in symbolic skin painting (Pawnee: four-pointed star combined with feather rays; Omaha: bisected design similar to that found on parfleches). Wood carving, usually a male art, was done by women among the Pawnee.

*Pottery painting of the Southwest*

Painting as a method of decorating pottery is almost exclusively limited to the Southwest. In the East, the second major pottery area, it never enjoyed much popularity, except for some late prehistoric wares of the Mississippian period and a few modern products that show strong evidence of White American derivation (for example, Pamunkey pottery).

Much is known of the evolution of Southwestern pottery painting over the last two millennia, owing to the abundance of datable prehistoric remains. Only the most superficial sketch can therefore be presented in this context.

The earliest Hohokam and Mogollon pottery is about coeval, was inspired from Mexican sources, and lacked decoration. In the first centuries A D, Hohokam developed a red painted style on grey and more especially on buff surfaces. In later periods, the design elements decreased in size, and paintings combined representational and abstract motifs. Design patterns are well integrated and often include negative forms. Solid colour areas with little hatching predominate. After A D 900, Anasazi influences become increasingly apparent. Hohokam pottery painting could never rival the classic developments of Anasazi and Mogollon pottery, but it did have some impact on Mogollon decorative styles.

Around A D 400, simple rectilinear designs in red-on-brown mark the beginning of the Mogollon pottery painting tradition, which was subsequently refined both in terms of the complexity of its design and the technique of manufacture. Coating the vessels with a white slip before decoration resulted in red-on-white patterns which after A D 900 were gradually replaced by Anasazi-inspired black-on-white styles. At first these retained the traditional complex rectilinearity, but in time were combined with curvilinear elements. The climax of this development occurred during late Mogollon times in the (contemporary) Tularosa phase and Mimbres *73* black-on-white styles. Both are essentially similar in their balance between

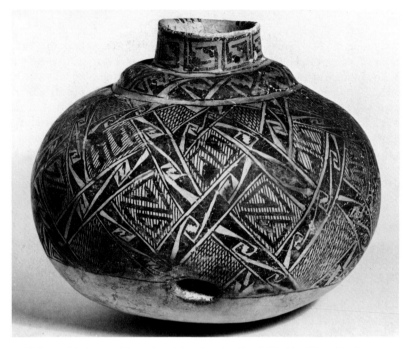

73 Tularosa black-on-white painted jar. Apache Creek Pueblo, New Mexico; Mogollon, *c.* 1150–1200.

white background, solid black, and hatched areas, which results in a certain ambiguity between positive and negative shapes in geometric designs. Some Tularosa designs reflect their Anasazi models more directly and add the illusion of depth by overlapping of design units.

Classic Mimbres pottery combines traditional Mogollon, Hohokam, and Anasazi elements but moves several steps beyond them. Besides featuring finer lines and a greater complexity of design, Mimbres pottery painting *74* adds life forms to purely geometric designs. In representational painting, animals are most frequently shown, followed by human and mythical creatures. The majority of these bowls show just one figure surrounded by a frame, but the Mimbres repertoire includes compositions with two or more figures, some of them with narrative content and some with perspective centred on the middle point inside the bowl. In others, the figures are completely integrated with the frame. Although a few polychrome examples of this style were produced, Mimbres pottery represents the highest development of black-on-white painting in the Southwest. The black-on-white tradition then ended abruptly and without immediate impact on the further development of Southwestern pottery painting.

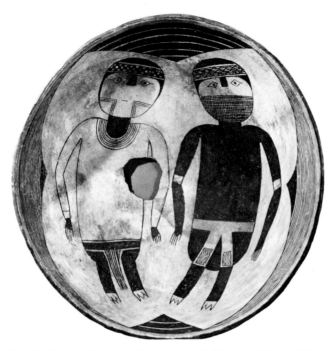

74 Mimbres black-on-white painted pottery bowl. Treasure Hill site, New Mexico; Mogollon, *c.* 1050–1150 (see also p. 35).

Anasazi pottery making began later than that of the Mogollon and Hohokam, in about AD 400, but it outlasted both these rivals. At the beginning of the Anasazi phase, the Basketmaker ancestors of the Pueblo Indians learned pottery making from their southern neighbours; their wares, however, differed from the very start in having a grey surface which was painted with black geometric patterns apparently derived from basketry designs. From early Pueblo times on, a white slip heightened the contrast with the rectilinear black decoration, in which hatching played a major role. Spiral ornaments were incorporated as the designs became more complex.

. Just at the time when the black-on-white style attained its climax both in the Mogollon and Anasazi areas after AD 1000, the development of polychrome wares set in. By AD 1300 these had come to represent the predominant mode of pottery painting, with only some of the conservative Rio Grande pueblos sticking to the black-on-white tradition. At this point, representational decoration first appeared in Anasazi pottery painting, and lead glaze paints (which turn vitreous in firing) began to be used. The results of these changes can be seen as far away as northern Chihuahua, where the polychrome pottery of Casas Grandes betrays its debt to the Anasazi.

85

Among the many excellent wares of the late prehistoric period, the matt-
75  paint polychrome style of Sikyatki, in the Hopi country of Arizona, merits
special mention. Its designs range from stylized representational paintings,
combining elongated curved shapes with subordinate rectilinear elements
(partly as filler designs), to abstract and largely rectilinear patterns.
Representational painting, especially, tends to be asymmetric. In its later
development, the trend towards representational painting increased and
resulted in rather crude line drawings which lacked the sophistication of the
earlier patterns.

In the historic period, Spanish contacts did not immediately result in a
collapse of the old pottery-painting traditions. Glaze-paint pottery was
abandoned, but many of the pueblos continued to manufacture excellently
decorated pottery. Towards the end of the eighteenth century, overall
quality declined, and designs tended to become more abstract. During the
nineteenth century, increasing imports of trade goods lessened the
importance of Pueblo pottery. At the same time, floral elements and quite
naturalistic representations of animals were added to the repertoire. After the
opening of the railroad to Santa Fe, the new tourist market led to the
development of new styles but also to a further loss of quality. Once the
White customers of the Pueblo potters began to view the product as art
rather than as curios, however, a new economic incentive was created and
the trend was reversed.

Hopi pottery painting of the historic period is distinguished by an abrupt
decline of quality following the abandonment of Sikyatki polychrome
wares. Some new ideas were introduced by Tewa immigrants from the Rio
Grande around 1700, but the quality of the decoration remained less than
exceptional. Tiles and vessels with kachina figures and relatively realistic
designs appeared in the late nineteenth century and represent a break with a
long tradition of non-representational painting. Just as Hopi pottery was
about to fade away, the rediscovery of Sikyatki pottery by archaeologists
stimulated a renaissance of the stylized curvilinear black, orange, and white
76  designs. Led by Nampeyo, a potter from the village of Hano, and her
descendants, the revival continues to this day.

Nineteenth-century Zuni pottery features repetitive representational and
non-representational designs in both horizontal and vertical panels. Deer
17  with black, brown, or red heart-lines, small stylized birds, rosettes, serrated
lines, and spiral volutes are painted in red and black on a white slip. Fine line
hatching stresses the linear character of the design. Pottery making was given
up at Zuni during the 1930s.

Starting from a similar base to that of Zuni in the seventeenth century, the
pottery painting of Acoma and the related pueblo of Laguna took a different

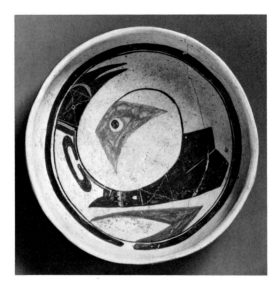

75 Sikyatki polychrome painted pottery bowl. Kawaika-a, Arizona; Anasazi, c. 1400–1625.

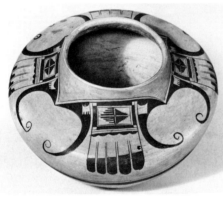

76 Painted pottery jar, black on orange. Attributed to Nampeyo. Hopi, early 20th century.

development. During the nineteenth century both geometric abstract and 77 curvilinear representational designs were painted in black or polychrome on a stark white slip. In recent decades, fine line patterns inspired by prehistoric wares have been developed by Marie Chino and perfected by Lucy Lewis.

Traditional Zia pottery resembles Zuni wares, but birds (which became a hallmark of Zia painting after 1850) and other animal and floral motifs are characterized by a greater freedom of expression than comparable designs among the Zuni. Neighbouring Jemez traded most of its pots from Zia for more than 200 years, but here a limited revival of pottery painting has occurred during the last fifty years and includes wares garishly painted with poster paint. (Similarly painted pots are made at Tesuque.)

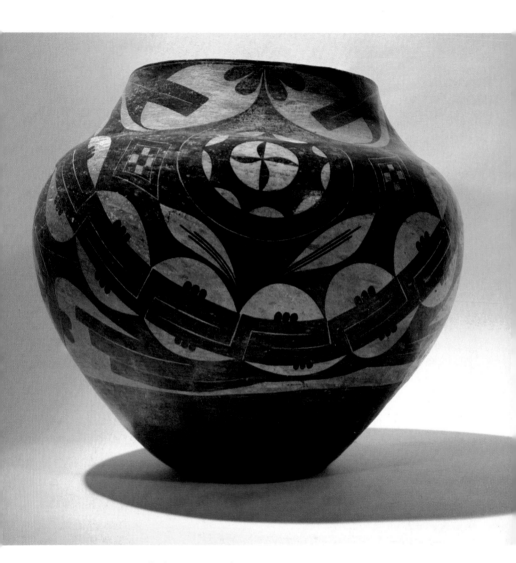

77 Polychrome painted pottery jar. Acoma, *c.* 1850–1900.

78 Black-on-black painted jar by Maria and Julian Martinez. San Ildefonso, *c.* 1930.

Although the pottery of Santo Domingo and Cochiti is often referred to as polychrome, red is largely limited to the rim and underbody, while the design is painted in black on a cream-coloured slip. Traditionally, designs were bold and largely geometric. Around 1900, some red appeared in Santo Domingo designs, and life forms (including the portrayal of religious motifs, which was regarded as sacrilegious by their neighbours) became frequent on Cochiti pottery.

San Ildefonso pottery was ancestral to that of Santo Domingo and Cochiti and shares many of its features. In addition to black-on-cream painting, some black-on-red geometric designs appeared. Around 1880, a return to an earlier polychrome ware was accompanied by the adoption of representational designs. The most important innovation, however, occurred in 1919 when Julian Martinez developed a technique of producing matt-on-polished black designs on pots made by his wife Maria. These proved to be a lasting success on the White market. New motifs were introduced at the same time. Maria's son, Popovi Da, continued the family tradition by experimenting with sienna-and-black two-tone wares and refining the

polychrome painting style. Outside the Martinez family, San Ildefonso boasts several other famous potters, including Tonita Roybal and Blue Corn.

At Santa Clara, where pottery making is not traditional, there has been some imitation of the San Ildefonso black-on-black style, and a new matt painted pastel style has been invented by the Gutiérrez family (Lela, Van, Margaret, Luther).

Compared with Pueblo pottery painting, the products of the neighbouring tribes (Papago, Maricopa, Mohave, Yuma, Navajo) are rather simple.

*Mural painting*

Mural painting, in the fresco secco manner, is limited to the Pueblo area of the Southwest, the only area that had plaster walls. While there is an old tradition of mural painting in Mexico, the nature of its possible influence on that of the Southwest is far from clear, and does not seem to be reflected stylistically.

Paints used include charcoal and mineral pigments. There are indications of organic paints; these, however, are unstable and cannot be positively identified today. For similar reasons, little is known about the organic binders used. The walls were first covered with adobe plaster and sometimes whitewashed with gypsum; the paint was then applied with stiff brushes and with the fingers.

The earliest known Pueblo murals date from around AD 1000 and occur in the northern and eastern Anasazi area. These include simple lines and geometric figures, and occasionally simple human figures. Subsequently mural painting expanded to the south and west, but shows no significant development here. Designs were still predominantly rectilinear and geometric, and sometimes reminiscent of painted pottery decoration. Representational motifs resemble those encountered in rock art.

In the period between 1300 and the Spanish conquest, Anasazi mural painting reached its highest development in two separate areas: the Jeddito valley in the Hopi region of Arizona (Awatovi, Kawaika-a), and the drainage area of the central Rio Grande in New Mexico (Pottery Mound, Kuaua). Although there are convincing stylistic affinities between the two centres, chronological differences indicate largely independent evolution. Common characteristics include solid colour areas outlined in black (occasionally in white, rarely in red), and the almost complete lack of perspective or spatial depth.

Stylistic changes can easily be detected because the walls are covered with up to 100 superimposed layers of painted plaster. In the Jeddito area during the earliest period, non-representational designs, mostly round, together

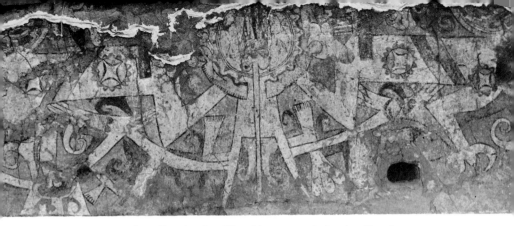

79 Mural painting stylistically related to Sikyatki pottery painting (cp. ill. 75). Awatovi, Arizona; Anasazi, *c.* 1400–1500.

with a few zoomorphs, were placed centrally to dominate each wall. By the end of the fourteenth century, the pictorial space was bordered by a black line enclosing complex and highly conventionalized designs, some of which are related to Sikyatki polychrome pottery decoration. A little later, static human representations firmly rooted on a baseline (sometimes with vertical extensions structuring the space) made their first appearance. Shown together with ritual paraphernalia, animals, and plants, they form the symmetrically balanced compositions most typical of the fifteenth century. Another style, showing anthropomorphs and zoomorphs in movement without regard to baselines and symmetry, seems to be partly contemporary with the earlier period of this style.

79

75

Pueblo mural painting has continued to the present, mostly in connection with ceremonial activities. However, because of the secrecy surrounding Pueblo reglion, very little evidence is available to trace the further development of this art.

*Rock art*

There are two types of decorated rock faces: petroglyphs (pecked, abraded, or incised), and rock painting. Patinated basalt lends itself especially to petroglyphs, in which light/dark contrasts are produced by removing the dark surface layer; granite is more suitable for painting. From a stylistic point of view, however, it seems more useful to distinguish between polychrome rock painting, and petroglyphs and monochrome painting. The great variety of rock art is demonstrated by the fact that a recent survey defines more than fifty distinct styles and implies many more.

Dating remains a major problem, but informed guesses are now available for several styles and regions. As a rule, rock paintings are less durable and therefore extant examples are of a later date than the oldest petroglyphs.

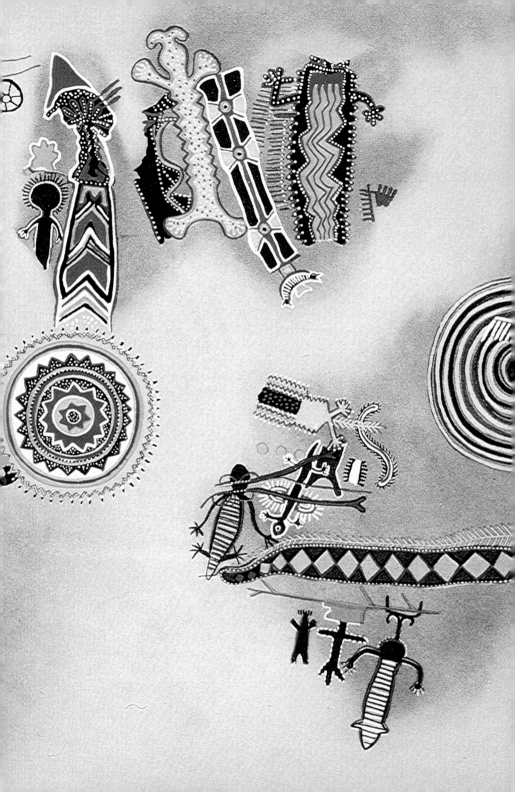

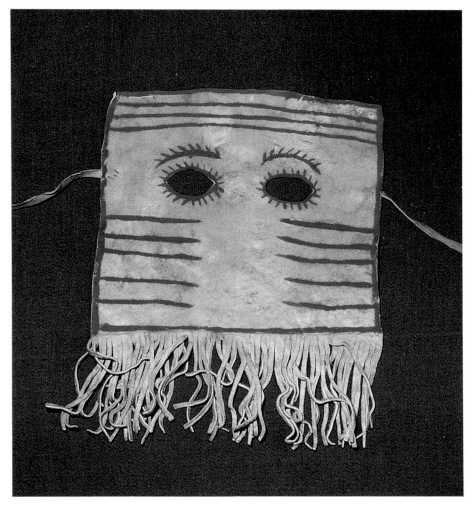

80 Redrawing of polychrome rock painting. Late prehistoric or historic Chumash, San Emigdiano Mountains, Kern County, California.

81 Painted skin mask. Naskapi, c. 1930 (see also pp. 18, 197).

Monochrome rock art is found all over North America. Most of the few examples from the Southeast and Northeast are petroglyphs, in which human figures are infrequent. Rock paintings using red pigment predominate in the Canadian Shield area of the eastern Subarctic. Many of these, as well as petroglyphs, are found on lake shores and were obviously made by the local Algonquians. Abstract and representational designs are equally common.

Human images are of central importance in Plains rock art. The majority of the red- or black-painted or incised pictures date from the eighteenth and nineteenth centuries and parallel the scenic style found in Plains skin painting of the same period. Figures of men carrying large round shields, a motif also found in the Southwest, may date from a slightly earlier period.

Red painting (in the north) and petroglyphs (in the south) appear in the
*82*   Plateau area: both show stylized silhouettes of men and animals, as well as largely rectilinear abstract designs. During the historic period the Salish made their rock paintings in connection with dream fasting, in which adolescents tried to obtain the vision of a guardian spirit. The style, however, probably has greater antiquity since it resembles the petroglyph styles known as 'Great Basin Representational' and 'Rectilinear Abstract' further south. The abstract style is also present in one form or another in California and the Southwest, and may be linked with the prehistoric Desert culture. In the Great Basin, petroglyphs in these same styles can tentatively be associated with hunting rituals, which illustrates how similar forms may be linked with different meanings and functions. Among the other styles of the Basin area, the simple 'pit-and-groove' style is probably the oldest, while painted styles seem to indicate late Pueblo influences.

On the Northwest Coast, petroglyphs are generally curvilinear and
*83*   include X-ray representations of humans, mythical and real animals, as well as concentric circles. The two-dimensional style of the central Northwest Coast seems to be better represented in rock art than is the later classic, Northern style.

The two major areas in which polychrome rock painting appears
*80*   (alongside simpler variants of rock art) are the Southwest and California. The Southwest in particular is richer in rock art than any other area in North America, and more styles can be defined and dated. Of these, the earliest is the impressive Pecos River style of southern Texas (usually assigned to a period before AD 600), with its monumental anthropomorphic figures carrying spear-throwers, executed in polychrome painting. The closest iconographic similarities are found more than 650 miles (over 1000
*84*   kilometres) away and several hundred years later in the Barrier Canyon style associated with the Fremont culture of Utah. In the heartlands of the

94

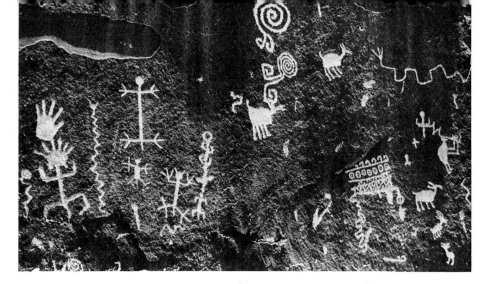

82 Petroglyphs at Village of the Great
Kivas, New Mexico; Anasazi, *c.* 1100–1200.

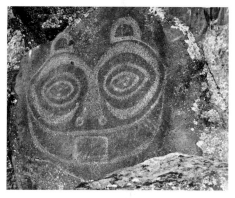

83 Petroglyph known as 'Tsigaglalal'. Dalles
area, Columbia River, Washington.

84 Barrier Canyon style rock painting.
Great Gallery, Barrier Canyon, Utah. The
attribution of this style to the Fremont
culture (950–1200) is in dispute (but see also
p. 190).

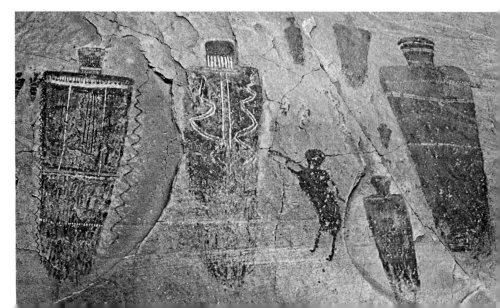

85 Wooden frontlet with haliotis shell inlay. Haida, 1850–1900 (see pp. 104, 174).

prehistoric Southwest the most significant development in rock art was the emergence around AD 1000 of the Jornada style in the Mogollon area. Its repertoire includes horned masks, rectilinear human figures, and 'kachina blankets', combining mask-like faces with rectangular bodies painted in the style of non-representational Mimbres pottery. After AD 1300 this style influenced the rock art of the Rio Grande Pueblo area; forms become more rounded, and some masks are identifiable with those of historic kachinas.

The Santa Barbara painted style is undoubtedly the most elaborate product of Californian rock art. Its individualistic polychrome paintings, found in almost inaccessible areas, combine curvilinear and angular elements in abstract or highly conventionalized anthropomorphic and zoomorphic designs. Although some stylistic developments are recognizable, all the paintings can safely be attributed to the late prehistoric and historic Chumash. These, as well as the pictographs of the related Southern Sierra painted style (attributed to the Yokuts) were apparently the work of ritual specialists, whereas the much simpler rock paintings of the southwestern coast of California were connected with the girls' puberty ceremonies of the Luiseno and their neighbours.

*Body art*

There is no reason why tattooing and face and body painting should be denied the status of 'art'; if they are nevertheless commonly excluded, this may be due to the impermanent nature of face and body painting as well as to marketing problems.

*3*

The most common technique of tattooing in native North America was by pricking the skin with sharp points, sometimes arranged on a special comb-like implement. As in the less widely distributed scratching technique, designs are usually first sketched with charcoal paste, then rubbed into the breaks in the skin. In northern and northwestern North America, threads covered with soot are drawn through punctures made by needles to apply the pigment beneath the skin.

In face painting, mostly mineral pigments (but sometimes including charcoal for black, or pollen for yellow) are mixed with water and/or grease before being applied to the skin with fingers, paint brushes, or wooden paint sticks. Dry painting is much less common. Negative techniques, such as that of painting solid areas and then partly removing the paint, are used among the Thompson of the British Columbia plateau, among others, who use deer jaws to scratch parallel lines. Painting is generally done by the wearer himself (with occasional help from others, and with the exception of some ceremonial painting), using a bowl of water to serve as a mirror. Tattooing, on the other hand, is done by others, who tend to be specialists.

The functions of body art are extremely varied, even within a single tribe. They range from pure beautification of the wearer, through expression of mood, prevention of disease, protection against misfortunes, and the recording of a ceremonial event, to the identification of an individual's status or membership in a social group. Obviously, tattooed designs will be used only for more permanent functions, whereas ornamental painting often follows trends of fashion.

Even though there is ample information on the body art of various individual tribes, no significant comparative studies (stylistic or otherwise) are available for the continent. Regional stylistic variations are as yet undefined. However, some generalizations about style are possible. Tattooed designs are all basically linear, with simple symmetrical, non-representational designs on the face, and forms of greater complexity on the body. Tattooing is black (with rare red/black exceptions); but painting is frequently bichrome or polychrome, with solid colour areas as important as lines. Asymmetrical and representational designs also occur in face painting. Body art relates to other two-dimensional arts through the occasional use of similar designs and motifs. It is clearly reflected in the painted decoration of masks and other representations of the human face and body.

*81*

*Non-traditional painting*

The adoption of artistic media and styles from the Whites has occurred in varying degrees during the whole period of contact. This trend accelerated as tribal arts became ethnic art, which was addressed primarily to a White audience. Plains ledger drawings of the nineteenth century are a prime example, but the same development can be documented for other parts of the East as well.

*26*

During the twentieth century, schools of non-traditional painting were formed, whose products were often taken for traditional art by the White public. However, few of these drawings and paintings represent a direct transfer of tribal modes of artistic expression to paper or canvas: major differences exist both in style and subject matter.

Two related mainstreams of non-traditional painting had their origins between 1910 and 1920 in New Mexico and Oklahoma, and reflect the influence of White anthropologists and schoolteachers. Anthropologists in the Southwest (notably Jesse W. Fewkes, Kenneth Chapman, and Edgar L. Hewett) commissioned Indians to illustrate various aspects of traditional culture, thereby becoming the first patrons of non-traditional painters, even before their works were discovered to be art by the market. Of even greater importance was the fact that some teachers encouraged their native students to experiment with White artistic media. The day school at the pueblo of San

Ildefonso was the basis for a school of native American watercolourists, whose influence spread to neighbouring tribes when the experiment was continued on a larger scale at the Santa Fe Indian School. Crescencio Martinez and Awa Tsireh of San Ildefonso, Otis Polelonema and Fred Kabotie of the Hopi, and Velino Herrera of Zia were among the first generation of non-traditional painters of the Southwest. Their work is exclusively concerned with the representation of tribal life and religion; it often combines native symbolism with White representational conventions, and manifests the transition from naïve portrayal to distinctive style.

If some of this development was due to the White mentors of the art, this was increasingly so after the founding in 1932 of The Studio, the first art school for native Americans, at the Santa Fe Indian School. Its first director, Dorothy Dunn, is generally credited with influencing her students to adopt a flat, two-dimensional, 'Indian' style, and to use pastel colours. The rediscovery of prehistoric Pueblo mural painting during the same period further helped to shape stereotyped notions about 'Indian painting'. Despite this, the major artists, from more than 700 to emerge from The Studio, developed their individual stylistic characteristics. Among them are Harrison Begay and Andrew Tsinajinnie (both Navajos), Allan Houser (Apache), Oscar Howe (Yanktonai Dakota), and Pablita Velarde and Joe H. Herrera (Pueblo).

*86*

Oklahoma Indian painting had its origin when a group of Kiowa painters came under the influence of Susie Peters, the field matron of the Kiowa

86 *Navajo Man and Horse.* Tempera painting by Harrison Begay, Navajo, *c.* 1940. Begay's work is one of the forerunners of the 'Bambi' style in its pleasant scenes and soft colours, but has an originality that is lacking in later copies.

Agency, who later managed to obtain academic instruction in art for her students under Oscar B. Jacobson at the University of Oklahoma in Norman. There is less difference in style than in cultural heritage, as reflected in the subject matter, between such early Kiowa painters as Stephen Mopope or Monroe Tsatoke and their Southwestern contemporaries. Existing distinctions diminished as the Oklahoma schools (particularly the art department of Bacone College, established in 1935) assimilated the Santa Fe style. Bacone was the first school in which native artists rather than Whites held teaching positions: Acee Blue Eagle, Woody Crumbo, and Dick West, whose works constitute a good sample of Oklahoma Indian painting. By 1940, non-traditional painting had become a recognized and recognizable art form practised in a similar way by members of widely differing tribes: it had come to be the first Pan-Indian art.

In the 1950s and 1960s, a growing number of younger artists tried to free themselves from the constraints of the established style (which they ridiculed as 'Bambi art') and moved in new directions, absorbing pop art and other forms of international art, just as Oscar Howe had incorporated Cubistic elements into his personal style. The Institute of American Indian Arts at Santa Fe took over the dominant role formerly played by the now-defunct Studio in the shaping of new trends. While the old schools of non-traditional painting continue to evince strong signs of life (and have entered the field of pottery decoration in the Southwest), new Indian artists like Fritz Scholder, T.C. Cannon, R.C. Gorman, or Kevin Red Star reflect a new awareness of the situation of the native American in a largely alien world.

Outside the Southwest and Plains there have long existed individual non-traditional painters, such as Earnest Spybuck (Shawnee) or Patrick Des Jarlaits (Ojibwa). But only during the last twenty years have distinctive regional styles established themselves. It speaks for the efficiency of various native art marketing organizations supported by the Canadian government that the three major new styles have originated there.

In 1957, James Houston (a White artist and collector) induced a group of Eskimo artists in the community of Cape Dorset to produce prints for sale. After some early experiments with stencil printing, stone cutting became the major technique for rendering traditional subjects (economic life, mythology) in a non-traditional style. During the 1960s and 1970s other Canadian Eskimo groups followed suit in producing a highly saleable instant art, devised by enterprising artists, missionaries, and government officials, to be devoured by an eager White public.

Norval Morrisseau, a Canadian Ojibwa, is to be credited as the founding father of the Woodlands school of 'legend' painting whose origins date from the early 1960s. Its style is based on a formline structure, lacking the

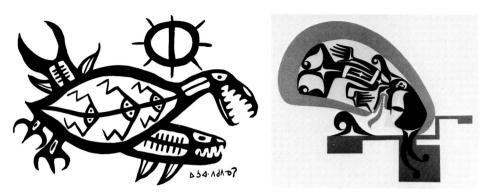

87 *Thunderbird, Loon Totem and Evil Fish* by Norval Morrisseau. Ojibwa, 1965.
88 *Mussel.* Five-colour silkscreen print by Art Thompson. Nitinaht Nootka, 1977.

rigour and symmetry of Northwest-Coast art, but including its use of variable width formlines and 'X-ray' representations. In the work of Morrisseau, Daphne Odjig, Joshim Kakegamic, and others – which deals primarily with Algonquian mythology – bright acrylic colours dominate. Silkscreen prints have contributed to its growing distribution.

Recent Northwest-Coast art, and especially print making, is rooted in the principles of northern Northwest-Coast two-dimensional art as discovered and formulated by Bill Holm. Far from being a barren revivalistic art, however, it shows considerable creative vitality. Although obviously based on a traditional style, it seems to be moving gradually in a new direction. *88*

### Dry painting

A two-dimensional technique which may be regarded as intermediate between painting and mosaic is that commonly referred to as sand painting. Dry painting is a more appropriate term, since besides red, yellow, and white sands, such materials as corn meal, pollen, pulverized flower petals, charcoal, separately or in mixtures, are strewn on a background of usually tan-coloured sand. Paintings varying in size from 1 to 24 feet (0·3 to 7 metres) across were made exclusively for ceremonial purposes by the Navajo as well as by inhabitants of the pueblos, of southern California, and occasionally also of the Plains. Dry painting is an extremely impermanent art form: no fixatives are used and the painting had to be destroyed for religious reasons immediately after use.

Very little is consequently known about dry paintings from the Pueblo area (where traditional religion is scrupulously concealed from outside view) and from the Plains (where little attention has been paid to it), except that it originated in the Southwest. Navajo dry painting, first recorded in 1885, was

given permanence by White observers who copied the originals on paper or cardboard, and later by Navajos who did the same in spite of traditional prohibitions against the making of permanent representations of the sacred designs. (Navajo dry-painting rugs are a derivative source of information.)

*126*

Pueblo dry paintings were usually made in connection with wooden slat altars. The compositions, rectangular, circular or semi-circular, tend towards symmetry; they most frequently include representations of clouds and lightning, as well as animals and human or mythical beings and are polychrome with bold black outlines. Our knowledge of southern Californian dry painting (as practised by the Luiseno, Gabrielino, Tipai, and others), comes only from the recollections of old timers; the practice was abandoned before records were made. It is obviously related to the Southwestern tradition, but has undergone a distinctly local development in connection with the *toloache* (or Jimson weed) cult and differs from Southwestern dry painting in style, content, and symbolism. Circular frames, some with an opening towards the north, enclose cosmological or cosmographic pictures, distinguished by greater realism among the Tipai, and by greater symbolism among the Luiseno. In the dry painting of the Blackfoot, Arapaho, Cheyenne, and Dakota of the northern and central Plains, simple, symmetric arrangements including crescents, circles, and stripes seem to predominate.

In Navajo tradition, and presumably elsewhere, dry painting is inseparable from the whole ritual of which it is a part. Navajo dry paintings are used in healing ceremonials together with drama, poetry, and music, the total impact of which is to restore spiritual harmony within the patient. Four or five dry paintings are made during each ceremonial (judging from a total of around 600 known designs). Even though they are connected with the myth recited on the occasion, their content is symbolic rather than narrative.

There are three major patterns of composition: linear arrangements of figures in one or two rows, radial arrangements oriented towards the cardinal directions around a centre with equivalent use of the resulting quadrants, and compositions in which a dominant central motif takes up most of the pictorial space. All these types are surrounded by a frame or 'guardian' (usually like a rainbow) whose opening towards the east is

*89*

conventionally oriented towards the top in later copies by Whites or Indian medicine men. A common stylistic feature is the elongated, rectilinear representation of spirits (*yei*) seen frontally, but with their legs shown in profile. These, as well as the occasionally more curvilinear figures of plants and animals, are highly stylized and static. Compositions are tightly organized and inclined to symmetry, but details are often asymmetrical and therefore lend a dynamic quality to the whole.

The soft colours that give Navajo dry paintings a distinctive quality seem to be the result of limited possibilities rather than aesthetic intention. Whenever a full colour range became available (as in crayon redrawings), Navajo ritualists made extensive use of bright colours, perhaps to give better expression to colour symbolism. Colours are generally associated through certain rules with cardinal directions. Differences in colour and compositional detail in the execution of a specific pattern reflect not only individual and regional variations (as yet little understood), but also other factors, such as the season of the year in which the painting was made.

An insurmountable problem in the study and appreciation of Navajo dry painting is that none of the sources permanently available for inspection is original. The paintings themselves represent the communal effort of four to six men working under the supervision of the ritual specialist. Besides being in a different medium, copies by Navajos often exhibit the colour changes noted above, while copies by Whites appear to include many stylistic conventionalizations and idiosyncrasies of their collectors. Since 1958, permanent versions of dry paintings on boards have been produced for the tourist market. Made by more than 500 Navajo men and women, especially

89 *Whirling Logs.* Dry painting by the Navajo shaman, Klah, used in the Nightway Chant. The guardian (in the form of the curving body of the rainbow goddess) encloses four *yei* and four pairs of male and female figures standing on logs, and accompanied by corn, beans, squash, and tobacco. Navajo, 1965.

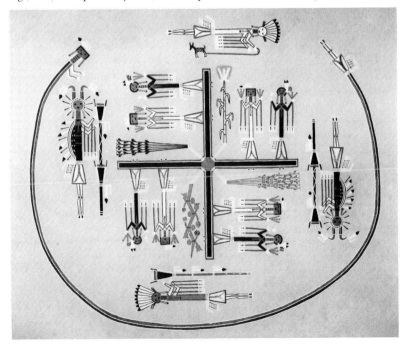

from the Sheep Spring area in New Mexico, these works are hardly representative of the original art form.

*Mosaic, inlay, overlay, cut-outs*

Mosaics, mainly made of turquoise, jet, and shell, have a limited distribution
90   in the Southwest, where the technique was apparently introduced from Mexico during the second half of the first millennium AD. Prehistoric examples, composed of mostly rectangular or triangular tesserae, have been recovered from the Hohokam and Anasazi regions, and point to Mexican inspiration. In late prehistoric times, mosaics were especially popular at the Zuni pueblo of Hawikuh, and Zunis continued to make them into historic times. A new application has become increasingly important since the 1930s, when mosaics (incorporating more recently received materials such as coral) were transferred to silver jewellery; the mosaic here is usually enclosed by a bezel. A related but technically different style, which originated at Zuni at about the same time, is channel work, in which strips of silver soldered to a silver base form compartments into which shaped pieces of shell or stone are cemented. Motifs in both these modern techniques include life forms, ceremonial dancers, mythical beings, and, much less commonly, geometric designs. Individual tesserae are frequently cut in irregular shapes of very small size, testifying to the outstanding workmanship of the Zuni lapidaries.

Inlay, in which thin pieces of stone or shell are set in shallow depressions of the surface of an object, is much more widely distributed in native North America than mosaic, particularly on the Northwest Coast, where haliotis
85   shell is inlaid in wood or bone. It may once have been equally common in the
4    East, but only a few early examples have survived. Inlays with European trade materials, however, occur in the Midwest and in the Great Lakes area either as geometric lead inlays on catlinite pipes or as brass inlays on iron tomahawk blades (often featuring life forms). With the exception of some examples in the last group, inlays are rarely used to create designs but rather to support forms created by other means.

The term 'overlay', which could be applied to mosaic, is usually reserved for a silverwork technique developed in 1938 by Hopi artists under White influence. Two sheets of plate silver are soldered together: the upper layer bears positive cut-out designs (derived from traditional motifs on pottery, basketry, etc.), while the lower layer offers a contrasting chemically blackened matt background. This technique has since been adopted by neighbouring tribes (with Zuni artisans fitting mosaics into the cut-out shapes), but in its basic form it remains typical of the Hopi.

An art form widely practised in native North America was the use of positive cut-outs made from flat pieces of material such as leather, bark, shell,

bone, or sheets of mica or copper. Even though there is a certain three-dimensional quality in these images, they clearly derive from a two-dimensional graphic tradition. Prehistoric Southwestern cut-outs (such as Hohokam stone palettes) as well as historic examples from the same area (such as Zuni bird fetishes of shell) tend to be more sculptural than comparable items from the East, ranging from Hopewell copper and mica naturalistic images to elk antler roach spreaders (hair ornaments) and Plains skin cut-outs. Also in this group belong the flaked flint images used as amulets by the Eskimo, and similar items known as 'eccentric flints' from the prehistoric Southeast. The bark templates used from the Subarctic to the Northwest Coast are another related form (see pp. 58, 60).

Negative cut-outs (openwork) of a graphic character are found in the East, especially on flat wooden pipe stems, metal tomahawk blades, and once again with elk antler roach spreaders. Northwest-Coast openwork carving in wood and argillite also derives from two-dimensional concepts but is nevertheless more sculptural in its effect, while the mechanical theatrical screens made of wood by the Kwakiutl are primarily two-dimensional. Somewhat closer to the Eastern examples are the (positive) cut-out and (negative) openwork horn spoons and wooden mush paddles (stirrers for acorn food) of northwestern California.

90 Mosiac-encrusted flint blade. Poncho House, Arizona; Anasazi tradition, c. 900–1100.

91 Profile of human head. Mica cut-out. Turner Mound Group, Ohio; Hopewell, c. AD 100–500.

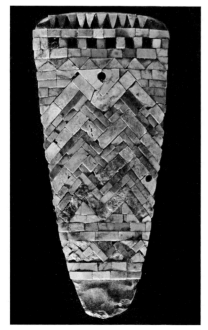 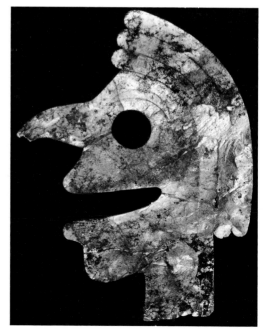

# Textiles

The textile arts afford a much greater variety of technique and consequently of style than do painting and engraved work. Nor should they be regarded as minor arts simply because their utilitarian character is more obvious than that of painting. On the contrary, since textile arts were almost exclusively the work of women, their appreciation is vital for an understanding of the tribal arts as a whole.

A somewhat arbitrary distinction will be made here between basketry and textiles proper. Only more or less rigid and three-dimensional weaving products, generally made without the aid of specialized devices, will be included under basketry. Soft and two-dimensional fabrics, made with specialized equipment, will be treated as textiles, though the distinctions are gradual rather than absolute. Some techniques are employed in the manufacture of both types of material.

*Basketry*

Basketry is an art form of considerable antiquity in North America. Particularly in the arid portions of the West, fragments several thousand years old have come to light in archaeological excavations; and the three basic techniques found in historic native American basketry all go back to prehistoric times.

In plaiting, the weft elements simply pass over and under the warp to produce plain weaves (crossing one warp element at a time) or twilled weaves (crossing an extra warp each time to produce a diagonal pattern). True wickerwork is also a plaiting technique; fixed, rigid warp elements are interwoven with a single, continuous and flexible weft.

In twining, two or more weft elements are twisted around the warps. An even greater multitude of weaves is encountered in this group, including plain, three-element, wicker, twill, and wrapped twining. In the latter variant, the flexible weft element wraps around the two crossed rigid elements, providing a different pattern on either side of the fabric. Two decorative techniques which occur with twining are overlay and false embroidery. In overlay, a non-structural decorative element is added to the weft. This shows on the outside in half-twist overlay and also on the inside in full-twist overlay. In false embroidery, decorative material, usually of a

contrasting colour, is wrapped around the outer wefts and consequently remains invisible on the inside.

A third method, coiling, is basically a sewing technique. A spiralling foundation of rods or filaments is stitched together in any of several possible ways by means of a flexible weft which usually creates the decorative effects. A special decorative technique found in coiling is called imbrication: a non-structural element is folded under each weft stitch on the outside of the basket to produce a scaly or looped texture.

Eastern North America is a region in which basketry is of comparatively minor importance: almost no baskets were made in the Subarctic, very few on the Plains, and even in the Northeast most basketry is historic. The major basketry technique here, as well as in the Southeast and on the Upper Missouri, is plaiting. In the Southeast, split river cane was the traditional material for single- and double-woven baskets (the latter diagonally woven with double warps and wefts, producing different patterns on the two surfaces). Undyed, red, black, and occasionally orange and yellow cane splints of equal width are twilled to produce simple geometric designs. Only the Chitimacha and their neighbours in Louisiana transcended the limitations imposed by the technique. Using extremely narrow cane splints, they succeeded in creating complex curvilinear patterns of an abstract nature. As elsewhere, names attached to certain designs – like 'alligator's entrails' or 'fish' – are not indicative of symbolic meaning, but should be seen as labels of reference.

Wood splint basketry has become an Indian art, though its origins are plainly post-European since iron implements are needed to obtain thin and regular hardwood splints. The basic technology, and even some details like block-stamping, derive from European basketry traditions, but most of the developments of the craft are indigenous. Hard ash splints are plaited throughout the Northeast among the Algonquians and others and as far south as the Cherokee of North Carolina. Superficially resembling river cane basketry, the technique differs in several respects. While twilling is less common, surfaces are enlivened by the use of wefts and warps of different width and colour, as well as by overlay and false embroidery in which the decorative elements are twisted to produce a curly or spiny texture. Stamped decorations of plain checkerwork are found among some tribes, but the greatest variation of structural decorative techniques is found in the Great Lakes area. (Simple flexible baskets of finely split cedar bark strips and spruce roots occur on the Northwest Coast with a wide variety of applied decoration, but are of little aesthetic merit.)

Most Southwestern plaited baskets are made of sotol or yucca leaves with structural decorations derived from twilling. Only the Hopi add geometric

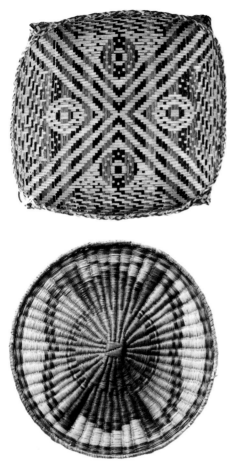

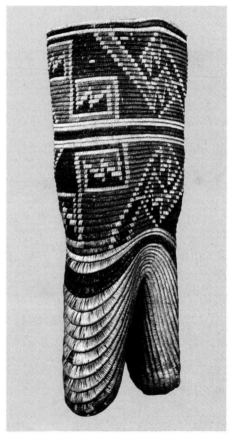

92 Single-woven cane 'farmer's basket' with
circular design traditionally called 'eyes of
cattle' by Clara Dardin. Chitimacha, collected
in 1904.

93 Wood splint basket by Margaret Boyd.
Ottawa, Harbour Springs, Michigan, c. 1875.

94 Wicker basket with polychrome painted
butterfly design. Hopi, Oraibi, early 20th
century.

95 Coiled carrying basket. Arizona; Anasazi,
c. 1100–1300.

designs based on dark/light contrasts. On the other hand, the Hopi or Oraibi on Third Mesa manufacture the most elaborate true wicker baskets in the whole of North America, which are exceptional for their wide range of colour. Both geometric and representational designs are woven into plaques and bowls. Among the life forms, butterflies, birds, and kachinas are most frequently encountered. On circular plaques or trays, which make up the majority of Oraibi wickerwork, the spiralling weft tends to produce curved outlines which are set against rectilinear blocks derived from the radial warps. In the walls of round baskets, analogous patterns become more stylized and their lines straight. *94*

The same formal tendencies, and similar designs, appear in coiled yucca basketry from the Hopi villages on Second Mesa. Both wicker and coiled Hopi baskets have improved in quality during the last few decades, following a revival in which native dyes have replaced the aniline dyes common around the turn of the century.

In general, neither the designs nor the colours used in modern Hopi basketry are in the classic Pueblo tradition. Anasazi basketry (both in its Basketmaker and Pueblo phases) exhibits the typical zigzag and fret patterns duplicated on black-painted pottery, except that here red takes the place of hatching. *95*

The beginning of coiled yucca basketry among the Papago dates from the beginning of the twentieth century. Their use of decorative split-stitches against the plain background of open coils is apparently of Spanish derivation (and is today also seen on the pine-needle baskets of several Southeastern tribes). In addition, the traditional close-coil technique is still practised, yet the designs have changed as Papago basketry moved from tribal to ethnic art. What has remained is the essentially bichrome nature of the designs, with a third colour used infrequently.

Numerous variations of the spiral fret pattern characterize Pima basketry (to which the older Papago style was closely related). Patterns are in black devil's-claw splints on a light willow background, and much of their fascination lies in their dynamic quality and the balance between dark and light. Both the use of occasional red elements and of representational motifs are late phenomena and may have been borrowed from the Western Apache. *96*

Realistic designs showing horses, deer, and humans are not much more than a hundred years old in Apache coiled basketry, which probably evolved in early historic times from Pueblo models, incorporating Pima and Yavapai influences at a later date. Banded zigzag patterns and other geometric elements dominate even after the appearance of life forms. *97*

Coiled baskets were also made by the tribes of the Great Basin and of southern and central California. Those of the Great Basin are distinguished

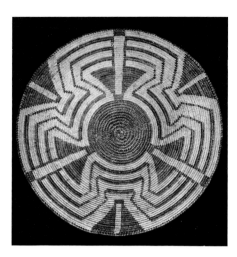

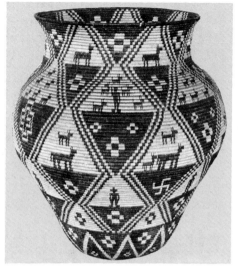

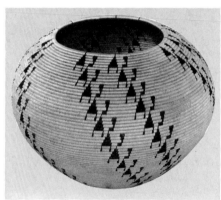

96 (above left) Coiled basketry bowl. Pima, c. 1900.

97 (above right) Coiled basket for storing corn. White Mountain Apache, Arizona, early 20th century.

98 (left) Coiled basket by Datsolalee. Washo, 1924.

by bold, simple geometric patterns. Again, life forms executed in various shades of red, yellow, and brown are a late development reflecting the spread of a style originating under Spanish stimuli among southern California's Mission Indians.

Perhaps the most highly praised of all the coiled baskets of North America are those of the Washo of Nevada and California, particularly the work of 98 Datsolalee (c. 1835–1925), who produced finely stitched baskets, with traditional designs consisting of small repetitive units, for the White market. Similar specializations which made the works of individual weavers synonymous with a tribal style were common in the late period of ethnic art, when White patrons cultivated the few remaining artists.

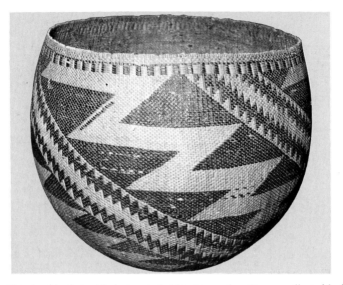

99 Twill twined basket with designs in half-twist overlay. Pomo, collected before 1873.

Of a technical perfection often equal to Datsolalee's work, with counts of well over 200 stitches per square inch (31 per square centimetre), the baskets made by the Yokuts and Chumash feature a wider array of patterns. Yokuts trays and jars often combine bands of diamonds with rows of stylized human figures or animals in black and red on a tan marsh-grass background, whereas Chumash baskets generally lack the representational component. The willingness of Chumash basket makers to copy any given pattern, however, is exemplified by some early specimens with decoration almost entirely devoted to European subject matter. *7*

Besides using the ordinary style of forming black geometric designs by altering the colour of the weft, Pomo basket makers decorated coiled baskets by attaching brightly coloured feathers or beads to the surface in the process *115* of weaving. In some feather baskets, feathers supplement the woven pattern; *100* in others, they cover the whole surface. Although many different colours appear in the featherwork, their number in a single basket rarely exceeds two or three. Originally shell or white glass beads were threaded on the weft as rim finish or to support the woven design. Since around 1900, however, some baskets have been fully beaded in the same technique.

Imbrication is the unmistakable hallmark of the Interior Salish and their neighbours in the Plateau area. Whether derived from woven porcupine quillwork or from false embroidery, the method is undoubtedly a local development. The tile-like texture of imbrication lends itself well to

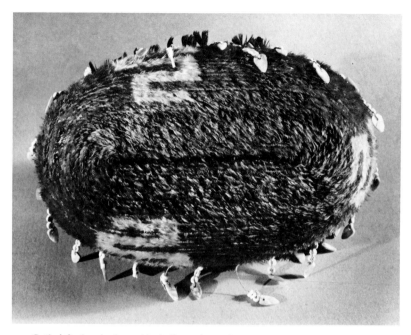

100 Coiled feather basket with shell pendants. Pomo, c. 1900.

101  rectilinear patterns, and horizontal or vertical bands of geometric elements may be regarded as the most characteristic decoration. Figures of humans and animals occurring on some specimens are possible late imitations of motifs originally developed in twined overlay work. Occasionally, imbrication is replaced by beading.

In twined basketry, wefts of different colours cannot be substituted for one another as freely as in coiling. To do so would jeopardize the stability of the fabric. If the colour is changed after one or two rows, a simple banded design results. The major structural means of decoration in twining is twilling, and alternation of plain and twilled twining, resulting in slightly raised designs. Geometric 'self designs' of this kind are characteristic of the rims of some Tlingit and Haida spruce root hats. A comparable effect is achieved by interspersing rows of three-element twining, a technique used by several tribes in western North America, mainly for adding strength to the basket.

For all complex designs in twining based on colour contrast, false embroidery, wrapped twining, or overlay has to be used. Overlay is characteristic of northern California, Oregon, and some Washington
99  basketry. The Pomo of central California used it with either plain or twilled

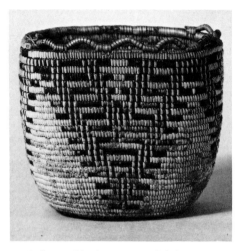

101 Imbricated basket. Interior Salish, collected before 1842.

102 Twined basket cap decorated with half-twist overlay. Yurok, collected in 1854.

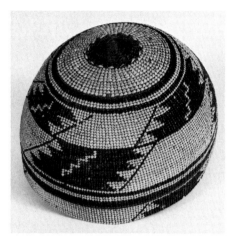

twining. In the first case horizontal bands with geometric patterns result, in the second case spiralling bands are the rule. The patterns make use of a simple dark/light contrast and are often based on the repetition of triangles and diamonds. The Hupa, Karok, and Yurok (north of the Pomo), whose basketry forms are very similar to one another, combine a greater variety of geometric elements and often use three-colour designs; frequently the whole surface is covered with overlay. The same is true of northeastern California and Klamath work, but full-twist instead of half-twist overlay is used.

*102*

False embroidery is featured on baskets from tribes of the northern Northwest Coast and some of their Eskimo and Aleut neighbours. Traditional Tlingit designs, which were shared by most adjacent tribes, are based on stepped bands, chevrons, diamonds, hexagons, and rectangles combined with diagonal lines and divisions. Whereas horizontal lines define the design areas, vertical and diagonal elements in the geometric patterns produce a certain amount of tension. In historic times, the range of colours in false embroidery was expanded, from the original black, purple, red, and the natural dry grass colour, by boiling out trade cloth and later by aniline dyes; at the same time, realistic designs (especially those representing animals)

*103*

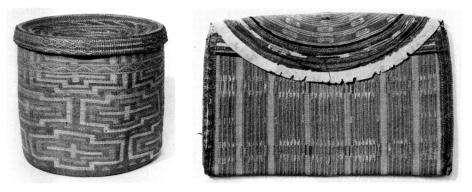

103 Lidded basket, twined, with false embroidery. Tlingit, collected at Kenai Bay before 1858.

104 Twined bag showing a variety of techniques, such as plain, open, and three-element twining. Aleut, Unalaska, collected by G.H. von Langsdorff on Krusenstern voyage in 1803–07.

gained ground. These are not usually executed in the northern graphic style, and may be an imitation of designs found on the commercially successful Makah basketry (see below) of around 1900.

Finely split grasses are the material with which the Aleut women wove the most delicate baskets in North America. With up to 1300 stitches per square inch (400 per square centimetre), their surface quality has often been compared with that of linen cloth. In addition, a multitude of techniques was used to vary the texture of the weave. Plain, open, and three-element twining, and crossed and divided warps, are often found on a single basket, besides false embroidery with reindeer hair and the use of different coloured weft strands. Traditional designs were purely geometric. During the nineteenth century, floral patterns became popular, mainly on items made for sale to tourists; silk thread replaced reindeer hair; and finally even the basic weaving material, beach grass, was replaced by imported raffia.

Between these two areas, there is a region in which representational motifs are apparently pre-European. Although both overlay and false embroidery are known in this area, which extends on both sides of the Canadian-American border, representational basketry design is usually associated with wrapped twining.

A cylindrical type of firm but flexible basket, which often carries representational designs, the sally bag, is commonly attributed to the Wasco of the Columbia River valley, although neighbouring tribes are known to have produced similar baskets. Both abstract and stylized realistic motifs are found, and, owing to the rarity of representational basketry designs in aboriginal times, these were suspected to be of post-European origin. Recent

research, however, has shown that at least one basket of this type, featuring both stylized animal figures and rows of conventionalized human faces, was collected by Lewis and Clark in 1805 (the first expedition to make contact with the Wasco). Other representational designs (such as horsemen) do in fact represent post-European additions to the list of decorative patterns, but the tradition is basically pre-European.

In the case of the Nootka (and their Makah relatives) there has never been any doubt regarding the aboriginal nature of this style, because it was found there in the late eighteenth century by Captain Cook and other explorers. It seems to have been confined mostly to whaling scenes, and was originally found only on the onion-topped hats of the Nootka. In early specimens, the pattern is highly conventionalized and rectilinear, and is sometimes accompanied by geometric filler designs. In the second half of the nineteenth century the still popular whaling motif was rendered in a more realistic way, and other realistic designs – animals and flowers – were added to the native inventory. A further sign of orientation towards the new market was the appearance of basketry-covered glass and stoneware containers.

106

105 Sally bag with stylized representational designs in wrapped twining. Wasco, c. 1900 (see also p. 36).

106 Basketry-covered stoneware bottle with whaling scenes in wrapped twining. Attributed to Nellie Jacobson. Nootka, Ahousat, late 19th century.

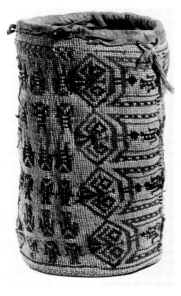

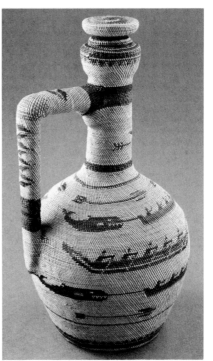

It may be significant that at least one Salishan tribe in the area between the Wasco and Nootka, the Skokomish, did produce wallets with stylized animal representations in overlaid twining.

*Interlacing*

Among the various kinds of interlacing in North America, only wood fibre and sinew netting is pre-European. In most cases, however, netted textiles are not decorated by structural means but by painting. Even the structural geometric designs on netted Pima and Papago burden baskets are painted as well.

71

Netted fabrics with a potential for design can be made with the help of dyed porcupine quills or glass beads. In the 'netted fringes' seen on early tobacco pouches, knife sheaths and bag straps from the Great Lakes area, different coloured quills are wrapped around alternate pairs of threads, resulting in a compact net. Since each individual wrapping may be in a different colour, there are few limitations on the design other than an overall rectilinear appearance. Besides geometric patterns, the favourite motif found on netted fringe, irrespective of tribal origin, is a stylized thunderbird. Designs are usually outlined and filled with solid colour. The technique does not appear to have survived the early nineteenth century. On pipe bags of the Plains, the netted fringe is replaced by a rawhide fringe wrapped with quills.

39

Similarly netted fabrics can be produced with glass beads instead of wrapped quills. However, netted beadwork has a different distribution from netted quillwork, and in the Southwest and in the Arctic has evolved independently. The similarity which nevertheless exists between the netted beadwork collars of the Greenland Eskimo and those of the Mohave, Mono, or Washo attests to the limitations imposed by the technique. Some Southwestern groups, like the Paiute, used netted beadwork to cover the outside of their baskets, making use of the local netting technique to imitate Pomo beaded basketry, in which the bead overlay is part of the weave. From the Kiowa and Comanche, netted beadwork spread to other tribes together with the paraphernalia of the Pan-Indian Peyote religion since the nineteenth century, whence it acquired the name 'Peyote stitch'.

107

Knitting and crochet were introduced to the Pueblo Indians by the Spaniards, and supplanted older Anasazi netting techniques. Since no contrasting colours are used, designs such as stripes and zigzag bands must be formed by openwork. Only at Zuni, coloured yarns were employed to produce checkerwork designs. While knitting with wool predominates in the western pueblos, crocheted garments are characteristic of the Rio Grande pueblos.

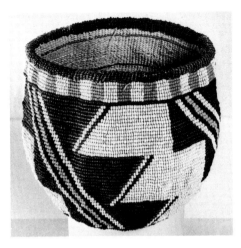

107 Twined basket fully covered with beadwork sewn to basket, superficially resembling netted beadwork covering. Achomawi (Pit River), early 20th century. Sewn beadwork covering probably represents the final stage in a development which started with beads threaded on basketry stitches, leading to a second stage of netted beadwork covering.

108 Rush mat with rows of thunderbird effigies. Ottawa, Michigan, collected in 1851–53.

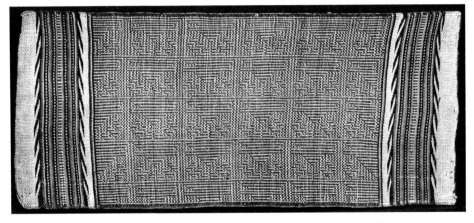

Among the Coast Salish of Vancouver Island, the origin of knitting dates from the nineteenth century. Derived from Scottish immigrants, it has developed into an important home industry. Best known are the white and brown woollen sweaters made by the Cowichan, decorated with geometric as well as stylized floral and zoomorphic motifs, the former adapted from basketry design, the latter being an innovation. The style has spread from the lower Fraser valley to other Salishan groups.

*Plaiting and braiding*

Mats and belts were often made in various plaiting and braiding techniques. Northwest-Coast cedar bark mats are generally woven in a checker weave with some twilling round the edges to achieve simple geometric patterns. The same style occurs in the Great Lakes region, where more complex *108*

designs, including stylized life forms, appear on warp faced mats combining natural and dyed reed or cattail (bulrush) warps with bast fibre wefts. Designs are produced by crossing the warps or changing them from side to side.

One type of twilled mat from the Great Lakes is often referred to as 'diagonally woven' or 'braided'. A few examples of true diagonally woven cane mats are known from the Southeast, but the Great Lakes type is actually made in a fingerweaving technique otherwise used for the manufacture of multicoloured yarn sashes.

Throughout the Northeast and Southeast, fingerweaving techniques such as double or multiple band plaiting served to make bands for use as bag straps, belts, garters, or sashes, as well as bags. These methods are undoubtedly aboriginal, but glass beads, as well as commercial yarns replacing native vegetal fibres and moose or bison wool, are found even in most eighteenth-century specimens. Double and multiple band plaiting lend themselves to polychrome structural designs. In early specimens, however, there is a distinct preference for plain backgrounds, occasionally relieved by narrow borders or central stripes in a contrasting colour, or by horizontal zones of tie-dying; geometric designs are created by white glass beads threaded on some of the strands of yarn. Multicoloured sashes with horizontal V, W or zigzag designs gained in popularity as the supply of commercial yarns was diversified, and finally replaced the older style. They are obviously related to the sashes used by the French *voyageurs* (Canadian river boatmen) in the eighteenth century.

The only example of foundationless fingerweaving outside the East is found in the Pueblo area. White cotton threads strung on a frame are braided into ribbed sashes, which are otherwise undecorated.

*Woven quill- and beadwork*

Narrow bands or rectangular panels may be made by looping a sinew thread around loosely spaced warps and threading dyed and flattened porcupine quills through the resulting grid. The quills, which now serve as alternate warps, are then pushed together to hide the weft. Designs are achieved simply by introducing different coloured quills. Because of the width of the quills and their arrangement in parallel bands, patterns are rectilinear. Abstract geometric motifs are the rule wherever the technique is employed. From the Iroquois to the Athapaskan tribes of the western Subarctic, woven quillwork was sewn to moccasins, shirts, coats, belts, and bags. The most complex designs were produced by the Cree and their Chipewyan neighbours. Some of the northern Athapaskans occasionally substituted moose hair for the quills in parts of the design.

On first sight, the ribbed surface of woven quillwork may be mistaken for small cylindrical beads threaded on the weft. In a very few examples, quills are actually cut into beads and woven into bands. It is possible that the Iroquois used this technique before the adoption of wampum in early historic times for the same purpose.

Wampum are white and purple tubular beads made from certain marine shells. There is only limited evidence for their prehistoric manufacture by the tribes of the northeastern Atlantic coast. The production of wampum increased after iron tools became available, and was later taken over by Whites who employed machines to manufacture them for an expanding

109 Sections of two fingerwoven sashes, wool yarn and white beads. Left: Iroquois (?), collected before 1828; right: made by Grethomi, Osage, 1828.

110 Pouch with woven quill panels and quill appliqué (diamond and inclined bar bandwork, and fine linework). Chipewyan, c. 1840.

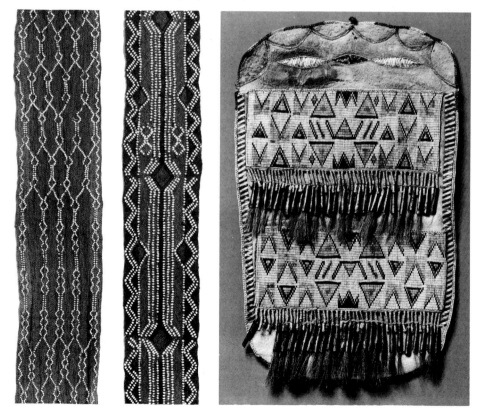

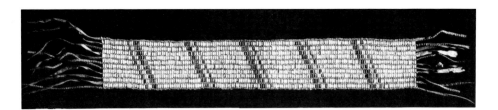

111 Wampum belt with non-representational design of unknown meaning. Iroquois, 18th century.

112 Bandoleer bag with black, white, and green imitation wampum glass beads, and quill appliqué (triangle bandwork). Iroquois, collected in 1776.

113 Bandoleer bag with woven beadwork. Potawatomi, c. 1880. Note asymmetry of designs on shoulder strap (cp. ills. 126, 134).

native market. Other types of shell bead (disk-shaped, for example) seem to have been used aboriginally for many of the purposes later served by wampum. Besides becoming a major medium of exchange, they were also woven into bands. Some of these were used as ornaments (headbands, bracelets, necklaces), especially by the coastal tribes. Among the Iroquois, they acquired the character of mnemonic devices in which the designs, based on the contrast between the white and purple beads, were associated with conventionalized meanings. In all important ceremonial and political transactions, words were accompanied and given weight by wampum belts. From the Iroquois, the use of mnemonic belts spread to most other tribes of the Northeast. In wampum, unlike quillwork, representational designs, as well as geometric patterns, occur.

Trying to capitalize on the native liking for wampum, White traders introduced tubular glass beads into the Northeast. But glass wampum were never wholeheartedly accepted, and only a very small number of specimens survive from the eighteenth-century Northeast, in which woven imitation wampum are used for decorative purposes. Their use remained sporadic throughout the nineteenth century.

Other types of glass bead proved to be more popular among the tribes, especially the small 'seed' beads which came in a great variety of colours and were often woven into garters, belts, or panels sewn on to pouches and bags.

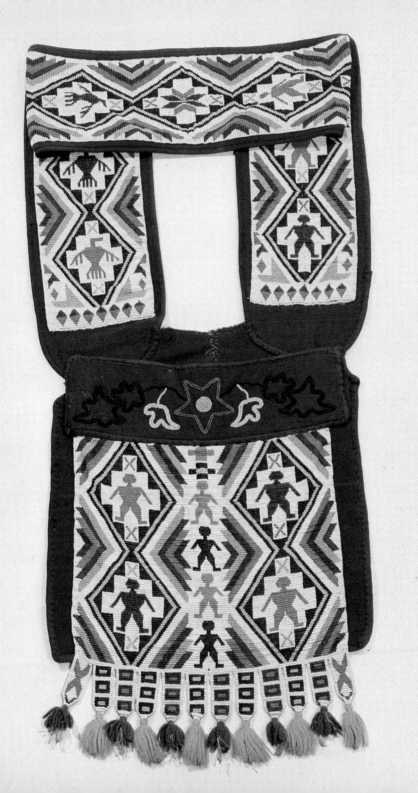

'Pony' beads, so called because they reached the tribes on the backs of traders' ponies, are larger than 'seed' beads and were especially popular on the Plains during the early nineteenth century. Traditional fingerweaving techniques were not ideally suited to the new uses for these beads, and the breakthrough came only after the hole-and-slot heddle was adopted by the tribes of the western Great Lakes during the early nineteenth century. This was a rectangular grid consisting of alternate slots and perforated slats used to form sheds (openings between the threads of the warp). Horizontally symmetrical

*113* geometric designs, sometimes faintly reminiscent of floral forms, and, less frequently, realistic motifs in traditional conventionalization, are characteristic of most of this type of work. In the Subarctic, some patterns were directly copied from woven quillwork.

Rectilinearity in woven beadwork must be regarded as the result of technical limitations, since contemporary sewn beadwork among the same tribes in the Great Lakes abounds in curvilinear forms. Instances of realistic motifs in woven beadwork are rare and late. On the Plains, where a rectilinear/abstract tradition was firmly established, woven beadwork never became of much consequence, as there was no suitable weaving apparatus.

*Twined textiles of the East*

In the Northeast, solid basketry was relatively unimportant; instead, soft twined bags were commonly used. The greatest variety in technique and design is found among the Algonquian tribes of the western Great Lakes area and some of their Dakota neighbours, who made such items until fairly recently. From other parts of the East, only a few specimens remain to give us an idea about regional variants of twining; it was used, for example, in the production of fabrics in the prehistoric Hopewell and Mississippian cultures.

Two types of bag which even during the nineteenth century were largely made of aboriginal raw materials are warp-faced, spaced-weft fibre bags. Wefts are made of apocynum (milkweed or Indian hemp), nettle fibre, or commercial cotton twine. In the first type, if basswood or some other bark fibre is used for warps, simple vertical banded designs produced by different coloured warps are the rule. To allow a somewhat greater flexibility in the creation of patterns, bark fibres of contrasting colour are used in what is called half-twist overlay of warps. In the second type of fibre bag, the warp is also of apocynum, nettle, or bast fibres, as well as of buffalo wool or moose

*114* hair. Spaced alternate-pair weft twining is employed, in which paired warps of contrasting colour switch positions to form dark/light contrasts in the design. A central vertical panel, showing either geometric designs or life forms (usually with different designs on each side of the bag), is framed on

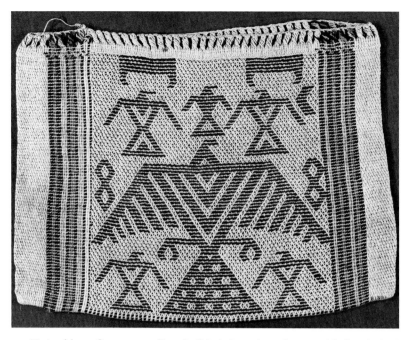

114 Twined bag of apocynum fibre, buffalo hair, and wool yarn, with thunderbird motif. Menominee, mid 19th century.

both sides with narrow multicoloured borders of wool. The life forms include, most commonly, mythical beings (such as the thunderbird or underwater panther), sometimes animals – but only rarely humans – rendered partly as solid figures, partly as outlines with filler designs.

Woollen blankets introduced by white traders were ravelled by the Great Lakes tribes in the eighteenth century to procure yarn for another type of bag. Later, Saxony yarn, often redyed with native vegetal pigments, and still later Germantown yarn, were employed for the same purpose. These woollen yarns were used as wefts with warps of native fibres or cotton twine to manufacture weft-faced textiles, allowing the weaver to make better use of colour in the designs, which in weft facing tend to be horizontally patterned. Techniques employed were compact plain and twill twining with weft floating (patterns created by floating the weft threads on the surface of the fabric), and especially full-turn twining, which allowed the greatest freedom in creating designs. The multitude of geometric designs was vastly increased in woollen yarn bags, whereas life forms decreased. One overriding design principle, that of using different motifs on each side of the bag, remained constant.

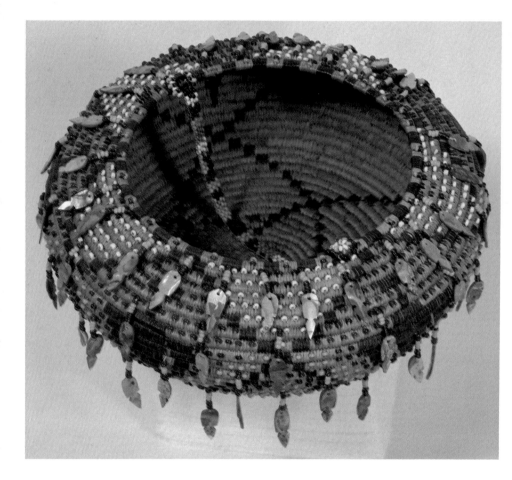

115 Coiled basket with threaded glass beads and shell pendants. Pomo, 19th century (see p. 111).

116 Blanket made for use of local nobility, commercial yarn. Coast Salish, lower Fraser River, collected before 1833.

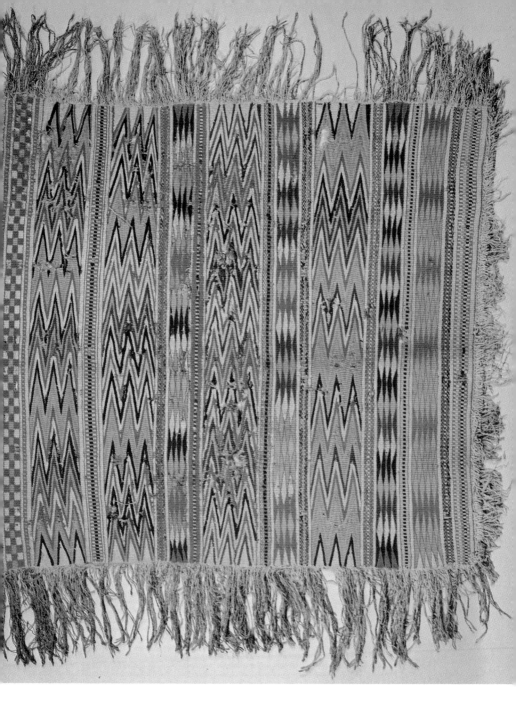

Compact plain twining with native fibre warps and wefts was also used by
117 the Iroquois, Huron, and New England Algonquians in the weaving of belts,
burden straps, and bags. All these items, most of which date from the
eighteenth century, are decorated with polychrome false embroidery in
moose hair. Designs are almost exclusively geometric, dominated by
stepped and serrated triangles and diamonds, although stylized human
figures sometimes appear.

In the southwestern Great Lakes region, where the highest perfection of
twining in the East was achieved, yet another method was developed.
Discontinuous wool wefts were used to produce tapestry twined bags, whose
diamond and serrated-line designs resemble some of the simple geometric
patterns found in silk ribbon appliqué. This appears to be a fairly late
technical development.

In all variants of twining recorded in the East, the warps are suspended
from a horizontal beam or string. In bags, the weft forms a continuous spiral
around the warps, producing seamless pockets or flattened cylinders.

*Twined textiles of the Northwest*

In the Plateau area, a type of soft twined basketry closely resembles the
twined textiles of the Northeast. Flat 'cornhusk' bags were traditionally
made of apocynum warps and wefts in compact plain twining, and
decorated with false embroidery in bear grass. During the nineteenth
century, apocynum was replaced by cotton twine, and bear grass by dyed
cornhusks. Even more recent is the use of wool for false embroidery. This
kind of wallet is usually associated with the Nez Perce, but it was also
118 produced by several other tribes of the Columbia River plateau. The whole
surface (except for narrow bands along the bottom and top) is covered with
false embroidery in which an almost endless variety of polychrome abstract
and rectilinear designs (showing influences from both the Plains and the
Northwest Coast) appears on the light natural-coloured background. As in
Eastern bags, the designs on the two sides are different. Some neighbouring

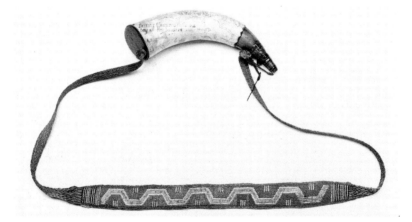

Salishan tribes imitated this type of bag, but used wrapped twining, which also shows on the inside, rather than false embroidery.

The weaving of the Coastal and Interior Salish makes use of a device resembling the true loom in having two warp beams, but lacks heddles. The warps strung around the two beams were either twill-plaited or twined to form a continuous fabric which had to be cut up to form a square blanket. Besides vegetal fibres and mountain goat wool, the hairs of a special breed of dog (now extinct) were spun for use in weaving; bird down or cattail (bulrush) fluff was sometimes added to make the yarn soft and warm. The use of a highly decorated variety of blanket was restricted to the local nobility. In this, triangles, diamonds, zigzag and checkerboard designs are usually organized in bands, which are horizontal, vertical, or restricted to the sides, according to the region of manufacture. The same designs occur on twined burden straps. <span>116</span>

Commercial yarns were introduced to the Salish during the early nineteenth century, adding to the choice of colours. At the same time, the use of dog hair declined. Only recently, when Salishan weaving had all but died out, it was revived and is now practised by the Salish of Sardis in southwestern British Columbia.

The simpler twining technique of suspending the warps from a single horizontal beam is found everywhere else on the Northwest Coast. The most common textile fibre is cedar bark, which is occasionally supplemented with or replaced by mountain goat wool. A widespread simple style of fabric consisted of cedar-bark warps and wefts in spaced twining. Round capes, cloaks with a convex lower edge, and square wraparound skirts for everyday use were woven in this style by the Nootka, Kwakiutl, Bella Coola, and others. In some specimens, a decorative border was added by using brown and/or yellow wool as a weft. Patterns are geometric (triangles, zigzags, diamonds), and both twilled twining and false embroidery in wool were used. Most of these decorated types were collected in the Nootka area during the early contact period. <span>63</span>

117 Moosehair-embroidered strap (on Jonathan Webb's powder-horn). Iroquois, dated 1758.

118 Twined bag with 'broken diamond' in false embroidery. Nez Perce, c. 1900.

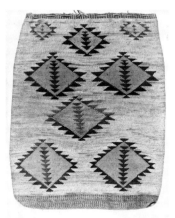

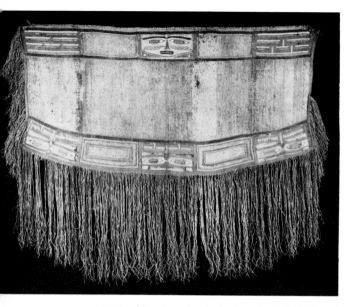

119 Twined blanket of cedar bark and wool. Collected among the Nootka by Captain Cook in 1778.

120 Twined blanket of cedar bark and wool. Tlingit, probably collected in Prince William Sound by Captain Cook in 1778.

121 Chilkat blanket. Tlingit, 1850–1900.

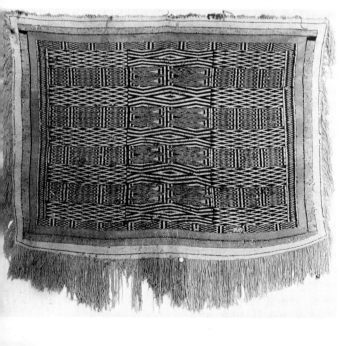

This is also true of an exceptional item which represents an ancestor of the Chilkat blanket, although technically it remains close to the simple cedar-bark cloaks. Like some others traded from the Nootka, it may be of a more northerly origin. Wool is present not only in the decorated border panels, but is also added to the cedar-bark warp. Both top and bottom panels are divided into five equal sections in which faces (inverted in the lower border) and rectilinear designs alternate. The faces show an attempt to render the curvilinear elements of the Northwest-Coast graphic style in weaving.

An equally early type of rectangular blanket can tentatively be assigned to the Tlingit. Its warps are of cedar bark, wool, or a combination of both, but the weft is of goat wool only, perhaps reflecting the scarcity of cedar in the northern section of the Coast. Compact plain and full-turn twining is used to

produce horizontal and vertical bands of geometric design (zigzags, diamonds, H, U, and W patterns) derived from basketry. There is some resemblance to both Tlingit basketry patterns and to Salish weaving, but the multiple border of plain-coloured stripes foreshadows a feature of the later Chilkat blanket. In some of these blankets, warps of fur strips alternate with ordinary warps to give one side of the textile the appearance of fur.

The form now known as the Chilkat blanket, after a northern Tlingit group which monopolized its production in historic times, is traditionally said to have been invented by the Tsimshian. No examples were collected by eighteenth-century European travellers (unless we count the prototypical form mentioned above), and so its origin and its spread to the Tlingit, with whom it replaced the earlier geometric design, presumably took place not long before the year 1834, when Tsimshian weaving is thought to have come to an end with the establishment of a local trading post at Fort Simpson.

*121* Chilkat blankets are shaped like the convex-edged cedar-bark cloaks from which they developed. They are, however, made with a mixed cedar-bark and wool warp, and a white, yellow, blue, and black wool weft, by a technique of compact plain, twill, and tapestry twining which lends itself to the reproduction of the classic two-dimensional style of the northern Coast. The framed central design is generally divided vertically into three zones. The central zone is best visible when the blanket is draped over the shoulders, and carries the major design. The flanking zones are decorated symmetrically with minor motifs and fillers. Specimens dating from the first half of the nineteenth century often deviate from this general pattern, which apparently was not yet fully established.

The blankets were woven by the women, who copied designs painted by male artists on special pattern boards. This practice explains the rather abrupt change from designs derived from basketry (female) to those derived from painting (male). Aprons, sleeved or sleeveless tunics, and leggings were also produced in the Chilkat style. After 1900, the manufacture of Chilkat blankets declined rapidly. Commercial yarns were used occasionally, but with poor effect, in the twentieth century. In recent years, there has been a limited revival of Chilkat weaving, mainly among the Tsimshian.

*Twined textiles of the Southwest*

Twined textiles in the Southwest date from as far back as the Basketmaker period of the Anasazi tradition (AD 300–700), when sandals, soft bags, and tumplines (burden straps) were made of yucca leaf and apocynum fibres. Many of them have bands of simple geometric designs. While twined fabrics decreased in quantity as the loom became available, two related types of twined textiles remained popular in historic times: fur and feather cloth.

In fur cloth, a vegetal fibre warp was wrapped with narrow strips of fur and twined with a simple spaced weft. As a variant, tufts of fur could be twisted between the strands of a two-ply fibre cord. Even simpler was the use of twisted fur strips as warps. In the Southwest, fur textiles survived among the Hopi and Paiute, but they were also made in California, on the Plateau, and on the Northwest Coast. At the pueblo of Taos, rabbitskin blanket making was revived in the twentieth century, using a similar technique.

On Basketmaker fur cloth there are sometimes borders in which strips of birdskin replace the fur; and blankets made completely of feathers rather than fur occurred at the same time and continued to be produced in historic times. Their distribution outside the Anasazi area includes parts of California and the Northwest Coast. Turkey-feather cloaks are likewise reported from the East, but no specimens survive to ascertain the technique employed.

A number of superior feather textiles from central California, dating from the first half of the nineteenth century, still exist and are commonly *122* identified as Maidu work. Here the webs of feathers are wrapped around a double weft of apocynum fibre and twined by spaced warps in a full-turn twine. Different kinds of feather are used to achieve simple horizontal stripes bordering a plain central area.

Other types of Californian feather textiles are represented by garments in which whole feathers are secured in the knots of loose nets, and apocynum fibre belts in which bunches of small feathers are held in place by the weft. Early examples of the latter type show zones of different colours combined with geometric figures in shell beads, and late nineteenth-century Pomo specimens abound in polychrome geometric designs in featherwork.

*Weaving*

True loom weaving (that is, with a mechanical formation of sheds) in native North America was limited to the Southwest. Its advent in the Anasazi area coincided with the introduction of domesticated cotton from the south

122 Feather blanket. Central California, *c.* 1830.

during early Pueblo times (eighth century AD). By 1300, Pueblo weavers were using a wide vertical loom as well as a small belt loom and had mastered a variety of techniques, including weft-faced plain weaves, a number of twill weaves, brocading, weft-float pattern weaves, and weft-warp openwork, to produce items of dress, bags, and bands. Since painting and tie-dying were used for decoration, structural embellishments were largely confined to striped patterns on plain and twill weaves. Brocading and weft-float pattern weaves, however, produced dark and light designs reminiscent of Anasazi pottery decoration. Vegetal and mineral dyes, formerly used for the treatment of other fibres, were now applied to native cotton.

Towards the end of the sixteenth century the Spanish introduced sheep, of the Andalusian churro breed, to the Pueblo area. Their cream-coloured to dark brown wool, sometimes dyed with imported indigo, was woven into blankets which were wider than they were long and featured narrow horizontal stripes. With embroidery gaining ground, raised weft-float pattern weaves were restricted to narrow bands, and other techniques were apparently completely abandoned.

Checkerboard patterns were produced by the Hopi, and entirely black blankets by the Zuni. After 1900 Hopi weavers occasionally produced Navajo-style blankets, including some with kachina designs in tapestry weave. Cotton was gradually replaced by wool in all but ceremonial contexts, and many pueblos entirely gave up the art of weaving. Pueblo weaving in general was traditionally done by the men, but women did most of the weaving at Zuni and have also taken greater interest in recent revivalistic movements in other pueblos.

Very little is known about Pima weaving, which became obsolete in the nineteenth century, except that a horizontal loom was employed for the manufacture of undecorated white or red cotton blankets and geometrically patterned woollen belts.

Towards the end of the seventeenth century, the Navajo adopted Pueblo weaving techniques along with the vertical loom. Within a short period of time they had become such expert weavers that by the early eighteenth century they were already selling their textiles to both Spanish and Pueblo communities. Beside blankets, women's dresses and belts were woven. Red was added to the traditional colours (white, brown, indigo) during the late eighteenth century. The red threads were procured by ravelling and respinning pieces of bayeta, an English trade flannel imported by the Spaniards.

In addition to the wide Puebloid textiles, the Navajo also learned to make the longer-than-wide serapes (long shawls) of the Spanish weaving tradition, and began to practise the tapestry weave. During the nineteenth century,

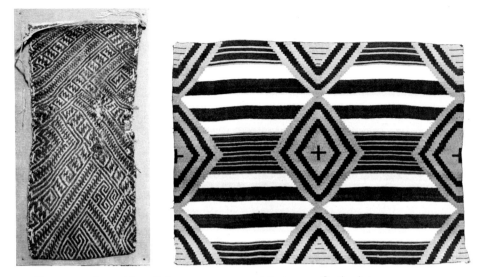

123 Cotton yarn bag with weft-float pattern weave. Montezuma Castle, Arizona; Anasazi, *c.* 1400.

124 Third Phase 'chief's blanket'. Navajo, *c.* 1870.

two types of blanket reflecting these two sources were concurrently produced by the Navajo. Puebloid textiles (commonly but misleadingly called 'chiefs' blankets') of the early period were decorated with alternating white and dark (brown, blue, red) horizontal stripes. The central stripe, which is especially wide, and the border stripes each consist of several narrow bands of alternating colour (First Phase). After 1850 a new style came into vogue in which the central and border stripes were structured by nine, or twelve, blocks of contrasting colour (Second Phase). Some ten years later, the blocks were transformed into stepped diamonds which intersected with *124* the border and consequently appeared as halves or quarters, with only the central diamond shown in full (Third Phase). After about 1880 the diamonds increased in size until they merged at their corners (Fourth Phase). Only a few years later, the Navajo manufacture of Puebloid textiles declined, and it finally came to an end before 1900.

Serape weaving also started from simple striped patterns but moved in a different direction. Zigzag bands, either derived from native basketry designs or enlarged from Saltillo and Rio Grande serapes, were combined with horizontal stripes to produce diamonds and triangles. Similarly, stepped designs were blended with stripes. Another and later line of development leads from striped to banded blankets, in which broad patterned horizontal bands dominate. Here, as in the decoration of Puebloid

textiles, the evolution of design clearly reflects the growing technical skill of the weavers.

The finest quality of serape-style blanket dates from the 1840 to 1860 period. After 1850 a commercial three-ply yarn of merino wool (Saxony yarn) became increasingly available to the Navajo, adding somewhat to the range of colours. During this phase, Navajo blankets became the leading textile product over much of western North America. Items were traded as far away as the northern Plains.

While confined to Fort Sumner at the Bosque Redondo (1864–68), the Navajo were supplied with large numbers of Mexican-influenced Rio Grande blankets from which they derived their own rendering of the 'Saltillo star' motif. Serrated lines now tended to replace stepped ones. At about the same time, aniline and other synthetic dyes began to appear, especially in tightly spun three-ply and later in four-ply yarns originally made in Germantown, Pennsylvania. The sudden explosion of colours, coupled with a tendency to resolve the star design into a series of small triangles, led to the development of 'eyedazzlers' which enjoyed particular popularity during the 1870s and 1880s.

After 1885, Navajo weaving deteriorated in quality because of the increased competition from imported textiles, and because the wool from merino-churro crosses did not take the cheap synthetic dyes evenly. On the other hand, a certain freedom from traditional constraints is reflected by experiments with new techniques and designs. Wedge weave, double weave, and twilled blankets were made, commercial cotton twine was tried for warps, and pictorial rugs (whose roots date from the early nineteenth century) became current for a while. Pictorials included representations of cattle, trains, houses, birds, the American flag, letters, and words. These elements were treated much like the design units in the traditional, abstract style.

As the tribal demand for Navajo textiles declined in the late nineteenth century, weaving was primarily continued for sale to Whites. The traders who acted as middlemen consequently tried to influence the weavers to meet the tastes of their ultimate customers. Whereas blankets were formerly worn as part of the native attire, the demand now was for rugs. Framing borders were introduced first, and, around 1900, weavers were beginning to be supplied with oriental rug patterns which they more or less faithfully copied in soft colours. The role of the traders as designers led to a marked regionalization of styles: names for these styles are therefore generally derived from the names of the trading posts (for example, Two Gray Hills, Ganado). Samplers containing several different types of weaving have to be understood in this context.

125

Pictorials, which represent a true Navajo folk art, also developed in a new direction under commercial influence. Instead of cattle and brand labels, figures of spirits (*yei*) and their masked impersonators (*yeibichai*) were thought to be more appealing to the buying public. These appeared on blankets after 1900, first as single figures, later in rows. From 1919 onwards, dry-painting designs were woven by Hosteen Klah, a ritualist, in spite of traditional prohibitions and contrary to the female domination of weaving. A rare 1883 dry-painting rug is indicative of earlier exceptions; it is also the *126* earliest record of Navajo dry painting. The dry-painting rug has since become one of the established types of Navajo weaving.

125 Eyedazzler blanket. Navajo, *c.* 1885.

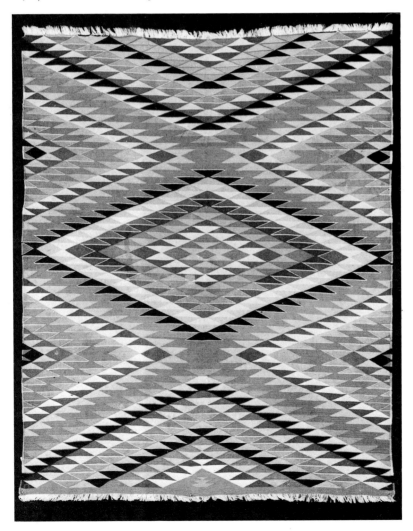

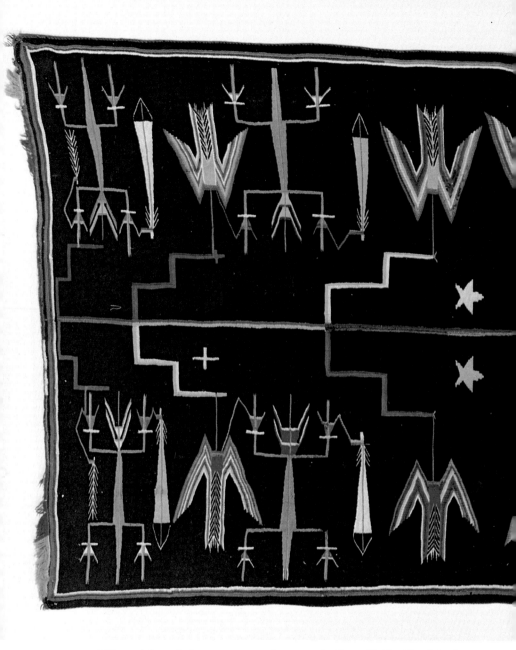

126 Unusual dry-painting rug, supposedly woven by Eston Naltha Chu. Navajo, near Farmington, New Mexico, 1883 (see also p. 102). Thought to represent dry painting from an eagle ceremonial, no longer practised even then.

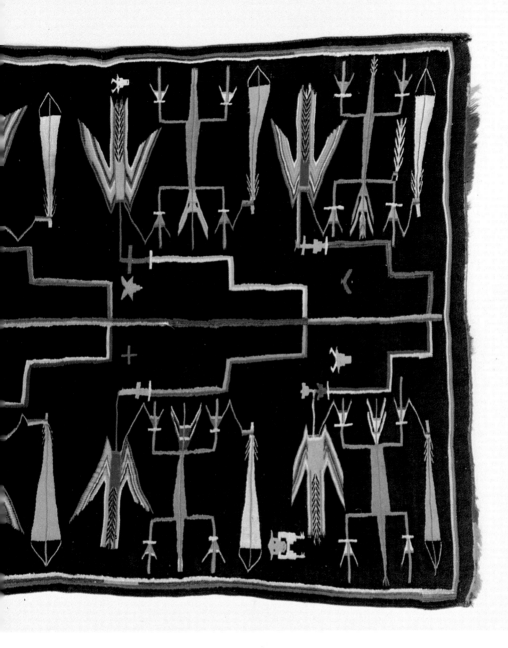

During the last sixty years, revivalistic trends in Navajo weaving have led to the rediscovery of older designs and styles, as well as to the use of vegetal dyes, which are not traditional at all as far as weaving is concerned.

In the East, the use of the true loom is clearly post-European. Sheds are formed mechanically by means of the hole-and-slot heddle in the manufacture of woven bands of beadwork or of belts.

*Quill and hair appliqué*

Quillwork in its broadest sense is a form of decorative art highly characteristic of North America. It includes several different techniques by which the quills of the American porcupine, some of the white winter hair of the moose and caribou, split bird quills, and occasionally also vegetal fibre substitutes (such as sweet grass and maidenhair fern) are worked into two-dimensional designs. The natural habitat of the porcupine embraces the Subarctic, the mountainous areas of western North America, and the northern half of the Northeast. The quills, however, were traded far beyond the southern limit of this natural distribution and were used by many Plains tribes as well. The habitat of the moose is roughly the same, but its hair was rarely used outside this area.

Quills and hair were originally dyed with a limited range of mostly vegetal dyes (black, some shades of red and yellow, and, less commonly, blue). When European trade cloth became generally available, this could be boiled to extract other colours. The introduction of aniline dyes during the late nineteenth century removed the final limitations on colour choice.

Appliqué of quills and hair on tanned and sometimes blackened leather is the most widespread technique. The stitches do not completely pierce the decorative material, as in textile or leather appliqué, but pass over the flattened quills or bundles of hair. The sinew thread used for this purpose may then be concealed by folding the quill over the stitch.

The designs of early Iroquois and Huron moosehair appliqué are based exclusively on the combination of fine oversewn lines. Curvilinear elements, only partly of floral derivation, but including paired ('bracket') curves, circles and half-circles, often consist only of outlines marked by several parallel lines of the same colour. During the first half of the nineteenth century, they tended to become increasingly naturalistic, with their outlines filled with contrasting colours. When the Iroquois, and perhaps some of the other tribes of the Great Lakes area, abandoned moosehair appliqué, the Huron of Lorette near Québec continued the craft. Sewing now on light rather than blackened buckskin, the exuberant floral designs degenerated into mass-produced simplicity. This style was also adopted by some of the tribes in the Canadian Maritimes and featured the technical innovation of

*127*

raised elements, especially bristles, made by trimming bundles of moosehair with scissors. Similar work has more recently been reported from the Canadian Northwest Territories. Comparatively simple line work and edging in caribou hair was traditional among the Aleut and Alaska Eskimo.

Quill appliqué embraces a far greater number of techniques than does moosehair appliqué. Many are limited to edgings and fillers and will not be dealt with here. Two techniques are of major importance. Fine linework resembles moosehair appliqué except that quill lines are not oversewn but folded over the stitch; only one sinew thread is used. In bandwork, of which there are several varieties, two threads are needed: one or more quills are bent back and forth between the two threads, thereby concealing the stitches. The bands consist of triangles or rectangles, depending on how the quill is folded. If two, four, or more quills are used side by side, diamonds, inclined bars, or other shapes may be formed by plaiting. In addition, overlay techniques are employed to achieve saw-tooth patterns in contrasting colours. Linework imposes fewer restrictions on the design than bandwork, which tends towards geometric forms, especially if the band is of constant width.

Three broad style groups may be discerned in quill appliqué. The first group probably represents an early style of the Northeast. Panels are formed *128*

127 Pair of moosehair-embroidered moccasins. Huron style, *c.* 1830.

128 Quilled bandoleer bag (triangle bandwork) with beaded straps. Northeast, 1800–50.

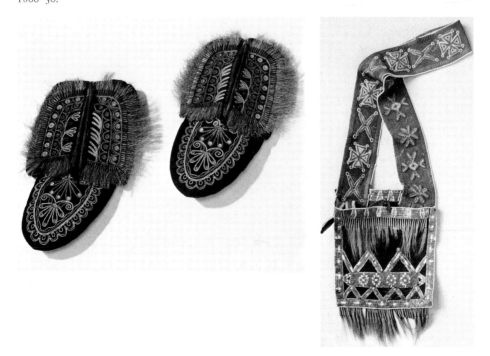

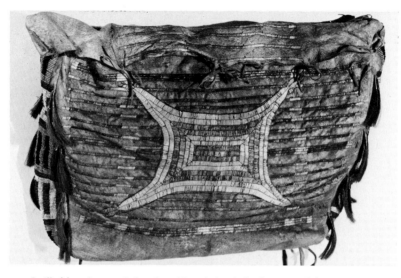

129 Quilled bag (rectangle bandwork) with beaded sides; central design represents spider-web motif (cp. ill. 46). Dakota, *c.* 1850.

by several parallel bands of triangles, of constant width. Geometric and stylized representational patterns are created by concerted colour changes within the bands. Other designs may be outlined in triangle bands edged with linework, or consist entirely of groups of parallel fine lines. The linear rather than solid character of these designs is obvious, even when the outlines are filled with linework. Besides the representation of thunderbirds, underwater panthers, other mythical beings, and humans, designs of a remote floral derivation occur in linework of this group.

The second group is made up of conventionalized floral patterns in triangle bands of changing width, edged with and connected by fine lines. It has an overall northern distribution from the Great Lakes area into the Subarctic and the margins of the northern Plains, and seems to suggest a refining White stylistic influence on older patterns. Its graceful curvilinearity is often combined with an extraordinary subtlety of colours and execution.

The third group, which dominates on the Plains, employs mainly bands of *129* rectangles, either in panels (as in the first group) or in solid designs made up of bands of changing width. Linework is usually absent, but its place is partly taken by narrow bands. Quillwork of this group is frequently combined with complex plaited bands. Traditional designs are either geometric or stylized and representational, and sometimes duplicate the symbolic abstractions found in Plains painting. Truly pictorial designs (including a *130* variety of animals and floral patterns) occur only from the late nineteenth century onwards.

140

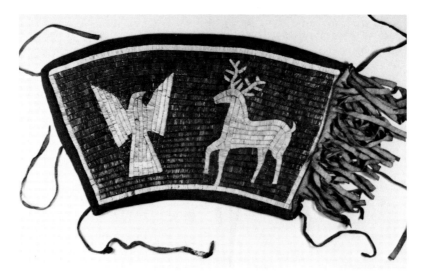

130 Quilled cuff (rectangle bandwork). Oglala Teton Dakota, c. 1900.

Since the three stylistic areas overlap to a certain extent, numerous combinations may be encountered.

In addition to appliqué quillwork, woven quillwork (see pp. 118–22), and quill embroidery (see pp. 154–55), two other quilling techniques should be briefly noted. Round wooden pipestems, leather fringes, and strips of rawhide may simply be wrapped with quills of various colours, secured by a thread on the back. Designs result when several wrapped units are placed next to one another. Coils of hair are likewise wrapped with quills and sewn to leather as rosettes. The second technique involves the plaiting of porcupine quills around two warp strands. The braid-like band is then wrapped around flat pipestems. In spite of the difficulties involved, complex and even representational designs were created in this way.

*Bead appliqué*

Before the arrival of European trade goods, beads used for purposes of appliqué were primarily of shell. Some shells, like dentalium, have holes through which they may be threaded; others had to be shaped and drilled. Unfortunately, there is little evidence for the traditional use of shell beads in appliqué work because the majority of archaeologically recovered specimens could just as well have been strung as necklaces or similar ornaments. From the East only one early historic example of bead appliqué survives, but it must be assumed that this decorative technique was widely used. On the

Plains, dentalium and elk teeth remained popular natural beads throughout the nineteenth century. With the exception of wampum, the native production of shell beads was abandoned as soon as European glass beads could be procured in trade. Since the majority of shells are white, designs were probably largely linear rather than based on colour contrast.

Although a preference for white and blue continues to be evident well into the nineteenth century all over the East (and probably reflects earlier decorative patterns), glass beads could be bought in all shades of colours. This finally stimulated the evolution of polychrome decorative styles.

Glass bead appliqué did not become a major art until the nineteenth century. Early trade beads were regarded either as too expensive to be used in great numbers, or as otherwise unsuitable. Around 1800 a comparatively large opaque bead known as a 'pony bead' was introduced and came to be the type most frequently used. From about 1840 onwards, smaller opaque seed beads replaced pony beads in the Indian trade and became the standard material in bead appliqué and other beadwork.

Glass bead appliqué has not only replaced quill appliqué wherever the latter had been practised: it also occurs among other tribes. Furthermore, by no means all the designs used in beadwork (not even all early ones) are derived from quillwork. As the techniques employed were different from both traditional shell beadwork and quillwork, new approaches to design were possible, and indeed necessary.

Aboriginal beads were generally applied to a base by sewing each bead individually. This method, widely employed to attach dentalium shells or elk teeth, survived on the Northwest Coast in the use of imported mother-of-pearl buttons to outline the figures on cloth blankets, both with and without textile appliqué. As with aboriginal beads, this buttonwork is entirely linear and offers no colour contrasts, except with its background.

In glass bead appliqué, only two basic stitches and one major variant are encountered. In the 'spot stitch' or 'overlay stitch', a line of threaded beads is sewn to the base by means of a second thread catching the first one at short intervals. Both outline patterns and solid areas can be beaded in this way, curved lines pose no problem, and colour may be changed at will. This technique offers a wide range of decorative possibilities and has an extensive distribution from the East to the Northwest.

The 'lazy stitch' employs a single thread both for threading and sewing large quantities of beads. Lines are straight and usually form bands of constant width, which make the technique easily recognizable. Lazy-stitch beadwork is typical of the Plains area and naturally lends itself to the creation of solid and rectilinear designs. The same is true of 'Crow stitch', named after the tribe which made frequent use of it. Beaded lines are straight as in lazy

*131*

stitch, but a second thread which runs at right angles overlays them in a manner similar to spot stitch.

In the Northeast, the early nineteenth-century beadwork of the Micmac and Iroquois was almost entirely made up of white spot stitch curvilinear patterns on a plain cloth or silk background. Designs are strongly conventionalized, include in- and outcurving ('bracket') curves, and are lacy though not obviously floral. The major difference between Micmac and Iroquois styles is that the former shows a greater tension between straight lines and curves. The range of colours increases with a growing reinterpretation of the old motifs as realistic floral designs. Beadwork also becomes more and more solid: outlines are filled, but backgrounds as a rule remain blank. Around 1860, Victorian needlework influences led to the adoption of embossed beading: heavy floral designs in shaded colours were produced in lazy stitch rather than the traditional spot stitch, and padding gave the work a three-dimensional quality not unlike that of raised moosehair appliqué.

In the Great Lakes area, the development was similarly from stylized, white, and linear to realistic, polychrome, and compact floral forms. While embossed work is rare, backgrounds are often filled and some rectilinear patterns occur. Two methods of filling solid forms are separated

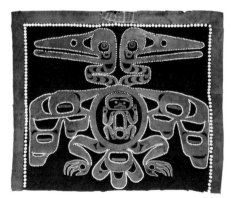

131 Button blanket made of trade cloth, mother-of-pearl buttons, and white glass beads. Note the two-headed bird design. Tsimshian, late 19th century (see also p. 151).

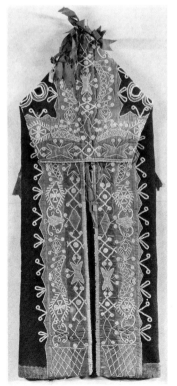

132 Headdress with beadwork (spot stitch) and ribbon appliqué on cloth. Seneca (Iroquois), 19th century (see also p. 150).

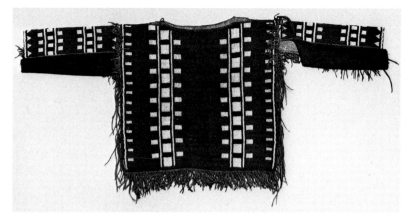

133 Fully beaded boy's shirt (lazy stitch). Plains, 1850–1900.

134 Polychrome beaded triangular flap pouch. Creek or Seminole, 1800–50.

geographically and seem to be related to two quill appliqué styles. Northern groups, like the Ojibwa, preferred to fill areas with lines parallel to the outline. This resembles semi-floral fine line quillwork and facilitates shading. Southern groups, like the Potawatomi, filled the forms with parallel lines irrespective of the outline shape, which is reminiscent of the contrast between triangle band shapes and fine line edging.

Southeastern beadwork appears never to have moved into the realistic floral direction, but has remained curvilinear and abstract. Some types, like the scroll patterned sashes of the Choctaw and their neighbours, even *134* retained their all-white character, but on the whole polychrome beadwork came to dominate. In overall composition, the same asymmetry prevailed as in the Northeast.

Plains beadwork in general is distinguished by geometric designs in lazy-stitch work, usually covering extensive spaces. Designs are formed by a *133* method similar to that employed in rectangle band quill appliqué. Many of the early beaded patterns are taken from quillwork and, less commonly, from parfleche painting; in about 1870, several central Plains tribes (Teton Dakota, Cheyenne, Arapaho, Assiniboin) adopted intricate geometric designs apparently derived from Oriental rugs brought to the frontier by White settlers. The new designs were often given new symbolic interpretations. Along the eastern and northern margins of the Plains spot-stitch bead appliqué similar to that of the Great Lakes area is found. Floral beadwork was probably introduced to the Kiowa by the Delaware upon their removal to Oklahoma.

Of all tribal styles of Plains beadwork, that of the Crow is the easiest to *135* recognize, not only because of their use of the Crow stitch. The Crow

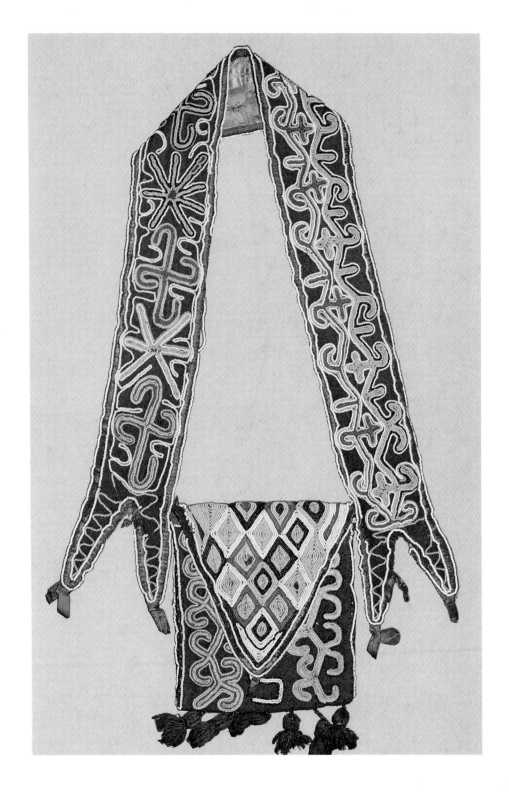

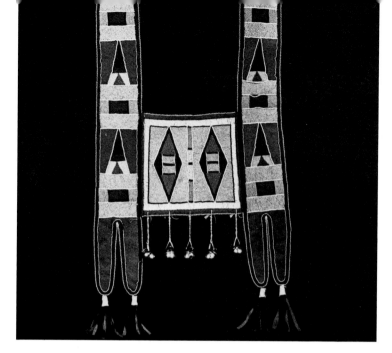

emphasized the same simple triangular designs as those found in parfleche painting, and their choice of colours (including many pastel shades as well as bright colours) is as unique as their use of single white lines to outline geometric patterns.

A late nineteenth-century development which perhaps originated in the central Plains is pictorial beadwork in lazy stitch, with realistic representations of humans and animals in the manner of ledger drawings. Pictorial beadwork in spot stitch was taken up, probably around the same time or slightly later, by the Yakima and other Plateau tribes. The polychrome style can hardly be said to be traditional, but it produced some of the finest solid beadwork ever done in North America.

In the Subarctic, a floral style spread from the Great Lakes region all the way to the Northwest Coast, coexisting with earlier styles derived from local quillwork patterns. On the Coast itself, bead appliqué was used mainly to outline designs in the traditional symbolic style, but solid beadwork appears on smaller items such as collars or aprons.

*Leather, textile, and feather appliqué*

Designs formed by sewing pieces of leather to a leather base are found all across the Arctic. In most cases, the technique is used to embellish borders or seams of clothing or bags. An extraordinary mastery of this method is displayed on belts and bags from nineteenth-century West Greenland.

146

135 Beaded horse collar (Crow stitch). Crow, c. 1900.

136 Beaded bag (spot stitch) with eagle, deer, and floral design. Yakima, 20th century.

137 Beaded dance apron (spot stitch) with rows of thimbles. Kwakiutl, collected by Captain A. Jacobsen in 1882.

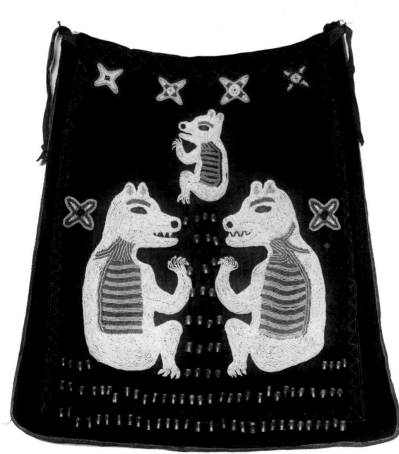

138 Folded trade cloth blanket with silk ribbon appliqué and silk thread embroidery. Menominee, c. 1820.

139 Sections of two belts with leather appliqué. Sukkertoppen and Upernivik, West Greenland Eskimo, c. 1890.

140 Woman's blouse with cotton appliqué. Florida Seminole, probably Mikasuki, c. 1895.

Minute squares of leather of various colours are combined to form intricate geometric patterns. Occasionally there are attempts at scenic representation, using stylized cut-out forms instead of squares. As a modern commercial art, pictorial sealskin appliqué is also found in Alaska. It is more difficult to determine the aboriginality of a limited number of leather appliqué specimens from the nineteenth-century Midwest, because technically and stylistically they resemble silk ribbon appliqué which by that time had become fashionable among many Eastern groups and followed the import of the ribbons at the end of the eighteenth century.

The two areas in which silk or satin ribbon appliqué was cultivated as a major art are the region south and west of the Great Lakes and the eastern Plains.

Ribbon panels are generally used as structural equivalents of quill appliqué panels, and so it is only logical to expect that, after the large-scale introduction of silk ribbons towards the end of the eighteenth century, needleworkers would adapt traditional quill designs to the new medium.

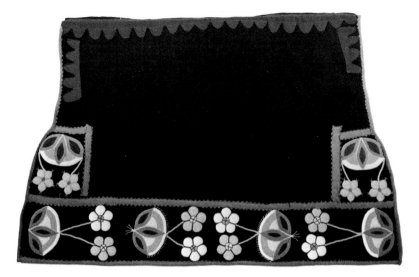

141 Trade cloth horse blanket with bead and cotton appliqué. Plateau, c. 1900.

Early nineteenth-century examples do in fact tend to duplicate the simple diamond patterns found in quillwork. With the rise of floral beadwork *138* during the nineteenth century, floral motifs were transferred to ribbonwork in a highly stylized form.

In its simplest variety, ribbonwork is used to fill small areas of floral designs outlined by glass beads. More typical, however, are broad panel designs consisting of several ribbons cut in elaborate patterns, which are sewn to a background of different coloured silk. Such panels are in turn applied to the borders and seams of garments and other items. Usually the base material is imported cloth, but leather is also used. The use of bark and paper stencils, which helped to improve the regularity in repetitive floral patterns and in mirror designs, is a late phenomenon. Particularly in recent decades, there has been a renewed trend away from the less spectacular diamond designs.

In other parts of the East, ribbon appliqué remained fairly simple. The only major exception is found among the Florida Seminole, whose cotton ribbon appliqué, previously confined to decorative borders consisting of bands of triangles, became much more elaborate during the second half of *140* the nineteenth century. Designs on male and female clothing were all rectilinear, and included parallel horizontal stripes of variable width, either in plain material or with rows of triangles, crosses, square frames, meander lines, and the like. The use of several superimposed layers of fabric is

142 Headband with feather appliqué. Hupa, *c.* 1900.

reminiscent of the molas (appliqué panels sewn to the front of women's blouses) made by the Panamanian Cuna.

A different tradition of appliqué is encountered in the Northwest from the mid nineteenth century onwards. Both on the Coast and (less commonly) in the Plateau area, shaped pieces of felt or flannel were sewn to cloth blankets, *141* shirts, or leggings. Red floral or zoomorphic images dominate, on black or blue backgrounds. Plateau examples are usually less elaborate, while Northwest-Coast appliqué features representations of the 'configurative' *131* variety stylistically reminiscent of the local painting tradition. The reduction to two colours on the Northwest Coast is distinctive, though outlines are often emphasized by lines of white beads or buttons; conversely, small elements in white-beaded figures are sometimes accentuated by the use of appliqué.

Feather appliqué is found in northern California (Hupa, Yurok). Whole woodpecker skins and strips of deerskin were sewn or glued to broad deerskin headbands. They are remotely related to central Californian feather *142* ornaments, consisting of feathers with the webs partly removed. These were sewn together to form bands with serrated edges.

*Patchwork and quilting*

Patchwork and appliqué quilts were introduced into the repertoire of the native needleworkers of the East probably during the early nineteenth

century. Designs tended to follow established Anglo-American patterns with some additions, such as the 'squaw quilt', depicting rows and columns of female figures. Nowhere, however, did patchwork quilting become as important as on the northern Plains, where quilts were used increasingly as substitutes for painted skins after large-scale hunting had to be abandoned. *143* The predominant use of the star or sunburst design may best be understood as a direct continuation of one of the earlier symbolic hide-painting traditions. Quilting on northern Plains patchwork is generally done in simple parallel arcs.

The patchwork tradition of the Florida Seminole is of even more recent origin. It was only around 1915 that the design bands on men's and women's clothing began to be made in unquilted patchwork rather than appliqué. The use of hand-operated sewing machines obviously facilitated the work and led to ever smaller design units, while retaining their rectilinearity. If there is a connection with patchwork quilting elsewhere, it is remote. Similarly, Alaskan Eskimo skin patchwork seems to be related rather to an older appliqué tradition than to Western influences.

*Embroidery*

Embroidery can confidently be regarded as pre-European in the Pueblo area only, where cotton threads were used to decorate cotton textiles. Sometimes during the Spanish colonial period a variation of the back stitch was adopted and woollen yarns (either native-spun, bayeta, or Saxony) were substituted for cotton threads. Cotton textiles continued to be embroidered even after native woollen garments were also decorated in this way. Commercial textiles (traded from the Whites) were only sporadically used, except for short-lived experiments in the 1920s and 1930s, which included copies of Hopi wicker plaque designs in wool embroidery.

Designs are mostly rectilinear and abstract, with the exception of one stylized floral element of Mexican derivation. Traditional colours for embroidery on a white cotton background are black (or indigo), a greenish yellow, and red (which in Acoma was sometimes substituted for the otherwise dominant black). Highly characteristic are the use of negative decorative elements (especially fine lines); the subdivision of the design area into three horizontal zones of unequal width; and further structuring by means of contrasting vertical panels. All these features are designed to break up the monotony of the heavy zones produced in the dominant colour.

Embroidery on dark woollen textiles is best known from Acoma, Laguna, and Zuni. Acoma and Laguna continued the traditional style of cotton *147* embroidery in the new medium, substituting red as the dominant colour and exhibiting a greater freedom of forms. The floral motif appears in more

143 Star quilt with tipis and 'squaw' figures by L. Gibson and Dorothy Thomas. Choctaw, Conehatta, Mississippi, 1976.

elaborate shapes (using satin stitch rather than back stitch), and some curvilinear designs are added. Zuni departs from the traditional style and prefers blue to red as the dominant colour.

In the East, embroidery seems to be post-European in all its manifestations. This is most obviously the case with commercial silk or cotton thread embroidery on items of skin clothing. A fine, naturalistic style, utilizing the many shades of commercial yarns and a variety of stitches, was used wherever this kind of embroidery is found. Minor differences exist between earlier Cherokee examples and later specimens from the northern Plains and the Plateau.

A derivation from this European type is moosehair embroidery on cloth, which may be seen as the result of the activities of Ursuline nuns in French Canada after 1639. Moosehair had been used traditionally in parts of the Northeast in false embroidery, and was now chosen as a substitute for silk threads. The shortness of the hairs makes a birch-bark base necessary to hold them firmly in place; it seems likely that the technique was first applied to birch bark, then to birch bark covered with cloth, and finally to cloth with birch-bark backing. Most extant pieces date from the late nineteenth century, can be identified as Huron work, and display elaborate polychrome floral designs in satin stitch and raised figures of knotted hair.

Moosehair on bark embroidery has a somewhat wider distribution in eastern Canada and is distinguished by greater variety of motifs. Besides the strictly floral patterns and naïve scenic representations of Indians smoking and drinking and carrying baskets, trees, birds, and other animals are shown on trays, cigar and call-card cases, boxes for gloves, fan handles, picture frames, and the like. All these nineteenth-century products were made for sale to tourists, especially at Niagara Falls.

A technically related but stylistically different art is porcupine quill embroidery on birch bark. Dyed and unflattened quills are inserted into the bark at both ends, but they are not employed as a continuous thread. Whereas steel needles are necessary for moosehair embroidery, only awls are needed for quillwork of this sort, and so the art could have had a pre-European origin. However, its distribution, style, and function suggest a beginning in colonial times.

At least three styles can be discerned. Micmac work features solid geometric designs which cover the whole surface and combine rectilinear patterns with circles and arcs; it also exhibits a marked preference for bilateral symmetry. Seventeenth-century references prove the existence of at least some Micmac quillwork on bark, and by 1750 the distinctive style can already be recognized. While boxes remained a perennial favourite, other items, including cradles and chair seats, were added during the nineteenth

century to meet the rising demand from tourists and exporters; chair backs are apparently a late nineteenth-century development.

Floral patterns covering the whole surface are typical of nineteenth-century Ojibwa style. Later they became less stylized, and animals and humans were included. More recently, natural quillwork has been adopted, decorative in its contrast between the white quills and their brown ends.

Other Algonquian groups, to the south of the Ojibwa, preferred to leave the background unembroidered. The Ottawa, in particular, excelled in clearly European-inspired floral quillwork during the early nineteenth century; rather crude pictorial embroideries also occur in this style. A few late seventeenth-century specimens from French Canada have affinities to both later Micmac and Ojibwa styles and may be a missing stylistic link.

*148*

144 Buckskin coat with silk embroidery by Nancy A. Riley and Dolly Webber. Cherokee, Oklahoma, 1865.

145 White-American-style cradle with quill-embroidered birch-bark panels. Micmac, 1841. Note the zoomorphic design uncommon in Micmac quillwork.

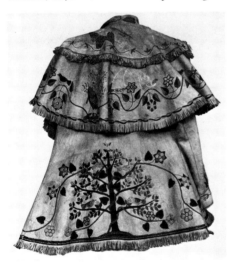

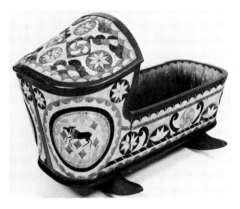

146 Moosehair-embroidered lid of bark box. Eastern Canada (Huron style), c. 1850.

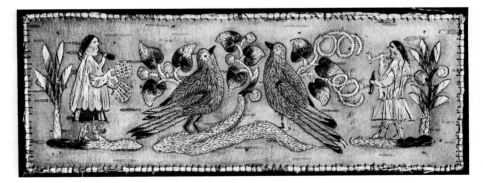

147 Diagonal twill woollen manta (garment worn either as a dress or a shawl) with cotton embroidery. Acoma, late 19th century.

148 Tabernacle with quill-embroidered birch-bark panels. Ottawa, Cross Village, Michigan, 1846–48.

156

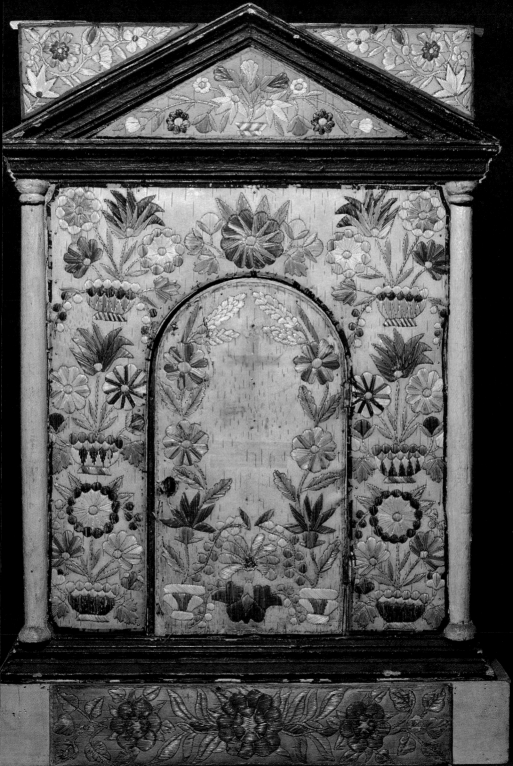

# Sculpture

In sculpture, as elsewhere, the materials available have an effect on style. Most materials are carved, but clay sculpture is usually modelled, and effigy basketry is produced by means of textile techniques. Wood, the easiest material to carve, is not universally available, and is also rarely preserved in prehistoric contexts. Stone and ivory sculpture thus afford better insights into the development of the sculptural arts, even though it must be assumed that excellent wood carving was produced by at least some of the prehistoric groups, whose traditions we can judge by their efforts in less easily carved materials.

*Stone sculpture*

Eastern stone sculpture is primarily associated with effigy pipes ranging in size from utilitarian to monumental. The oldest known stone sculpture from this area is a tubular pipe from Adena dating from the last millennium BC, which portrays a standing male figure. Of remarkable technical and artistic quality, it is the only known example of its kind. In Hopewell times (from the end of the last millennium BC to about AD 700), platform pipes with

*11*

149 Stone pipe with effigy of a bird eating a fish. Hopewell. 100 BC–AD 400.

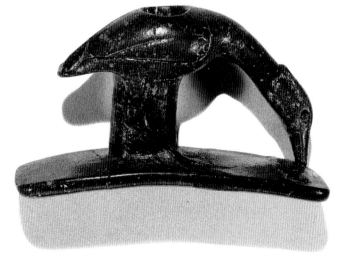

animal effigies abound, which continue the naturalistic tradition of the
Adena pipe. Many of them have incised surfaces imitating the texture of
skin, fur, or feathers. Most (later) Mississippian animal effigy pipes, on the
other hand – especially those of the earlier period – show certain
conventionalized features. Human effigy pipes also reappear, in which a
narrative component is often added to the naturalistic tradition. Mexican
echoes are discernible in some of them, but are more obvious in stylized
stone masks and in a few larger stone images, some of which have retained
traces of polychrome painting.

In the Southeast, the Mississippian effigy tradition was continued into
historic times in a somewhat provincial version by Cherokee pipemakers,
whose repertoire included an unusual group illustrating human sexual
activity. Although the quality of stone carving among the Cherokee
declined towards the end of the eighteenth century, it was reaching a new
climax in the Northeast and the eastern Plains. Stones of various colours,
especially red catlinite and other clay stones were carved by tribes from the
Micmac in the Northeast all the way to the Blackfoot in the west. During the
first half of the nineteenth century the finest pipes originated in the western
Great Lakes region and among the neighbouring eastern Dakota. The most
popular types were pipes whose bowl was carved as a human head
(sometimes Janus-faced) and elbow pipes with humans and/or animals
(singly or in groups) arranged in front of the bowl. Themes such as Indians
drinking occur on pipes made by carvers from widely differing tribes and
indicate the growing orientation towards the tastes of White American

150 Figural catlinite pipe head. Ojibwa, c. 1830.

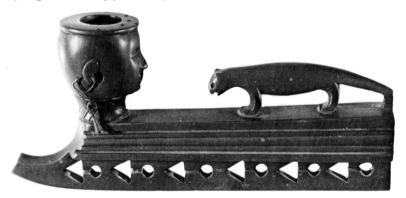

151 Unusual figural catlinite pipe head with bowl between buttocks of naked male figure. Dakota, mid 19th century.

customers. More of the craftsmen were now specialists, and this, together
*151* with the availability of metal tools, helps to explain the high quality of some
of these small sculptures.

Stone sculpture never became an important art form in the heartlands of
the Southwest. Besides a number of large stylized figures made by the
historic Pueblo communities and their Anasazi precursors, and some more
expressive Hohokam animal effigy bowls, stone sculpture was more or less
limited to small ceremonial fetishes representing animals, most of them of
Zuni origin. In marked contrast to these are the elegantly carved soapstone
*152* (steatite) effigies of killer whales, seals, fish, and other animals, recovered
from graves in the territory of the Chumash and their southern Californian
neighbours. Entirely free from two-dimensional features even in their
treatment of the surface, these little figurines are among the purest works of
sculpture in western North America.

Further north, two centres of prehistoric stone sculpture were the valleys
of the Columbia and Fraser Rivers. When compared with stone sculpture
from other parts of North America, Columbia River sculpture exhibits a
greater massiveness and simplicity of expression. Although many boulders
were carved in the round, the style is essentially that of a three-dimensional
relief, firmly related to local rock art. Besides the circle-and-dot motif and
*153* parallel grooves and chevrons, emphasis on rib structure is a frequent
characteristic. The greatest diversity of styles occurs near the Dalles area,
where features typical of the lower and upper courses of the river meet.

Fraser River stone sculpture is less stylized, but also less bold. The most
frequent type of carving (usually of soapstone) represents a seated human
*154* figure holding a bowl. Such objects were apparently being made at least 2000

152 Whale effigy, soapstone with shell inlay. Prehistoric Chumash, Arroyo Sewnit canyon, Santa Monica area, *c.* 1000–1700.

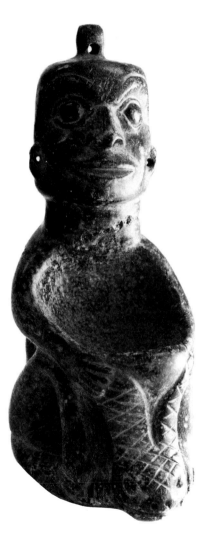

153 Standing owl, lava. Sauvies Island, lower Columbia River, Oregon.

154 Figural stone bowl, seated human figure and snake. Fraser River near Lillooet, British Columbia.

years ago; they were still used in historic times by the Salish tribes of the Plateau country in girls' puberty ceremonies.

Stone sculpture of the central Northwest Coast, some of it associated with the historic Nootka and Kwakiutl, bears a closer resemblance to that of the Columbia River than to that of the Fraser River, although the latter parallels in some respects the wood carving of the central Northwest Coast. Finely executed naturalistic sculpture (best represented by a group of stone clubs) appears to be typical of the area inhabited by the Tsimshian in the historic period. None of these styles reflects the influence of the classic northern graphic style, which becomes very obvious, however, in the animal-shaped tobacco mortars and related stone sculpture of the historic Haida and Tlingit. These, as well as a few other items of historic northern Northwest-Coast three-dimensional art in stone, closely resemble contemporary wood carving from the same area.

In general, the flourishing of wood carving during the historic period minimized the importance of Northwest-Coast stone sculpture; but there is one important exception, that of argillite carving. Argillite – or slate, as it is locally called – is a black carbonaceous shale, quarried on the Queen Charlotte Islands, which is easily carved with wood-working tools and takes a high polish when dried out. Because of its limited availability, argillite carving is a monopoly of the Haida, who seem to have first taken it up about 1820. An early use of Haida motifs combined with, and partly gave way to, exotic subject matter in accordance with the taste of the White visitors who dominated the market from the very beginning. Generally functionless panel pipes, flat boards, 4–12 inches (10–30 cm) long, with a hole through them, or pipeless panels derived from them, became a favourite type of carving, but early works included dishes, cups, flutes and individual figures, followed by elaborate chests and totem-pole models. Figure groups of Haida mythology (especially numerous renderings of the Bear Mother story) became popular during the last quarter of the nineteenth century, when European motifs gradually disappeared from carving. Well-known artists, such as Charles Edenshaw, George Gunya, Isaac Chapman, and John Smith, some of whom signed their works, emerged during this period. As in other areas of Northwest-Coast art, the golden period of argillite carving was followed by a decline in quality. But since it had always been an ethnic rather than a tribal art, the collapse of the traditional culture did not lead to a total breakdown. Good work has continued to be done, increasingly so in the recent past.

Work in argillite is characterized by two different approaches. One of them clearly derives from the two-dimensional compositions of the northern Coastal tradition (for example, flat panels with native topics).

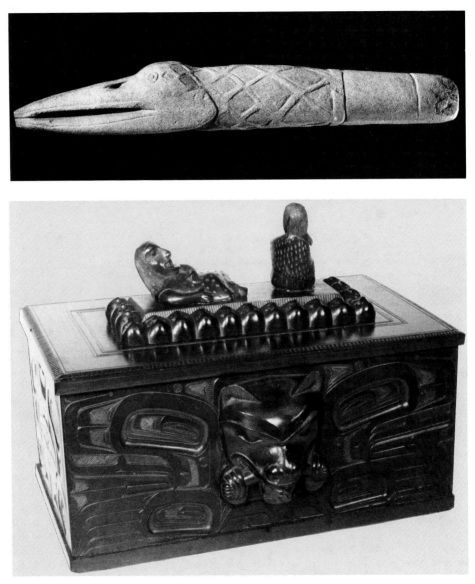

155 Stone club with head of sandhill crane. Hagwilet, Bulkley canyon, British Columbia. *c.* 500–1800.

156 Carved and engraved argillite box. Haida, attributed to Charles Edenshaw, *c.* 1880.

163

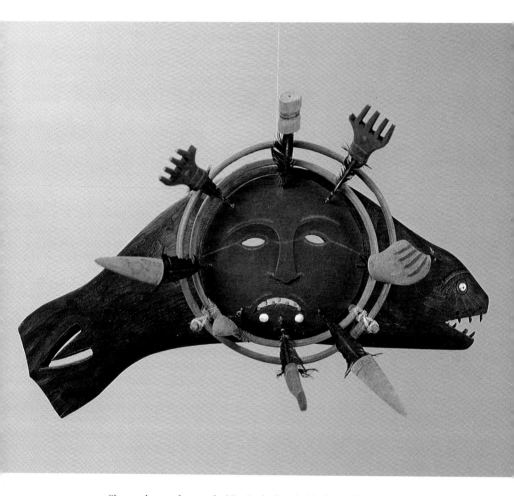

157 Shaman's wooden mask. Nunivak, South Alaskan Eskimo, early 20th century (see also p. 176, 178).

158 Kachina doll representing Sip-ikne, the warrior kachina, dressed in leather mocassins, painted cotton breechclout, feather ruff. Zuni, early 20th century (see p. 185).

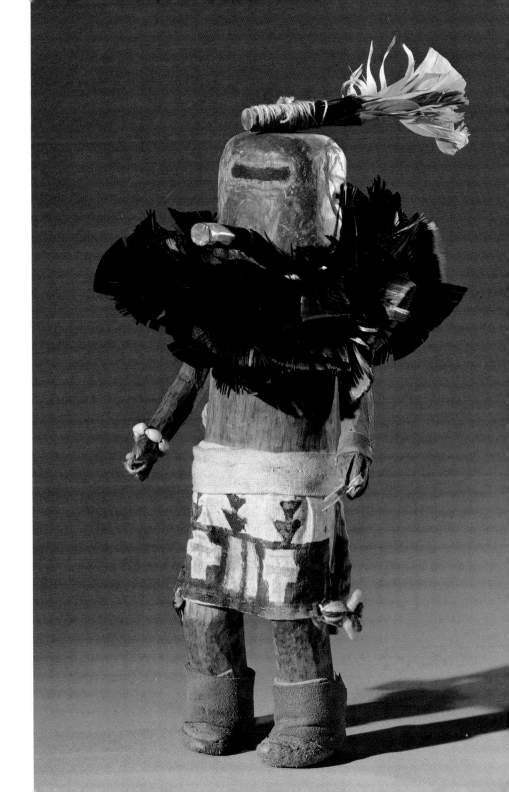

This approach is also represented by plates with Russian-inspired chip-carving decoration. The other approach is more sculptural, and is first exemplified in European-style figures and panels, but later also in native figure compositions. Broadly speaking, the trend has been towards the second approach.

Traditional Eskimo stone carving was largely confined to the manufacture of oil lamps, which were (with some notable exceptions from southwestern Alaska) plainly utilitarian. During the late nineteenth century, simple soapstone carvings of both human and animal figures made their appearance in Alaska and Greenland; many of them were made for sale to Whites. Production was discontinued in Alaska, but it carried on in *159* Greenland well into the twentieth century, in a naturalistic style closer to European than to native traditions. In the late 1940s James Houston, the same White artist who later initiated Eskimo print making, motivated Hudson Bay Eskimos to try their hands at soapstone carving, which met with immediate commercial success. This new art was tailored to the demands of the market; it embodies themes from Eskimo life and mythology, but it owes more to its sponsor than to any Eskimo artistic tradition. Soapstone carving later spread all the way to Alaska, resulting in the development of regional styles, and has also been taken up by non-Eskimo groups, such as the Cree and Iroquois.

*Wood carving of the Northwest Coast*

The extraordinary quality of Northwest-Coast wood carving is responsible for its comparatively early recognition as 'art' by European observers. The vast quantity and diversity of wood carving, ranging in size from gambling sticks to totem poles, that has found its way into the world's museums and private collections attests both to the fertility of the native professional carvers and to the importance of this art for the native societies. While a full appreciation of Northwest-Coast sculpture, as of any other art, is impossible without a detailed knowledge of its social and ceremonial functions, a discussion of style helps to bring order into a short survey like this and affords insights into the history of the subject.

Much of the apparent unity of Northwest-Coast art is due to the spread of a northern Northwest-Coast style, which combined carving with the graphic principles of the northern Northwest-Coast painting and engraving style. This process was still going on during historic times. In the nineteenth century, it strongly affected Kwakiutl and, to a lesser extent, Nootka carving. Underlying these late similarities are an older style, formerly widespread on the Coast, and distinctive local variations of sculptural expression. The older style is most obvious in prehistoric and early historic Nootka sculpture and emphasizes simple, clearly readable sculptural forms.

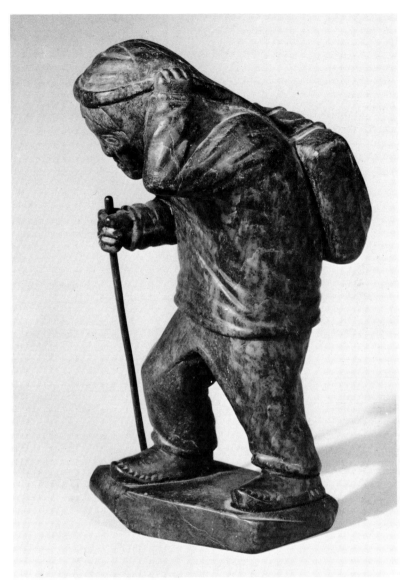

159 Soapstone carving of a man carrying a block of soapstone, by Anton
Thorsen, Frederikshaab, West Greenland Eskimo, c. 1960.

A general feature of Northwest-Coast sculpture is its symmetry.
Asymmetrical features, so common in Eskimo and Iroquois masks, are rare
in three-dimensional Northwest-Coast forms, although they occur in the

painted decoration of these carved objects. Unlike painting on other two-dimensional surfaces (in which the classic northern Northwest style is more rigidly symmetrical than the southern), painting of masks in the north of the region is generally asymmetrical, and is used to add dynamic features to balanced sculptural forms. Designs are painted deliberately to contrast with the carving among the Bella Coola, and are applied irrespective of it by the Tlingit, Haida, and Tsimshian; in the central part of the Northwest Coast, such as among the Kwakiutl, they enhance the three-dimensional forms.

On the southern part of this Coast, the Salishan tribes, and their neighbours between the Columbia and Fraser Rivers, developed a *160* conventionalized carving style in which protruding and receding horizontal planes are juxtaposed to add depth to an otherwise two-dimensional and

160 Carved wooden baton. Wasco, 19th century.

161 Carved wooden head for ceremonial use. Nootka, collected by Captain Cook in 1778.

162 *Nulmal* mask used by 'fool' dancers. Kwakiutl, collected by Captain A. Jacobsen in 1882.

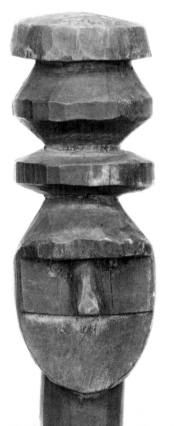

frontal composition. This basic structure is retained even where influences from the north have led to the adoption of a more sophisticated three-dimensionality.

Nootka sculpture also features a basically flat treatment of forehead and cheek planes, but combines it with lateral slopes and often rounded transitions. Particularly in early pieces, a certain realism is achieved, which is   *161* both sensitive and strongly expressive. In the late nineteenth century, Nootka sculpture became increasingly stylized, and abstract painted decorations gained ground as the overall quality of the carving diminished. Some masks were not even carved, but constructed from cut-out boards.

The complexity of sculptural form is further emphasized among the Kwakiutl and Bella Coola. Shapes are defined by a greater number of   *162*

intersecting planes, often resulting in a pronounced angularity of features. Influences from the north are of course strongest among the northern Kwakiutl groups such as the Bellabella, whose work is sometimes indistinguishable from that of the Tsimshian or Haida.

Northern Northwest-Coast carving in general shows both a greater concern for sculptured form and a wide use of the classic two-dimensional style. The first is apparent in realistic sculpture in which the transitions be-

*163* tween the various planes are gently rounded to render the interplay between the bony structure and the fleshy form of faces and figures. The second can be clearly seen in the painted designs on sculpture (employing a wider range of colours than does classic Northwest-Coast graphic art), and in the stylized sculptural examples where compositions follow the formline system. Of the three northern tribes, the Haida have achieved the best integration of graphic and sculptural forms. Tsimshian carving has been described as 'classic', because of the importance of the sculptural element, which leads to a great

*164* clarity of expression; whereas Tlingit work has been classed as 'rococo' because of the frequent use of conventionalized features overlaying otherwise realistically carved forms.

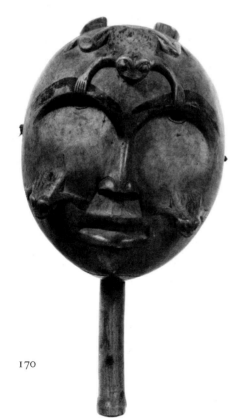

163 Carved and painted round rattle. Haida, collected by J. G. Swan before 1875.

164 Octopus mask with opercula inlay. Tlingit, Chilkat, collected in 1882.

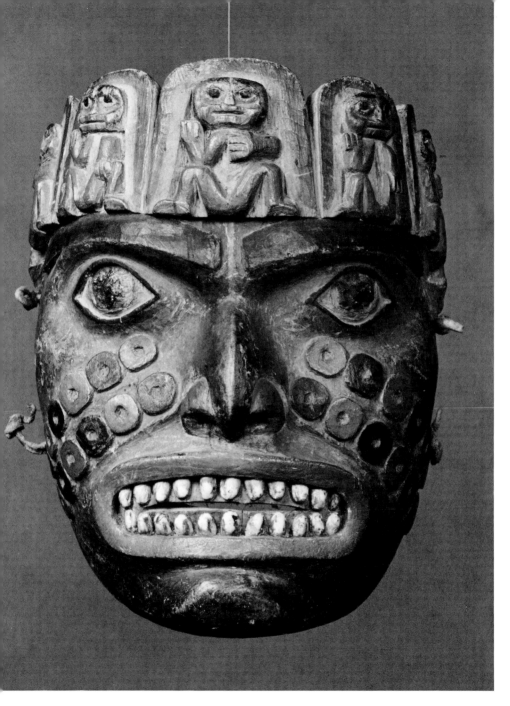

Thus the northern Northwest Coast can be seen as a centre that saw both the emergence of realistic carving (in the Tsimshian area?) and the application of the classic graphic style to sculpture (among the Haida?); presumably the realism spread southward several centuries earlier than the graphic style.

On the northern margin of the Northwest Coast and in the adjacent part of the Arctic, the carving style closely resembles that of the southern Northwest Coast. The simple three-dimensionality based on stepped planes is again encountered, and may indicate an old common Coastal feature.

Much of what has been said so far about styles in general can be better understood when it is related to certain classes of carving. Each functional type posed different problems of composition. Since totem poles are the most widely known, and masks the most widespread, kinds of wooden sculpture from the Northwest Coast, they merit particular attention.

Totem poles are monumental carvings representing heraldic crests derived from myths and legends and owned by specific kinship groups. They were erected in commemoration of special events, as frontal house posts, as grave markers, or as repositories for grave boxes, and served to identify the groups and to advertise their prerogatives. Thus, they were not themselves narrative in character but symbolic of rights validated by narratives. Totem poles were carved from large cedar trunks, which were frequently cut away or hollowed out on one side so that only about half of the circumference was available for carving. The proportions of the pole made it necessary to place one figure above the other. The vertical axis therefore tended to be divided into horizontal sections. A fairly general method of imparting a sense of monumentality, beyond the sheer size of the carving, was the alternation of figures represented in two different scales; this helped to lend rhythmic structure to the dominant vertical. The same end is attained by exaggerating the heads in an attempt to use the full width of the log.

The problem of horizontal division and vertical integration is solved in different ways. Among the Haida, the figures that together make up the pole are treated as interlocking elements and are carved in such a way as to retain as much of the continuous surface of the log as possible. The effect is that of a two-dimensional composition wrapped around the half-cylindrical pole. *165* Tsimshian poles also tend to follow the circumference of the log, using high relief for major features and low relief for details. There is less integration, however, and the horizontal divisions are more clearly marked – as they are to an even greater extent in Tlingit poles. In the northern Tlingit area, especially, there is no regard for the original surface. Deeply carved on all sides, the superimposed figures become almost independent of one another.

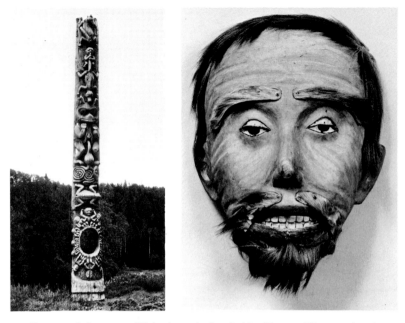

165 Totem pole known as 'Hole-through-the-sky' by Haesem-hliyawn, showing (from the top) migrating wolf taking away Ligi-ralwil, grizzly bear split open, his entrails bitten by the wolf, and hole surrounded by twelve human figures. Tsimshian, Kitwancool, c. 1870.

166 Wooden portrait mask with fur trimmings. Haida, c. 1880.

Kwakiutl monumental sculpture often combines the Haida regard for integration with the use of strongly sculptured figures heightened by the frequent addition of projecting features, such as arms, wings, or beaks.

Some totem-pole-like carvings were being made at the time of the first European contact, but the great efflorescence of this art occurred during the nineteenth century. It was caused by the increasing availability of metal tools and the growing wealth of the tribes, which led to a competitive consciousness of prestige. Totem-pole carving appears to be another late northern Northwest-Coast development that spread south but did not much affect the tribes beyond the Kwakiutl. On the southern part of the Northwest Coast, carved interior house posts, one of the traditional forms of monumental carving, show little influence of the northern formline system and totem-pole carving style.

All along the Northwest Coast, wooden masks were used in curing ceremonies and in the mid-winter performance of dramatized myths and legends. Representing a great number of individual human beings, humanoid and animal spirits, many distinct types of face had to be carved.

166    They range in character from highly realistic portrait-like representations to strongly stylized masks. Stylization is used here as a means of differentiating the characters in the ritual dramas. In terms of carving styles, portrait masks
85    show less tribal and local differentiation than stylized masks. It has been, however, largely in the field of realistic carving that individual and generally anonymous artists have been identified by recent research.

Because masks were carved from sections of split logs, the problem of organizing three-dimensional forms within the half-cylindrical shape of the raw material is the same as in totem-pole carving. Though it is not generally necessary to arrange figures along a vertical axis, the horizontal symmetry of masks places the weight of the composition on vertical relationships between forehead, brow, eyes, cheeks, mouth, and chin. The area around and including the eyes, and to a lesser extent the mouth, became the focal points of sculptural expression and of stylistic differentiation.

For heightened theatrical effect some masks were fitted with moveable or interchangeable parts. The most ingenious of these are the transformation masks (especially those of the Kwakiutl), in which one face is enclosed by another, consisting of two or more hinged parts. By operating strings attached to the outer face, the moveable parts open up to reveal the second face.

24    Related to masks in terms of composition are frontal headdresses and carved wooden helmets, both representing emblems owned by their wearer.
167    Of the many other types of Northwest-Coast carving, bowls and rattles may be mentioned briefly. Both are sculptured in the round rather than on one side only, and both show the same Northwest-Coast sculptural trends towards either naturalism or conventionalization. The latter is characterized by a combination of two- and three-dimensional features; prominent
168    elements are sculptured and protrude from surfaces decorated around a formline according to the principles of the northern Northwest-Coast graphic style.

The development of Northwest-Coast wood carving during the
169    nineteenth century led to a golden age of the art between about 1860 and 1890. It is from this period that several artists can be identified by both name and style. But as soon as the disadvantages of White influence (such as the prohibition of potlatching and the breakdown of traditional economy and social order) began to outweigh its benefits for the tribal societies, the output of wooden sculpture dropped sharply in quantity and quality. Among some groups (such as the Haida) the tradition became virtually extinct, but it survived among others (such as the southern Kwakiutl). A recent reawakening of the interest in the old traditions among both Indians and Whites has led to a triumphant revival of wood carving.

174

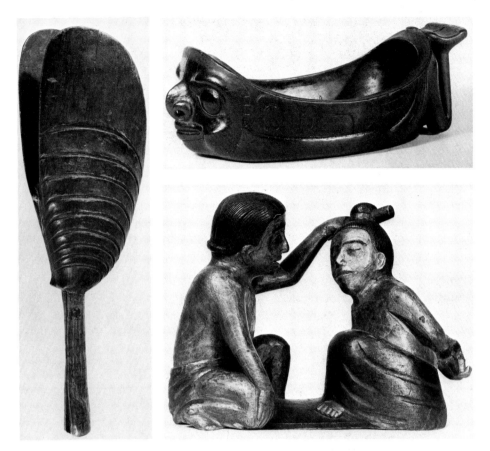

167 Wooden rattle in the shape of a mytilus shell. Tlingit, Sitka, collected by
J.G. Swan before 1873.

168 Wooden ceremonial grease dish. Haida, collected by Captain Dixon in 1787.

169 Scenic wooden sculpture showing a man torturing a witch. Tlingit, c. 1890.

*Eskimo wood carving*

The scarcity of wood in the North prevented wood carving from becoming
an important art among the North Alaskan and Canadian Eskimo. But both
in Greenland and on the shores of the Bering Sea and of the Pacific Ocean
enough driftwood was available to be used for carving. A number of truly
sculptured items were made, besides plain utilitarian objects such as snow
goggles, visors, or spear throwers.

A few of these, like the intricately carved boxes and bowls of the lower
Kuskokwim and Yukon River area, may perhaps be regarded as largely non-

*170*

175

religious art. Masks, which make up the majority of Eskimo and Aleut sculpture, however, are predominantly associated with ceremonialism. Based on a shaman's vision and carved either by himself or by another man according to his instructions, Eskimo masks represent the spirits of animals, deities, or natural phenomena, who appear in this visible form during dance ceremonies, to be honoured, fêted, or exorcised. Carved human and animal faces are developed through distortion, combination, or the attachment of animal or human body parts, producing amazing images of beings obviously not of this world.

Although these masks are deeply rooted in Eskimo beliefs, they apparently do not represent an old carving tradition. Almost no masks have been recovered from prehistoric sites, which contain an abundance of other wooden objects. A possible explanation may be sought in the historic Eskimo custom of destroying these masks after use; but this custom was not rigidly observed. It may be, therefore, that European contact was once more indirectly responsible for the development of a new native art form. Improved carving tools, and new forms of ceremonialism as a result of intensified contacts between villages due to improved means of transportation, have been identified as possible contributing factors in the rise of Eskimo mask making.

This does not necessarily mean that the whole carving style was new. Mask-like faces in other materials have a wide distribution across the North, and even wooden masks may be somewhat older than first European contact (early nineteenth century) among the Pacific coast Eskimo and Aleut. The basic sculptural rendering of human and animal faces is simple and stylized, although individual masks can be either realistic, abstract, or surrealistic. These three styles evolved independently, but especially within Alaska some types of mask seem to have been borrowed from other Eskimo groups during the nineteenth century.

One major centre of Eskimo mask making was the Bering Sea region where the greatest variety of types is encountered. These include half-masks showing only one side of the face; abstract masks barely recognizable as faces; transformation masks of simpler construction than those of the Kwakiutl; miniature finger masks used by the women; and the most portrait-like of all Arctic masks. The hallmark of this area, however, is the style of the grossly *171, 157*   distorted 'surrealistic masks' which attest to the extraordinary visual fantasy

170 Carved wooden tool box. Kwikpagmiut, South Alaskan Eskimo, collected by Captain A. Jacobsen in 1882.

171 Painted wooden mask with blood or paint markings around the mouth. Pastolik, South Alaskan Eskimo, collected by E. W. Nelson in 1877–81.

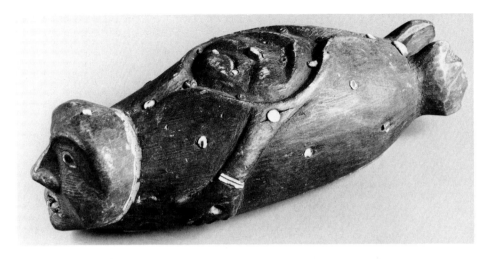

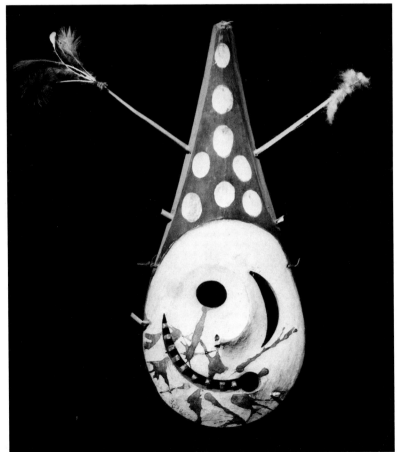

172 Wooden burial mask. Aleut, 19th century. Unlike most other examples found in burial caves, the original surface of this mask is well preserved.

173 Wooden mask representing a woman. By Inuk Elio, Ammassalik, East Greenland Eskimo, 1934.

of their makers. Polychrome painting (black, red, white, and blue) and asymmetrical compositions are frequent in this type and are occasionally found in other masks of the same area. Bering Sea styles were copied by some neighbouring groups such as the Ingalik.

Symmetry and strong conventionalization, on the other hand, are typical of the Pacific coast masks, which may conceivably be related to the old Northwest-Coast style, but show no trace of influence from classic Tlingit carving. On the Aleutian Islands, fierce-looking mortuary masks, with bulging noses, wide mouths, and incised designs, are quite unlike most Eskimo masks. Aleut dance masks, on the other hand, resemble those of the Bering Sea area. In the north, Point Hope was another centre of mask making. As on the Pacific coast, simpler types of carving predominate.

Of great interest are the wooden masks made by the East Greenland Eskimo. Far removed from other masking traditions, it must be assumed

*172*

that these constitute an independent development. They are distinguished by a stronger sculptural quality than can be found in most other Eskimo masks, *173* but they resemble the Bering Sea style in their predilection for distortion and asymmetry.

*Wood carving of the East*

Most of Eastern North America (excluding the almost treeless Plains) would appear to be an ideal place for the development of wood carving. Wood is easily available everywhere, and the sedentary inclinations of the corn-growing tribes of the Southeast and Northeast should also have furthered this art. And yet surprisingly few examples of wood carving from the East are found today in collections, and even fewer are being made as part of living traditions. There are two major reasons for this. Several centuries of intensive colonial experience have caused large-scale acculturation and disintegration of tribal societies, destroying many of the specific traditional contexts in which wood carving played a role. Also, a humid climate and acid soils have not helped to preserve wooden objects in prehistoric sites. If we did not know better from early accounts, we might easily underestimate the importance of three-dimensional art in wood in the prehistoric and early historic East.

This is especially true of monumental carving, for which the evidence is almost exclusively limited to literary sources. Some interior house posts with humanoid faces, carved by the Delaware in their Oklahoma exile, are about the only surviving traditional pieces of this kind. Carvers from other tribes such as the Abnaki or Ojibwa have in recent decades turned to the production of 'totem poles' in a style clearly imitative of Northwest-Coast art but incorporating to some extent older local features. (It is interesting that one major modern artist working in a fully traditional Northwest-Coast style, Lelooska, is a Cherokee.)

What has survived, both archaeologically (mostly in the Southeast) and ethnographically (mostly in the Northeast), is smaller sculpture of three kinds: masks, figurines, and a variety of three-dimensionally embellished objects.

The last group embraces a wide range of items: handles of crooked knives (the most important instrument used by carvers in post-European times), heddles for loom weaving, ladles, bowls, speaker's staffs, and clubs. Many of *174* these exhibit more or less stylized carvings of humans or animals. Some of the finest works of this class to be found are ball-headed clubs, several of *4* which date from the seventeenth century. The globular striking end is occasionally interpreted as a human or animal head; otters and kindred animals are seen standing on the crest (the small part of the handle nearest the

174 Upper part of hickory staff with carved head of Sir Wilfred Laurier. Mohawk (Iroquois), *c.* 1900.

175 Wooden male effigy doll with glass-bead eyes. Saulteaux (Northern Ojibwa), *c.* 1880.

striking end), or the ball may be held in the mouth of some beast or be grasped by claws emerging from the handle. (A variant of the last type also occurs on the Northwest Coast.)

Many of these carvings may well have served magico-religious purposes; one category of objects that certainly did so are the wooden figurines that originated mainly among the Algonquian tribes of the Great Lakes region. They were carved by ritual specialists to be used in magic, and represent a limited number of standardized types. Human puppet-like images are far more frequent than owls and other animals.

*175*

Undoubtedly the highest achievement in historic Eastern wood carving is to be found in the masks of the Iroquois, which were first reported in 1687, although except for a few late eighteenth-century pieces most extant

examples date from the nineteenth and twentieth centuries. These 'False-faces' were used in traditional Iroquois religion in curing ceremonies by members of a medical fraternity and portray first of all the Great Doctor, dwelling at the world's rim, whose broken nose and twisted mouth derive from a mythical struggle with the Creator for control of the world; then there are the forest-dwelling 'Common-faces' seen in dreams; and finally a countless multitude of beggar masks which caricature neighbours and strangers alike. Characteristics of all these masks include distorted features, *176* deep-set eyes with metal eye-plates, long hair made of horse tails, and generally red and/or black facial paint. Most are life-size, but miniatures occur and are used as protective amulets. Twelve general types may be distinguished (seven of them differentiated by the form of the mouth, the most variable feature), but the outstanding quality of the masks is their individuality. Inasmuch as they strive to represent a different reality, they are realistic and even naturalistic. Most masks are derived from human faces, but some show pigs, which are thought to have replaced bears in ceremonialism and masking.

176 False face mask. Seneca (Iroquois), New York, *c.* 1900, collected by J. P. Harrington.

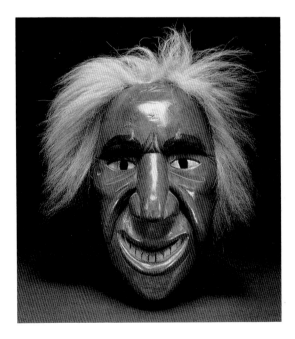

177 *Meezing* mask representing a supernatural being. Munsee Delaware, Ontario, early 19th century.

178 Painted wooden mask recovered by F. H. Cushing from Key Marco, Florida, in 1896. Calusa culture, 1400–1500.

In terms of style, local variations appear to be more obvious than variations between the tribes. Personal carving styles, a salient feature of the modern Western concept of art, could develop because of the wide range of permissible variation from the major types. Some degree of specialization in mask carving (certainly increased by the demand from White collectors) has been a contributing factor.

 There is less variation in Delaware masks, largely because a smaller number of them survived. Sharing some common stylistic ground with *177* Iroquois carving, they tend to be simpler and lack the False-faces' dynamic quality. In terms of individuality, the crudely realistic Cherokee masks are more like their Iroquois counterparts. The class of Booger masks in particular ridicules strangers – Indians, Whites and Negroes – who do not behave like decent human beings and are consequently characterized by exaggerated and grotesque facial expressions. Besides these secular masks, there are others used for magico-religious purposes.

*178* A group of Calusa masks and figurines recovered archaeologically on the Florida Keys affords us a glimpse of one of the many Eastern carving

182

traditions which were relegated to oblivion by the European conquest of America. Their technical excellence as well as their polychrome painted decoration, unparalleled elsewhere in the East, are especially noteworthy features.

No three-dimensional wood carving is known from the Plains, with one remarkable exception: a group of horse effigy sticks. Ranging from stylized to realistic and resembling hobby-horses, they were made to honour brave animals wounded in combat. The type is the result of a late and local development, but the carving tradition itself reflects the Woodland heritage of most Plains tribes.

*Wood carving of the Southwest*

In the arid Southwest, wood carving has traditionally been of minor importance; and from California and the Great Basin virtually none is known. In Pueblo territory, however, there has been a huge growth in output, associated with a rising trade demand over the last hundred years for one particular native form of sculpture: kachina dolls. Kachinas are supernatural beings who are embodied by masked dancers. Their likenesses are carved in cottonwood or pine by the men, and distributed to the women and/or children. The purpose of these dolls is sometimes related to beliefs about fertility, and sometimes to the education of the children who have to learn to distinguish the vast number of kachinas, each of which looks different and serves a different function in the spirit world.

The exact age of kachina-doll carving cannot be firmly established. None was collected before the 1850s and none is recognizably described in older Spanish reports. A single prehistoric figurine, found outside the historic Pueblo region and dating from the fourteenth century, resembles some of the simpler modern forms but cannot be confidently regarded as their precursor. The simplest forms, however, are found in the western Hopi and Zuni pueblos, as well as in the Rio Grande pueblos to the east, and this may indicate that they have a common heritage, and therefore an origin well before the nineteenth century. They are either flat boards or small cylinders, only superficially carved, but usually painted and adorned with other materials. Apparently the major form in the Rio Grande, they survive as cradle dolls for infants in the western pueblos.

True wooden figurines, as opposed to flat boards or cylinders, are best known from the Hopi and Zuni. (Non-Pueblo tribes like the Apache and Navajo have only recently started to carve dolls showing their own masked dancers.) Older Hopi examples tend to be static with only slight modelling *179* of the body, and formless legs and arms carved in low relief. Modern Hopi kachina dolls are far more naturalistic. Some 'action dolls' even represent the

179 Kachina doll representing Pö-ökang-hoya, one of the twin war gods, painted wood and horsehair. Hopi, *c.* 1915.

movement of the dancers. In the same styles, other carvings were produced by the Hopi. These include non-kachina dancers, such as ceremonial clowns, as well as secular figurines. Polychrome painting is a universal feature.

Zuni kachina dolls are less common, because commercial production was never extensive. On average they are more slender than the Hopi kachina *158* dolls, have separately carved and moveable arms, and are less elaborately painted because they are often dressed in miniature leather or cloth garments. In terms of carving style they have nothing in common with the other traditional form of Zuni wooden sculpture, the monumental stylized figures of the twin war gods. These resemble carvings of the Columbia River region rather than anything in the Southwest.

*Ivory, bone, and horn sculpture*

Walrus ivory and bone lend themselves primarily to small sculpture. Because they stand a better chance of preservation than wood, we are comparatively well informed about their development, and particularly that of walrus ivory carving in the North.

Early Eskimo ivory carving has a strong sculptural quality. This is particularly true of Dorset Eskimo miniature masks and figurines, which employ little or no engraving for surface texture. Engraving is found on Okvik sculpture of the early Northern Maritime tradition, but it is subordinate to a fairly realistic carving style, which produced a group of human figures with long oval faces whose expression ranges from stylized to animated.

Some spontaneity is lost in subsequent Old Bering Sea ivory sculpture, whose well-planned integration of engraved lines and sculptured forms leads to a point where purely two-dimensional design is transformed into sculpture. In contemporary Ipiutak style a similar curvilinearity is found in the carving of figures of mythological animals, and in openwork carving, *180* and seems to be related to the Scytho-Siberian animal style rather than to local art forms. Spectacular composite ivory human face masks are also more reminiscent of Asiatic models than of indigenous types.

Most early historic Eskimo ivory sculpture is simply but effectively carved by comparison with prehistoric examples. Engraving is rare, and animal figures tend to be more lively than human ones. Small images carved in relief or in the round appear on many utilitarian objects made during the nineteenth century. Early tourist attention was focused on engraved art, but since the early twentieth century, carving has come to occupy an important role in Eskimo ethnic art. Eskimo ingenuity is manifested in the use of all kinds of materials: porous whalebone masks and other carvings were made from about 1900 onwards, and erotic art carved from walrus penis bones has

become a favourite during recent decades. In Alaska, both style and subject matter were heavily influenced by Western tastes, and much the same can be said of West Greenland. East Greenland, however, remained isolated from European influences until late in the nineteenth century, and since the 1930s has produced a new type of ivory sculpture representing the bizarre and frightening spirits known as *tupilak*. Made today with power tools and from

*181*

180 Ivory burial mask. Ipiutak, Alaska, *c.* A D 300–600.

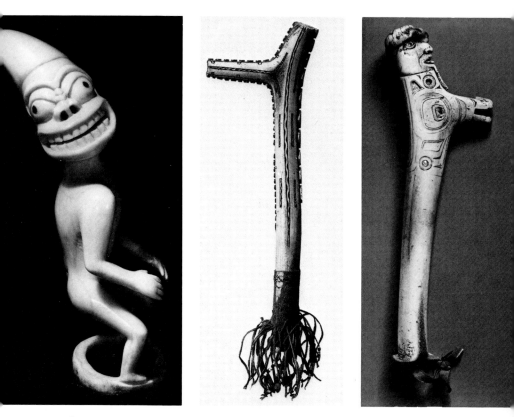

181 Walrus-ivory *tupilak* figure by David Nakinge. Ammassalik, East Greenland Eskimo, 1963.

182 Antler club with engraved decoration. Tanaina, *c.* 1840.

183 Ceremonial antler club with carved and engraved decoration and haliotis shell inlay. Tsimshian, collected by Captain A. Jacobsen in 1882.

imported ivory, they nevertheless constitute a fairly original and expressive variety of ethnic art.

On the northern Northwest Coast most bone or ivory carvings conform to the principles of the classic graphic style. The remodelling of traditional forms by means of this style is illustrated by the comparison between a simply carved and incised antler club, of a type used by the Athapaskan tribes *182* of the western Subarctic, and the sophisticated interpretation of the same *183* basic form in the hands of a Coastal carver.

A distinctive Northwestern technique – which has a parallel in the wooden boxes of the Northwest Coast – is the shaping of the horn of mountain sheep and mountain goat after heating it by steaming or boiling. *23*

184 Carved mountain goat horn spoon.
Tlingit, c. 1840.

185 Female pottery figurine.
Twenhofel site, Jackson
County, Illinois; Hopewell,
c. 100 BC–AD 400.

Bowls and spoons fashioned in this way may then be carved and/or incised. Horn bowls, like wooden bowls, combine carved major features with engraved connecting designs. Spoons may also be engraved, but carving *184* here is usually restricted to the handle, a second piece of horn riveted to the bowl. In terms of composition these handles are similar to totem poles (long vertical axis with horizontal divisions).

The Northwestern distribution of bone and horn sculpture extends to the Columbia River valley in the south, where carving generally conforms to *15* the Archaic style also found in stone sculpture, rock art, and basketry design. Outside this region, instances of true bone or horn sculpture are rare and isolated.

*Clay sculpture*

All native American potters, since the time of the earliest Southeastern pottery in the late third millennium BC, have created sculptural form. The potter's wheel was unknown, and differences in handling problems of proportion and outline play a significant role in defining all prehistoric and historic pottery types. Discussion here will, however, be limited to clay figurines and effigy vessels.

The earliest North American clay figurines appear in the lower Mississippi valley, during the first millennium BC, in an otherwise Archaic context. Their generally crude nature makes it unlikely that they can be regarded as the immediate ancestors of Hopewell ceramic sculpture. The latter includes a fairly large number of clay figurines (many of them fragments) from various Hopewell sites in the Northeast and Southeast, but mainly from Illinois, Ohio, and Michigan. In spite of obvious differences in the quality of execution as well as evidence for localized styles, all Hopewell figurines share *185* strong realistic tendencies. Both males and females are shown either seated or standing (with bent knees reminiscent of the sole example of Adena stone sculpture, of Olmec figures from Mexico, and of most types of wooden figurines in native North America). Considerable attention is devoted to details of dress, ornament, and hairstyle both in sculpture and painted decoration. Few clay figurines are reported from subsequent periods, and it is likely that the tradition was limited to the sphere of Hopewell influence.

Early pottery figurines in the Southwest resemble the crude clay sculptures from the lower Mississippi region, but may not be related historically. Within the Southwest, two traditions can be distinguished whose relationship is not entirely clear. One is represented by fired clay figurines of Mogollon and Hohokam origin (known to have been made since about AD 300), the other by baked clay figurines of late Basketmaker date (AD 600–700) which continued to be made on the northern periphery of

the Southwest, particularly in the Fremont culture of Utah. All are stylized rather than realistic, with details added by incision, appliqué, or
*186*  painting, rather than truly sculptured. The flat Fremont figurines, which are the most elaborate and artistically interesting examples from the prehistoric
*84*  Southwest, must be compared with the contemporary rock paintings of the same culture (see p. 94). Both show the same broad-shouldered anthropomorphic figures, often legless and wearing complex necklaces.

Small human and animal figurines (the latter rare in prehistoric times) have been made by historic Pueblo tribes as well. Some are connected with increase cults and fertility beliefs, but most of those that have ended up in collections were made for the growing tourist market. This is especially true of a wide variety of animal figures, and of a seated 'Rain god', manufactured in huge numbers at Tesuque, but also known to other Rio Grande pueblos. Cochiti in particular has become a centre for painted clay figurines, based on an older tradition of effigy vessel forms.

For at least the last hundred years, the Yuma and Mohave have made the
*187*  liveliest clay figurines of the Southwest. Indifferently modelled, with oversized heads and prominent noses, these dolls derive much of their individuality and charm from extensive face and body paint and added mixed-media features and costume, including real hair, glass bead necklaces and earrings, and miniature dresses. Both males and females are shown standing, but in different postures. Their relationship with prehistoric figurines is not clear, but the poor modelling is similar to older figurine styles.

Effigy pottery vessels postdate clay figurines both in the East and Southwest. In the East, it is a uniquely Mississippian trait, although the earliest examples come from the Weeden Island sites in Florida, which are transitional between Hopewell and early Mississippian. This early southern occurrence may point to a Mexican origin of effigy pottery, but the stylistic similarities are at best remote. Most Mississippian effigy vessels show a narrow range of standardized images of humans and animals. Frogs, owls,
*188*  and hunchbacked women appear frequently and on the whole exhibit little of the fine sculptural quality seen in contemporary stone sculpture. In another form of pottery sculpture, small human and animal heads are attached to the rims of bowls. In late Mississippian times, effigy-head vessels of greater realism were made in a fairly small area around Arkansas.

Effigy pottery is found in all Southwestern traditions. Seated human figures dominate in Hohokam clay sculpture and reappear in a less static
*189*  form during the late, Mogollon-Anasazi inspired phase at Casas Grandes. Bird effigy vessels, although occurring outside the Southwest as well, were a favourite subject of Anasazi potters. Duck-shaped pots appear as early as the

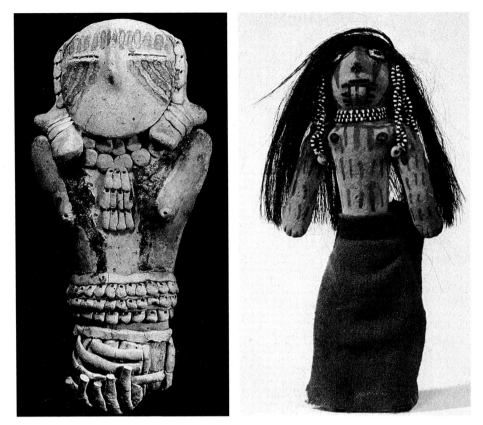

186 Female clay figurine, partly painted. Pillings Cave, Utah; Fremont, *c.* 950–1200.
187 Female clay figurine, partly painted, human hair, glass beads, trade cloth. Mohave,
*c.* 1890.

late Basketmaker period in northeastern Anasazi territory and may represent a local development. In time, crudely modelled birds became more graceful, and by the fourteenth century a considerable variety of easily identifiable birds and other animals was being manufactured in polychrome painted pottery. Some of these forms (for example, antelopes and owls) reappear in a strikingly similar way among the nineteenth-century Zuni, who modelled them as effigy vessels or clay figurines. The general trend during the twentieth century, both here and in Cochiti, has been away from effigy vessels and towards figurines.

188 Pottery effigy bottle. New
Madrid, Missouri; Mississippian,
c. 1200–1400.

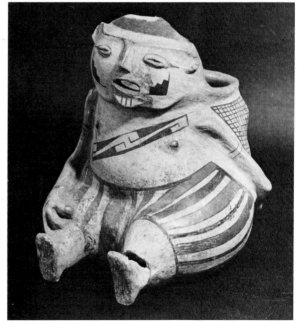

189 Effigy vessel. Casas Grandes,
Chihuahua, 1300–1500.

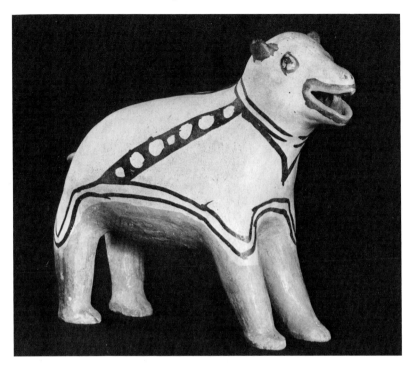

190 Mountain sheep effigy pottery sculpture. Cochiti, *c.* 1890.

### Other three-dimensional arts

In basketry, three-dimensional form is universal; but here the constraints of the technique are of far greater consequence than in carving or modelling, and basketry as a medium for true sculpture is therefore exceptional. There is, in fact, only one instance that can be regarded as traditional. One class of 191 supernatural beings, the agricultural Husk Faces, are represented by the Iroquois in masks woven from corn husks. Two techniques are used: sewing, of usually coiled husk braids, and twining. At first sight there appears to be little variety in these faces, which are always surrounded by husk streamers, but closer inspection reveals much individuality. Paint was only occasionally applied to these masks. Other examples of basketry sculpture are of recent origin and relate to the general trend of ethnic arts towards naturalistic representation. The coiled yucca or pine needle figurines depicting humans and animals among the Pagago and some Southeastern tribes, as well as the twined dolls of the Clallam, are typical in this respect.

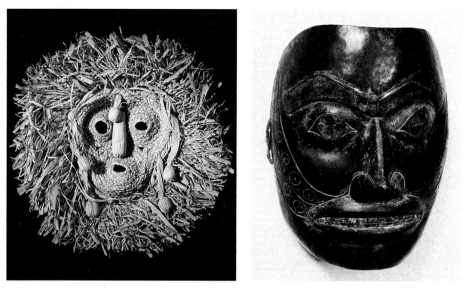

191 Corn husk mask, traces of red paint. Said to represent the male of a pair of masks. Iroquois, collected by Princess Therese of Bavaria in 1892.

192 Copper mask with shell inlay. Tlingit, *c*. 1850.

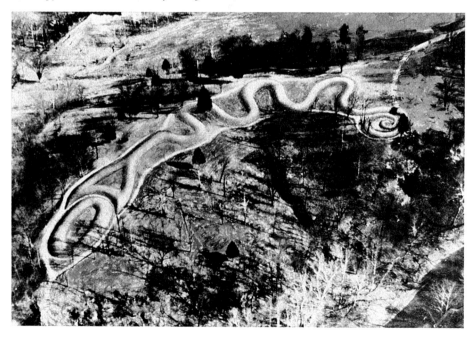

Copper, in its native form, was used as long as 5000 years ago in the Great Lakes area, but metallurgy remained basically lithic, with cold hammering, embossing, and annealing as the major techniques. Most work in copper therefore remained simple and two-dimensional. Only the Tlingit of the Northwest Coast, probably aided by European tools, produced copper *192* masks, daggers, and rattles in repoussé-work. All of these date from the nineteenth century and closely follow wood-carving styles. In Navajo silversmithing, soldering is employed to construct small three-dimensional forms (as in the well-known 'squash blossom' necklaces), although most casts retain a two-dimensional quality even when fashioned into bracelets.

The skin masks of Naskapi, Cherokee, Plains, Navajo, and Pueblo art can *3* likewise hardly be regarded as three-dimensional works. They are either flat or cylindrical, with eyes and mouth cut out and other features added primarily by painting. The modern Eskimo skin masks from Anaktuvuk are moulded over a wooden face form.

A unique medium of native American monumental art is a type of land art. The artificial earthworks constructed by the prehistoric inhabitants of eastern North America were mostly conical or truncated mounds, or else simple linear walls or 'enclosures'. Some, however, are shaped in the form of animals ranging from 50 to 500 feet (15 to 150 metres) in length, and up to 5 feet (1·5 metres) in height. These can be fully seen only from above, and thus were certainly not addressed to human spectators. The biggest of these effigy mounds, the Great Serpent Mound of Ohio, is found outside the centre *193* of their distribution. Hundreds of them, representing birds, bears, wolves, deer, water spirits, and humans, occur in Wisconsin, where the historic Winnebago explained their use as property marks of kinship groups. The question of their age and original purpose, however, is in dispute. A related type, also found in Wisconsin, consisted of intaglios (effigies furrowed out of the earth), with the soil heaped up along the edges to reinforce the shape. Few of these were ever found, and almost none has survived into the twentieth century.

Another form of land art consists of rock effigies, made by outlining figures with stones on a flat surface. Some are representational, like a 300-foot-long (90 metres) snake effigy in South Dakota, or two bird effigies in Georgia which date from early Hopewell times. Others found on the northern Plains are abstract and include spoked 'medicine wheels'. While the effigy mounds have a sculptural quality, both the intaglios and rock effigies point to the basically linear nature of native American land art.

193 Air view of the Great
Serpent Mound, Adams
County, Ohio. Probably
Hopewell, 100 BC–AD 500.

# Epilogue

The years since the first publication of this volume have seen a virtual explosion in the fields of native American art studies and appreciation. The enlarged and updated bibliography accompanying the new edition, which includes only a small fraction of the material published, conveys some sense of the growing scholarly and public interest in what used to be the domain of a small band of specialists.

The increasing attention paid to native American arts by art historians not only signals the endeavour to make their discipline a truly universal one, but also reflects the gradual discovery of and claim to their native heritage by the modern nation states of Canada and the USA. It illustrates the strength of the market forces that have converted yesterday's functional objects into today's prestige goods, which in turn has clearly created new advantages for native artists and craftspeople. However, despite the best efforts of the new body of critics, mediation through interpretation or attributions of meaning has not necessarily closed the cultural gap between the intentions of the makers and the perceptions of the buyers. Rather, it continues the process of transformation of native American arts described in Chapter three.

At the same time, what has happened illustrates Joseph Alsop's contention that the emergence of 'rare art traditions' is an incidental by-product of the functional decontextualization brought about by collecting. Five centuries ago many, though not all, of the native American 'tribal arts' as defined in Chapter one were the products of 'common art traditions'. Craft specialization often did not transcend the socially contracted division of labour by gender; producers and consumers of the created shapes were often identical or closely related by kinship; and a widespread unity of form, function and meaning prevailed. Likewise, visual shapes were not used and appreciated in isolation from language, music, movement, smell and taste. Visual art was no separate domain, because what in hindsight was called 'the luxury of form' pervaded the universe of handmade objects; and the same was true of religion. Meaning was ever-present.

When specialization did occur in native people's relationships to one another and to the supernatural, the production of visual forms was affected. The creation of paraphernalia, whose manufacture required superior knowledge of the non-human world and of the ritual necessities of dealing

with it, led to the emergence of separate 'ritual art traditions'. 'Craft art traditions', on the other hand, may be defined by the presence of a partial or general division of labour by occupational specialization, a concurrent rise of domestic and foreign markets, the origin of schools based on workshop situations, and the competitive production of quality items to serve the status needs of élites. Sometimes, as in the case of Plains Indian craftworkers' societies, a distinctive realm of sacred arts was defined; its knowledge had to be bought and was therefore considered valuable. The non-sacred arts, by contrast, were looked upon as less prestigious, irrespective of the amount of skill and time involved – a division and value judgment thus not based on aesthetic criteria in the Western sense. Despite the growing differentiation of the relative status of different crafts, there was still no disjunction of form and function, no collecting, no systematic reflection of past forms, no fakes, and no antiques. Moreover, even when 'ritual' or 'craft art traditions' were present, many artifacts were still produced in the manner of the 'common art traditions'.

The 'rare art tradition' in Renaissance Europe emerged at the time when Europe embarked upon its exploitation, domination and reinvention of the Americas, and it has obviously left its mark on the native arts of North America over the past 500 years. Form was alienated from function and meaning, and the holistic interconnectedness of visual forms was increasingly subverted. The universalist claim of Euro-American culture is apparent in its incorporation of native American (along with other non-European) visual forms into the canon of art history. It is this transformation of products from 'common', 'ritual' or 'craft' into 'rare art traditions' that necessitates the mediation and reinterpretation of meaning to serve today's needs.

The situation of the native arts in North America is more complex than ever before. Works of the past, produced under widely different conditions, have been preserved and reinterpreted through their integration into the Euro-American culture of collecting; some of them are now being reclaimed by the descendants of their makers as part of a heritage that, in the past, had generally not been transmitted by the decontextualized preservation of artifacts. Reconstruction of this original context – often a difficult and sometimes impossible task – rather than the invention of a new one, is an ongoing challenge for scholars. Works of the present day represent the results of an even wider range of frames of reference, defining the forms, functions and meanings of the finished products. Yet all are subsumed under the simple term 'native American art'.

# Bibliography

## General

American Indian Art Magazine, Scottsdale, 1975–; Peter Bolz and Bernd Peyer, Indianische Kunst Nordamerikas, Cologne, 1987; Ralph T. Coe, Sacred Circles: Two Thousand Years of North American Indian Art, London, 1976; idem, Lost and Found Traditions: Native American Art 1965–1985, Seattle, 1986; Richard Conn, Robes of White Shell and Sunrise, Denver, 1974; idem, Native American Art in the Denver Art Museum, Seattle and London, 1979; Frederick J. Dockstader, Indian Art in America, Greenwich, CT, 1961; idem, Indian Art of the Americas, New York, 1973; Frederic H. Douglas, Denver Art Museum, Department of Indian Art, Leaflets, 1–119, Denver, 1930–33; idem, Material Culture Notes, 1–22, Denver, 1937–53; Diana Fane et al., Objects of Myth and Memory, American Indian Art at The Brooklyn Museum, Brooklyn and Seattle, 1991; Norman Feder, American Indian Art, New York, 1971; idem, Two Hundred Years of North Amerian Indian Art, New York, 1971; Christian F. Feest, Indianer Nordamerikas, Vienna, 1968; Peter T. Furst and Jill L. Furst, North American Indian Art, New York, 1982; Winifred Glover, The Land of the Brave, Belfast, 1978; Erna Gunther, A Catalogue of the Ethnological Collection of the Sheldon Jackson Museum, Sitka, 1976; Wolfgang Haberland, Nordamerika, Kunst der Welt, Baden-Baden, 1965; Julia Harrison et al., The Spirit Sings, Artistic Traditions of Canada's First Peoples, Toronto and Calgary, 1987; Barbara Isaac (ed.), Hall of the North American Indian, Peabody Museum, Harvard University, Cambridge, MA, 1990; Walter Krickeberg, 'Das Kunstgewerbe der Eskimo und nordamerikanischen Indianer', in: H. Th. Bossert, Geschichte des Kunstgewerbes, 2:155–244, Berlin, 1929; Lowe Art Museum, The North American Indian Collection, Coral Gables, 1988; Evan M. Maurer, The Native American Heritage, A Survey of North American Indian Art, Chicago, 1977; Zena Pearlstone Mathews and Aldona Jonaitis (eds), Native North American Art History, Selected Readings, Palo Alto, 1982; Rennard Strickland, Native American Art at Philbrook, Tulsa, OK, 1980; Judy Thompson, The North American Indian Collection: A Catalogue, Bern, 1977; Gisela Völger, Indianer Nordamerikas, Zirkumpolare Völker, Offenbach, 1976; Edwin L. Wade (ed.), The Arts of the North American Indian, New York, 1986; Edwin L. Wade et al., As In A Vision, Masterworks of American Indian Art, Norman, OK, 1983; Walker Art Center, American Indian Art: Form and Tradition, Minneapolis,

1972; Andrew Hunter Whiteford, North American Indian Arts, New York, 1970; Robin K. Wright (ed.), A Time of Gathering, Native Heritage in Washington State, Seattle and London, 1991.

## 1  From 'artificial curiosities' to art (pp. 9–19)

SEVENTEENTH- AND EIGHTEENTH-CENTURY COLLECTIONS: Oliver Impey and Arthur MacGregor (eds), The Origins of Museums, Oxford, 1985; Arthur MacGregor (ed.), Tradescant's Rarities, Oxford, 1983; Torben Lundbæk and Bente Dam-Mikkelsen (eds), Ethnographical Objects in the Royal Danish Kunstkammer 1650–1800; H.J. Braunholtz, Sir Hans Sloane and Ethnography, London, 1970; Bibliothèque Sainte-Geneviève, Le Cabinet de Curiosités, Paris, 1989; Adrienne L. Kaeppler, 'Artificial Curiosities', being An Exposition of Native Manufactures Collected on the Three Pacific Voyages of Captain James Cook, R. N., Honolulu, 1978; J. C. H. King, Artificial Curiosities from the Northwest Coast of North America, London, 1981.
ETHNIC ART: N. H. H. Graburn (ed.), Ethnic and Tourist Arts: Cultural Expressions from the Fourth World, Berkeley and Los Angeles, 1976; June Bedford et al., Mohawk Micmac Maliseet . . . and other Indian Souvenir Art from Victorian Canada, London, 1985; Trudy Nicks, The Creative Tradition: Indian Handicrafts and Tourist Art, Edmonton, 1982; Ruth B. Phillips, 'Souvenirs from North America: The Miniature as Image of Woodlands Indian Life', American Indian Art Magazine, 14, no. 2: 52–63, 78–9, 1989.
THE RECOGNITION OF INDIAN ARTIFACTS AS ART: John Sloan and Oliver LaFarge et al., Introduction to American Indian Art, 2 vols., New York, 1931 (reprinted: Glorieta, NM, 1970); F. H. Douglas and R. d'Harnoncourt, Indian Art of the United States, New York, 1941 (reprinted: New York, 1969); Christian F. Feest, '[The Arrival of Tribal Objects in the West] From North America', in: William Rubin (ed.), 'Primitivism' in 20th Century Art, 1: 85–97, New York, 1984.
MODERN INDIAN ART: Fritz Scholder, 'Native Arts in America', in: Rupert Costo et al., Indian Voices: The First Convocation of American Indian Scholars, pp. 191–218, San Francisco, 1970; Jane B. Katz (ed.), This Song Remembers, Self Portraits of Native American Artists in

the Arts, Boston, 1980; Gerald McMaster, 'How the West was Lost, An Artist's Perspective', *European Review of Native American Studies*, 5, no. 2: 15–18, 1991. NATIVE CRITERIA: Lila M. O'Neale, 'Yurok-Karok Basket Weavers', *University of California Publications in American Archaeolgy and Ethnology*, 32: 1–58, 1932.

## 2 The makers (pp. 20–32)

GENERAL: George Peter Murdock and Timothy J. O'Leary, *Ethnographic Bibliography of North America*, 4th edn, 5 vols., New Haven, 1975 (Supplement: 2 vols., New Haven, 1990); Francis Paul Prucha, *A Bibliographical Guide to the History of Indian-White Relations in the United States*, Chicago, 1977 (Supplement: Chicago, 1983).
THE ARCHAEOLOGY, ETHNOLOGY, AND HISTORY OF NATIVE AMERICAN TRIBES: Harold E. Driver, *Indians of North America*, 2nd edn, Chicago, 1969; Richard Collins (ed.), *The Native Americans*, London 1991; Brian M. Fagan, *Ancient North America*, London and New York, 1991; Alvin M. Josephy (ed.), *America in 1492*, New York, 1992; Gordon R. Willey, *An Introduction to American Archaeology, I: North and Middle America*, Englewood Cliffs, 1966; William C. Sturtevant (ed.), *Handbook of North American Indians*, 20 vols., Washington, 1978–.

THE NORTH (pp 20–22)
*Inuit Art Quarterly*, 1986–; Hans-Georg Bandi, *Die Kunst der Eskimos auf der St-Lorenz-Insel in Alaska*, Orbis Pictus 65, Bern, 1977; Lydia T. Black, *Aleut Art*, Anchorage, 1982; Jean Blodgett, *The Coming and the Going of the Shaman: Eskimo Shamanism and Art*, Winnipeg, 1978; idem, *Grasp Tight the Old Ways, Selections from the Klamer Family Collection of Inuit Art*, Toronto, 1983; Don E. Dumond, *The Eskimos and Aleuts*, London, 1978; William W. Fitzhugh and Susan A. Kaplan, *Inua, Spirit World of the Bering Sea Eskimo*, Washington, 1982; William W. Fitzhugh and Aron Crowell (eds), *Crossroads of Continents, Cultures of Siberia and Alaska*, Washington, 1988; Grønlands Landsmuseum, *Gustav Holm Samlingen*, Nuuk, 1985; Hans Himmelheber, *Eskimokünstler*, 2nd edn, Kassel, 1953; Susan A. Kaplan and Kristin J. Barsness, *Raven's Journey, The World of Alaska's Native People*, Philadelphia, 1986; Shepard Krech III, *A Victorian Earl in the Arctic*, London, 1989; National Gallery of Art, *The Far North: 2000 Years of American Eskimo and Indian Art*, Washington, 1973; Bodil Kaalund, *The Art of Greenland*, Berkeley, 1983; Barbara Lipton, *Survival: Life and Art of the Alaskan Eskimo*, Newark, 1978; Dorothy Jean Ray, *Eskimo Art: Tradition and Innovation in North Alaska*, Seattle, 1987; idem, *Aleut and Eskimo Art: Tradition and Innovation in South Alaska*,

Seattle and London, 1981; Jean-Loup Rousselot, *Kanuitpit? Alaska Canada. Due aspetti delle culture eschimesi dell'Artico*, Lugano, 1992; Jens Erik Sørensen, *Natur og magi, Grønlandsk kunst*, Aarhus, 1987.

THE EAST (pp. 22–26)
Helga Benndorf and Arthur Speyer, *Indianer Nordamerikas 1760–1860*, Offenbach, 1968; Ted J. Brasser, *Bo'jou Neejee: Profiles of Canadian Indian Art*, Ottawa, 1968; David S. Brose, James A. Brown and David W. Penney, *Ancient Art of the American Woodland Indians*, New York, 1985; Norman Feder, 'American Indian Art Before 1850', *Denver Art Museum Quarterly*, Summer 1965; Walter Krickeberg, 'Ältere Ethnographica aus Nordamerika im Berliner Museum für Völkerkunde', *Baessler-Archiv*, N.F. 2, 1954.
THE SOUTHEAST: David M. Blackard, *Patchwork & Palmettos, Seminole-Miccosukee Folk Art Since 1920*, Fort Lauderdale, 1990; Roy S. Dickens, *Of Sky and Earth: Art of the Early Southeastern Indians*, Atlanta, 1982; Patricia Galloway (ed.), *The Southeastern Ceremonial Complex, Artifacts and Analysis*, Lincoln and London, 1989.
THE NORTHEAST: Louis B. Casagrande and Melissa M. Ringheim, *Straight Tongue, Minnesota Indian Art from the Bishop Whipple Collection*, St Paul, 1980; Christian F. Feest, 'Some 18th-Century Specimens from Eastern North America in Collections in the German Democratic Republic', *Jahrbuch des Museums für Völkerkunde zu Leipzig*, 37: 281–301, 1977; Flint Institute of Arts, *Art of the Great Lakes Indians*, Flint, 1973; J. C. H. King, *Thunderbird and Lightning, Indian Life in Northeastern North America 1600–1900*, London, 1982; Carrie A. Lyford, *Iroquois Crafts*, Lawrence, 1945; idem, *Ojibwa Crafts*, 2nd edn, Lawrence, 1953; David W. Penney (ed.), *Great Lakes Indian Art*, 2nd edn, Detroit, 1989; Ruth Phillips, *Patterns of Power, The Jasper Grant Collection and Great Lakes Indian Art of the Early Nineteenth Century*, Kleinburg, 1984; Alanson Skinner, *Material Culture of the Menomini*, Indian Notes and Monographs, Miscellaneous Series 20, 1921; Frank G. Speck, *The Double-curve Motif in Northeastern Algonkian Art*, National Musem of Canada, Memoir 42, 1914; Gaylord Torrence and Robert Hobbs, *Art of the Red Earth People, The Mesquakie of Iowa*, Des Moines, 1989; Leonardo Vigorelli, *Gli ogetti indiani raccolti da G. Costantino Beltrami*, Bergamo, 1987; Ruth Holmes Whitehead, *Elitekey, Micmac Material Culture from 1600 AD to the Present*, Halifax, 1980.
THE PLAINS: Richard Conn, *Circles of the World*, Denver, 1982; John C. Ewers, *Blackfeet Crafts*, Lawrence, 1945; Norman Feder, *Art of the Eastern Plains Indians*, Brooklyn, 1964; Carolyn Gilman and Mary Jane Schneider, *The Way to Independence, Memories of a Hidatsa Indian Family, 1840–1920*, St Paul, 1987; Barbara A. Hail, *Hau, Kóla: The Plains Indian Collection of the Haffenreffer Museum of Anthro-*

*pology*, Providence, RI, 1980; Horst Hartmann, *Die Plains- und Prärieindianer Nordamerikas*, Berlin, 1973; Alfred L. Kroeber, 'The Arapaho, II: Decorative Art and Symbolism', *Bulletin of the American Museum of Natural History*, 18: 36–150, 1902; F. Dennis Lessard (ed.), *Crow Indian Art*, Mission, SD, 1984; Robert H. Lowie, 'Crow Indian Art', *American Museum of Natural History, Anthropological Papers*, 21, no. 4, 1922; Glenn E. Markoe (ed.), *Vestiges of a Proud Nation*, Burlington, VT, 1986; Audrey Porsche, *Yuto'keca: Transitions, The Burdick Collection*, Bismarck, 1987; Axel Schulze-Thulin, *Indianer der Prärien und Plains*, 2nd edn, Stuttgart, 1987; Ann T. Walton, *After the Buffalo Were Gone*, St Paul, 1985; Clark Wissler, 'Decorative Art of the Sioux Indians', *Bulletin of the American Museum of Natural History*, 18: 231–77, 1904.
THE SUBARCTIC: A. McFayden Clark, *The Athapaskans: Strangers of the North*, Ottawa, 1974; Fitzhugh and Crowell, *Crossroads of Continents*; Barbara Hail and Kate Duncan, *Out of the North: The Subarctic Collection of the Haffenreffer Museum of Anthropology*, Brown University, Bristol, 1989; Kaplan and Barsness, *Raven's Journey*; National Gallery of Art, *The Far North*.

THE NORTHWEST (pp. 26–28)
Leonhard Adam, *Nordwestamerikanische Indianerkunst*, Orbis Pictus 17, Berlin, 1927; Roy L. Carlson, *Indian Art Traditions of the Northwest Coast*, Burnaby, B.C., n.d.; Barbara DeMott, *Beyond the Revival, Contemporary North West Native Art*, Vancouver, 1989; Wilson Duff, Bill Holm and Bill Reid, *Arts of the Raven*, Vancouver, 1967; Norman Feder and E. Malin, *Indian Art of the Northwest Coast*, Denver, 1962; Fitzhugh and Crowell, *Crossroads of Continents*; Erna Gunther, *Art in the Life of the Northwest Coast Indians*, Portland, 1966; Wolfgang Haberland, *Donnervogel und Raubwal, Indianische Kunst der Nordwestküste Nordamerikas*, Hamburg, 1979; Audrey Hawthorn, *Kwakiutl Art*, Seattle and London, 1979; Bill Holm, *The Crooked Beak of Heaven*, Seattle, 1972; *idem*, *Spirit and Ancestor*, Seattle, 1987; Bill Holm and Bill Reid, *Indian Art of the Northwest Coast*, Vancouver, n.d.; Robert Bruce Inverarity, *Art of the Northwest Coast Indians*, Berkeley and Los Angeles, 1950; Aldona Jonaitis, *Art of the Northern Tlingit*, Seattle, 1986; *idem*, *From the Land of the Totem Poles*, New York and Seattle, 1988; *idem*, *Chiefly Feasts: The Enduring Kwakiutl Potlatch*, New York, Seattle and London, 1991; Kaplan and Barsness, *Raven's Journey*; Ruth Kirk with Richard D. Daugherty, *Exploring Washington Archaeology*, Seattle and London, 1978; Claude Lévi-Strauss, *La Voie des masques*, Geneva, 1975; National Gallery of Art, *The Far North*; Peter Macnair, *The Legacy: Continuing Traditions of Canadian Northwest Coast Indian Art*, Victoria, 1980; Araceli Sánchez Garrido, *Indios de América del Norte*,

Madrid, 1991; Pirjo Varjola, *The Etholén Collection*, Helsinki, 1990; Allen Wardwell, *Objects of Bright Pride*, New York, 1979.

THE SOUTHWEST (pp. 28–32)
Linda S. Cordell, *Prehistory of the Southwest*, Orlando, 1984; Alan Ferg (ed.), *Western Apache Material Culture*, Tucson, 1987; Don D. Fowler and John F. Matley, *Material Culture of the Numa, The John Wesley Powell Collection 1867–1880*, Smithsonian Contributions to Anthropology, 26, 1979; Evelyn Payne Hatcher, *Visual Metaphors: A Formal Analysis of Navajo Art*, American Ethnological Society, Monograph 48, 1974; Travis Hudson and Thomas C. Blackburn, *The Material Culture of the Chumash Interaction Sphere*, 5 vols., Ballena Press Anthropological Papers, 25, 27, 28, 30, 31, 1979–87; Clyde Kluckhohn, W. W. Hill and Lucy Wales Kluckhohn, *Navajo Material Culture*, Cambridge, MA, 1971; George Mills, *Navajo Art and Culture*, Colorado Springs, 1959; Clara Lee Tanner, *Prehistoric Southwestern Craft Arts*, Tucson, 1976; *idem*, *Southwest Indian Craft Arts*, Tucson, 1968; Ruth Underhill, *Pueblo Crafts*, Washington, 1959; Barton C. Wright, *Hopi Material Culture*, Flagstaff, 1979.

## 3 Native traditions and the European impact (pp. 33–47)

THE DIVISION OF LABOUR BY GENDER: Marsha C. Bol, 'Lakota Women's Artistic Strategies in Support of the Social System', *American Indian Culture and Research Journal*, 9, no. 1: 33–51, 1984; Marvin Cohodas and Barbara de Mott, 'Women's Arts of North America', *Phoebus*, 4: 99–105, 1985; George Peter Murdock and Catherine Provost, 'Factors in the Division of Labor by Sex: A Cross-Cultural Analysis', *Ethnology*, 12: 203–25, 1973; Mary Jane Schneider, 'Women's Work: An Examination of Women's Roles in Plains Indian Arts and Crafts', in: P. Albers and B. Medicine (eds), *The Hidden Half: Studies of Plains Indians Arts and Crafts*, 101–121, Lanham, 1983.
THE USE OF COLOUR IN THE EAST: Frederic H. Douglas, *Red-Dark-Light in Designs*, Denver Art Museum Leaflet 114, 1951.
TRANS-PACIFIC CONTACT: Mino Badner, 'The Protruding Tongue and Related Motifs in the Art Styles of the American Northwest Coast, New Zealand and China', *Wiener Beiträge zur Kulturgeschichte und Linguistik*, 15: 5–44, 1966; Columbia University, *Early Chinese Art and the Pacific Basin*, New York, 1968.

## 4 Painting and engraving (pp. 50–105)

GENERAL: Norman Feder, *North American Indian Painting*, New York, 1967; Axel Schulze-Thulin,

*Indianische Malerei in Nordamerika, 1830–1970*, Stuttgart, 1973.

SKIN PAINTING OF THE EAST (pp. 50–58)
PICTOGRAPHIC TRADITIONS: James H. Howard, *The British Museum Winter Count*, British Museum, Occasional Paper 4, 1979; Garrick Mallery, 'Picture Writing of the American Indians', *10th Annual Report of the Bureau of American Ethnology*, pp. 3–807, 1893; Wilhelm Wildhage, *Die Winterzählungen der Ogala*, Wyk, 1988. Scenic painting on skins: John C. Ewers, *Plains Indian Painting*, Stanford, 1939; *idem*, 'Early White Influence upon Plains Indian Painting', *Smithsonian Miscellaneous Collections*, 134, no. 7, 1957; Norman Feder, 'Plains Pictographic Painting and Quilled Rosettes', *American Indian Art Magazine*, 5, no. 2: 54–62, 1980; Christian F. Feest, 'Pictographic Skin Painting in Eastern North America: Fact and Fiction', *Archiv für Völkerkunde*, 33: 85–104, 1979; Ernst Vatter, 'Historienmalerei und heraldische Bilderschrift der nordamerikanischen Präriestämme', *IPEK*: 46–81, 1927. Scenic painting on paper: Dorothy Dunn (ed.), *1877: Plains Indian Sketch Books of Zo-Tom and Howling Wolf*, Flagstaff, 1969; Christian F. Feest, 'The Arbre Croche Sketchbook', in: S. Graham (ed.), *Beadwork & Textiles of the Ottawa*, pp. 61–83, Harbor Springs, 1981; Moira Harris, *Between Two Cultures: Kiowa Art from Fort Marion*, St Paul, MN, 1989; C. Adrian Heidenreich, 'The Content and Context of Crow Indian Ledger Art', *Fifth Annual Plains Indian Seminar*, pp. 111–32; Ronald McCoy, *Kiowa Memories, Images from Indian Territory, 1880*, Santa Fe, 1987; Karen Daniels Petersen, *Plains Indian Art from Fort Marion*, Norman, 1971; Peter J. Powell, *People of the Sacred Mountain*, San Francisco, 1981; Burton Surpee with Ann Ross, *Bear's Heart, Scenes from the Life of a Cheyenne Artist of 100 Years Ago*, Philadelphia and New York, 1977; Leslie Tillett, *Wind on the Buffalo Grass, Native American Artist-Historians*, New York, 1976 (reprinted: New York, 1989).
VISIONARY TRADITIONS: Minneapolis Institute of Arts, *I Wear the Morning Star: An Exhibition of American Indian Ghost Dance Objects*, Minneapolis, 1976; Clark Wissler, 'Some Protective Designs of the Dakota', *American Museum of Natural History, Anthropological Papers*, 1: 19–53, 1907. Tipis: Ted J. Brasser, 'Tipi Painting, Blackfoot Style', *National Museum of Canada, Ethnology Service Papers*, 43: 7–18, 1978; John C. Ewers, *Murals in the Round: Painted Tipis of the Kiowa and Kiowa-Apache*, Washington, 1978; *idem*, *Blackfeet Indian Tipis, Design and Legend*, Bozeman, 1976; Myles Libhart and Rosemary Ellison, *Painted Tipis by Contemporary Indian Artists*, Anadarko, OK, 1973; Walter McClintock, *Painted Tipis and Picturewriting of the Blackfoot Indians*, Southwest Museum Leaflet 6, n.d.
SYMBOLIC TRADITIONS: Robes: E.-Th. Hamy, 'Note

sur d'anciennes peintures sur les peaux des indiens Illinois', *Journal de la Société des Américanistes de Paris*, 2: 185–95, 1897–98. Containers: Mable Morrow, *Indian Rawhide, An American Folk Art*, Norman, 1975; Leslie Spier, 'An Analysis of Plains Indian Parfleche Decoration', *University of Washington Publications in Anthropology*, 1, no. 3, 1923, Naskapi coats: Dorothy K. Burnham, *To Please the Caribou: Painted Caribou-Skin Coats Worn by the Naskapi, Montagnais and Cree Hunters of the Quebec-Labrador Peninsula*, Toronto, 1992.

OTHER SKIN PAINTING TRADITIONS (p. 58)
THE NORTHWEST COAST: Walter Krickeberg, 'Malereien auf ledernen Zeremonialkleidern der Nordwestamerikaner', *IPEK*: 140–50, 1925.
APACHE: John G. Bourke, 'The Medicine-men of the Apache', *9th Annual Report of the Bureau of American Ethnology*, pp. 443–603, 1892; Ronald McCoy, 'Apache Rawhide Playing Cards', *American Indian Art Magazine*, 9, no. 3: 52–9, 1984.
PUEBLO SHIELDS: Barton Wright, *Pueblo Shields from the Fred Harvey Fine Arts Collection*, Flagstaff, 1976.

BARK SGRAFFITO (pp. 58–61)
Frank G. Speck, 'Art Process in Birchbark of the River Desert Algonquin, A Circumboreal Trait', *Bulletin of the Bureau of American Ethnology*, 128: 229–74, 1941; *idem*, *Montagnais Art in Birchbark, A Circumpolar Trait*, Indian Notes and Monographs, 11, no. 2, 1937.

INCISED DECORATION ON BARK AND WOOD (pp. 61–62)
Selwyn Dewdney, *The Sacred Scrolls of the Southern Ojibway*, Toronto, 1975.

INCISED DECORATION ON OTHER MATERIALS (pp. 62–65)
J. Brown and P. Phillips, *Pre-Columbian Shell Engravings from the Craig Mound at Spiro, Oklahoma*, 2 vols., Cambridge, MA, 1978–84; Richard A. Pohrt, 'Plains Indian Riding Quirts with Elk Antler Handles', *American Indian Art Magazine*, 3, no. 4: 62–7, 1978; Frank G. Speck, *Eastern Algonkian Block-stamp Decoration*, Archaeological Society of New Jersey, Research Series 1, 1947; William Webb and Raymond S. Baby, *The Adena People, no. 2*, pp. 83–101, Columbus, OH, 1957; Charles C. Willoughby, 'The Art of the Great Earthwork Builders of Ohio', *Annual Report of the Smithsonian Institution for 1916*: 489–500, 1917.

ESKIMO ENGRAVING ON WALRUS IVORY (pp. 66–68)
Franz Boas, 'Decorative Designs of Alaskan Needle-cases', *Proceedings of the United States National Museum*,

24: 321–44, 1908; Walter J. Hoffman, 'The Graphic Art of the Eskimos', *United States National Museum, Annual Report for 1895*, pp. 739–968, 1897; Dorothy Jean Ray, 'Graphic Arts of the Alaskan Eskimo', *Native American Arts*, 2, 1969; Elisabeth Walther, 'Happy Jack and His Artistry', *American Indian Art Magazine*, 15, no. 1: 40–53, 1989; *idem*, 'Ritzzeich-nungen der Eskimo Nordwest-Alaskas', *Baessler-Archiv*, N.F. 31: 313–49, 1983.

HISTORIC TWO-DIMENSIONAL METALWORK (pp. 68–71)
IROQUOIS AND PLAINS: W. H. Carter, *North American Indian Trade Silver*, 3 vols., London, Ont., 1971–73 (includes reprints of works by J. P. Harrington and H. M. Converse on Iroquois silver); Rosemary Ellison, *Contemporary Southern Plains Indian Metalwork*, Anadarko, OK, 1976; Norman Feder, 'Plains Indian Metalworking', *American Indian Tradition*, 8: 55–76, 93–108, 1962; N. Jay Fredrickson, *The Covenant Chain, Indian Ceremonial and Trade Silver*, Ottawa, 1980.
THE SOUTHWEST: John Adair, *The Navajo and Pueblo Silversmiths*, Norman, 1944; Margery Bedinger, *Indian Silver: Navajo and Pueblo Jewelers*, Albuquerque, 1973; Larry Frank with Millard J. Holbrook III, *Indian Silver Jewelry of the Southwest, 1868–1930*, West Chester, PA, 1990; Louise Lincoln (ed.), *Southwest Indian Silver from the Doneghy Collection*, Minneapolis, 1982; Harry P. Mera and Dale Stuart King, *Indian Silverwork of the Southwest*, 2 vols., Globe, 1960.
THE NORTHWEST: Marius Barbeau, 'Old Canadian Silver', *Canadian Geographic Journal*, 22, no. 3: 150–62, 1941.

PAINTING AND ENGRAVING OF THE NORTHERN NORTHWEST COAST (pp. 71–77)
Bill Holm, *Northwest Coast Indian Art*, Seattle, 1965; Renwick Gallery, *Boxes and Bowls: Decorated Containers by Nineteenth-century Haida, Tlingit, Bella Bella, and Tsimshian Artists*, Washington, 1974.

OTHER PAINTING AND ENGRAVING TRADITIONS ON WOOD (pp. 78–83)
THE NORTHWEST: Norman Feder, 'Incised Relief Carving of the Halkomelem And Straits Salish', *American Indian Art Magazine*, 8, no. 2: 46–55, 1983; S. V. Ivanov, 'Aleut Hunting Headgear and its Ornamentation', *Proceedings of the 23rd International Congress of Americanists*, pp. 477–504, New York, 1928; Paul S. Wingert, 'Coast Salish Painting', in: M. W. Smith (ed.), *Indians of the Urban Northwest*, pp. 77–91, New York, 1949.
NORTHERN CALIFORNIA: Isabel T. Kelly, 'The Carver's Art of the Indians of Northwestern California', *University of California Publications in American Archaeology and Ethnology*, 24: 343–60, 1930.

PUEBLO: Barton Wright, 'Tabletas, a Pueblo Art', *American Indian Art Magazine*, 1, no. 3: 56–65, 1976.
THE EAST: Norman Feder, 'Pawnee Cradleboards', *American Indian Art Magazine*, 3, no. 4: 40–50, 1978.

POTTERY PAINTING OF THE SOUTHWEST (pp. 83–90)
HOHOKAM: Charles A. Amsden, *An Analysis of Hohokam Pottery Design*, Gila Pueblo, Medallion Papers, 23, 1936.
MIMBRES: J. J. Brody, *Mimbres Painted Pottery*, Santa Fe and Albuquerque, 1977; J. J. Brody et al., *Mimbres Pottery, Ancient Art of the American Southwest*, New York, 1983; Steven A. Leblanc, *The Mimbres People*, London, 1983.
ANASAZI: Robert H. and Florence C. Lister, *Anasazi Pottery*, Albuquerque, 1978; Dorothy K. Washburn, *A Symmetry Analysis of Upper Gila Area Ceramic Design*, Papers of the Peabody Museum of Archaeology and Ethnology, 68, 1977.
PUEBLO: Jonathan Batkin, *Pottery of the Pueblos of New Mexico 1700–1940*, Colorado Springs, 1987; J. J. Brody, *Beauty from the Earth, Pueblo Indian Pottery from the University Museum of Archaeology and Anthropology*, Philadelphia, 1990; Ruth Bunzel, *The Pueblo Potter*, Columbia University Contributions to Anthropology, 8, 1929 (reprinted: New York, 1972); Kenneth M. Chapman, *Pueblo Pottery Making*, 2 vols., Nice, 1933–36; Alfred E. Dittert, Jr., and Fred Plog, *Generations in Clay, Pueblo Pottery of the American Southwest*, Flagstaff, 1980; Larry Frank and Francis H. Harlow, *Historic Pottery of the Pueblo Indians 1600–1880*, Boston, 1974; Carl E. Guthe, *Pueblo Pottery Making*, New Haven, 1925; Francis H. Harlow, *Matte-paint Pottery of the Tewa, Keres, and Zuni Pueblos*, Santa Fe, 1973; *idem*, *Modern Pueblo Pottery*, Flagstaff, 1977; *idem*, *Two Hundred Years of Historical Pueblo Pottery*, Santa Fe, 1990; Marjorie F. Lambert, *Pueblo Indian Pottery: Materials, Tools and Techniques*, Santa Fe, 1966; Maxwell Museum of Anthropology, *Seven Families in Pueblo Pottery*, Albuquerque, 1977.
HISTORIC HOPI: Laura Graves Allen, *Contemporary Hopi Pottery*, Flagstaff, 1984; John E. Collins, *Nampeyo, Hopi Potter, Her Artistry and Legacy*, Fullerton, CA, 1974; Edwin L. Wade and Lea S. McChesney, *Historic Hopi Ceramics: the Thomas V. Keam Collection*, Cambridge, MA, 1981; Willard Walker and Lydia K. Wyckoff, *Hopis, Tewas and the American Road*, Middletown, CT, 1983; Barton Wright, 'Hopi Tiles', *American Indian Art Magazine*, 2, no. 4: 64–71, 1977.
SANTO DOMINGO: Kenneth M. Chapman, *The Pottery of Santo Domingo Pueblo*, Laboratory of Anthropology, Memoir 1, Santa Fe, 1939 (reprinted: Albuquerque, 1977).
SAN ILDEFONSO: Kenneth M. Chapman and Francis H. Harlow, *The Pottery of San Ildefonso Pueblo*, Santa Fe, 1970; Alice Marriott, *Maria: The Potter of San Ildefonso*, Norman, 1948.

SANTA CLARA: Mary Ellen and Laurence R. Blair, *Margaret Tafoya, A Tewa Potter's Heritage and Legacy*, West Chester, 1986; Betty LeFree, *Santa Clara Pottery Today*, School of American Research, Monograph 29, 1975. ZUNI: Marian E. Rodee and James Ostler, *Zuni Indian Pottery*, West Chester, 1986. PAPAGO: Bernard L. Fontana et al., *Papago Indian Pottery*, Seattle, 1962. NAVAJO: Russell P. Hartman and Jan Musial, *Navajo Pottery, Traditions & Innovations*, Flagstaff, 1987.

MURAL PAINTING (pp. 90–91)
J. J. Brody, *Anasazi and Pueblo Painting*, Albuquerque, 1991; Bertha Dutton, *Sun Father's Way: The Kiva Murals of Kuaua*, Albuquerque, 1963; Frank C. Hibben, *Kiva Art of the Anasazi at Pottery Mound*, Las Vegas, 1975; Watson Smith, *Kiva Mural Decorations at Awatovi and Kawaika-a*, Papers of the Peabody Museum of American Archaeology and Ethnology, 37, 1952.

ROCK ART (pp. 91–97)
Campbell Grant, *Rock Art of the American Indians*, New York, 1967; Klaus F. Wellmann, *A Survey of North American Indian Rock Art*, Graz, 1979. MONOCHROME: The eastern Subarctic: Selwyn Dewdney and Kenneth E. Kidd, *Indian Rock Art of the Great Lakes*, Toronto, 1962; J. M. and R. K. Vastokas, *Sacred Art of the Algonkians*, Petersborough, Ont., 1973. The Southwest: Robert F. Heizer and Martin A. Baumhoff, *Prehistoric Rock Art of Nevada and Eastern California*, Berkeley, 1962. The Northwest: Beth and Ray Hill, *Indian Petroglyphs of the Pacific Northwest*, Saanichton, B.C., 1974. POLYCHROME: The Southwest: Polly Schaafsma, *The Rock Art of Utah*, Papers of the Peabody Museum of American Archaeology and Ethnology, 65, 1971; *idem, Rock Art in New Mexico*, Santa Fe, 1972; *idem, Indian Rock Art of the Southwest*, Albuquerque, 1980; Forrest Kirkland and W. W. Newcomb, Jr., *The Rock Art of Texas Indians*, Austin and London, 1971. California: Campbell Grant, *The Rock Paintings of the Chumash*, Berkeley and Los Angeles, 1965; Robert F. Heizer and C. William Clewlow, Jr., *Prehistoric Rock Art of California*, 2 vols., Ramona, CA, 1973.

BODY ART (pp. 97–98)
Franz Boas, 'Facial Paintings of the Indians of Northern British Columbia', *Memoirs of the American Museum of Natural History*, 2: 13–24; D. W. Light, *Tattooing Practices of the Cree Indians*, Glenbow-Alberta Institute, Occasional Papers, 6, 1972; Edward Sapir, 'Hoopa Tattooing', *Essays in Anthropology Presented to A. L. Kroeber*, Berkeley, 1937, pp. 273–7; Gertrude Schier, 'Kunst am Körper. Zur sozialen Aussage von Tatauierung und Bemalung im indianischen Nordamerika', *Archiv für Völkerkunde*, 39: 1–

116, 1985; Edith S. Taylor and William J, Wallace, *Mohave Tattooing and Face-Painting*, Southwest Museum Leaflets, 20, Los Angeles, 1947; James A. Teit, 'Tattooing and Face and Body Painting of the Thompson Indians of British Columbia', *45th Annual Report of the Bureau of American Ethnology*, pp. 397–439, 1930.

NON-TRADITIONAL PAINTING (pp. 98–101)
Hartley Burr Alexander, *Pueblo Indian Painting*, Nice, 1932; *idem, Sioux Indian Painting*, Nice, 1939; Patricia Janis Broder, *Hopi Painting*, New York, 1978; J. J. Brody, *Indian Painters and White Patrons*, Albuquerque, 1971; Lee A. Callander and Ruth Slivka, *Shawnee Home Life, The Paintings of Ernest Spybuck*, New York, 1984; Katherin Chase, 'Navajo Painting', *Plateau*, 54, no. 1, 1982; Doris O. Dawdy, *Annotated Bibliography of American Indian Painting*, Contributions from the Museum of the American Indian, 21, pt. 1; Frederick J. Dockstader, *Oscar Howe, A Restrospective Exhibition*, Tulsa, 1982; Dorothy Dunn, *American Indian Painting of the Southwest and Plains Areas*, Albuquerque, 1968; David M. Fawcett and Lee A. Callander, *Native American Painting, Selections from the Museum of the American Indian*, New York, 1982; Gerhard Hoffmann (ed.), *Indianische Kunst im 20. Jahrhundert*, Munich, 1985; *idem, Zeitgenössische Kunst der Indianer und Eskimos in Kanada*, Stuttgart, 1988; Oscar B. Jacobson, *Kiowa Indian Art*, Nice, 1929; Tryntje Van Ness Seymour, *When the Rainbow Touches Down*, Phoenix, 1988; Arthur Silberman, *100 Years of Native American Painting*, Oklahoma City, 1978; Jeanne O. Snodgrass, *American Indian Painters, A Biographical Directory*, Contributions from the Museum of the American Indian, 21, pt. 1, 1968; Clara Lee Tanner, *Southwest Indian Painting*, 2nd edn, Tucson, 1973. MODERN INDIAN ARTISTS: Adelyn D. Breeskin, *Two American Painters: Fritz Scholder and T. C. Cannon*, Washington, 1972; The Native American Center for the Living Arts, *American Indian Art in the 1980s*, Niagara Falls, n.d.; Norman Mackenzie Art Gallery, *New Work by a New Generation*, Regina, 1982; Edwin L. Wade and Rennard Strickland, *Magic Images, Contemporary Native American Art*, Norman, 1981. ESKIMO PRINTS AND DRAWINGS: Jean Blodgett, *North Baffin Drawings*, Toronto, 1986; Helga Goetz, *The Inuit Print*, Ottawa, 1977; Marion E. Jackson and David F. Pelly, *The Vital Vision, Drawings by Ruth Annaqtuusi Tulurialik*, Windsor, 1986; Jørgen Meldgaard, *Aron, En af de mærkværdigste Billedsamlinger i Verden*, Copenhagen, 1982. WOODLANDS SCHOOL: Lister Sinclair and Jack Pollock, *The Art of Norval Morrisseau*, Toronto, 1979; Elizabeth McLuhan and Tom Hill, *Norval Morrisseau and the Emergence of the Image Makers*, Toronto, 1984. THE NORTHWEST COAST: Peter R. Gerber and Vanina

Katz-Lahaigue, Susan A. *Point, Joe David, Lawrence Paul: Indianische Künstler der Westküste Kanadas*, Zürich, 1989; Edwin S. Hall, Jr., Margaret B. Blackman and Vincent Rickard, *Northwest Coast Indian Graphics*, Seattle, 1981; Hilary Stewart, *Haida Printmaker*, Seattle and London, 1979.

DRY PAINTING (pp. 101–4)
Nancy J. Parezo, *Navajo Sandpainting*, Tucson, 1983; Gladys A. Reichard, *Navajo Medicine Man Sandpaintings*, New York, 1977 (reprint of 1939 edn); Leland C. Wyman, *Southwest Indian Drypainting*, Santa Fe, 1983.

MOSAIC, INLAY, OVERLAY, CUT-OUTS (pp. 104–5)
OVERLAY: Nicholson Wright, *Hopi Silver*, Flagstaff, 1972.
CUT-OUTS: Norman Feder, *Elk Antler Roach Spreaders*, Material Culture Monographs, 1, 1968; James H. Howard, 'Birch Bark and Paper Cutouts from the Northern Woodlands and Prairie Border', *American Indian Art Magazine*, 5, no. 4: 54–61, 86–7, 1980.

## 5 Textiles (pp. 106–57)

BASKETRY (pp. 106–16)
*American Indian Basketry*, Portland, 1979–; George Wharton James, *Indian Basketry*, New York, 1902 (reprinted: New York, 1972); Dena S. Katzenberg, '*And Eagles Sweep Across the Sky*', *Indian Textiles of the North American West*, Baltimore, 1977; Frank W. Lamb, *Indian Baskets of North America*, Riverside, CA, 1972; Otis T. Mason, *Indian Basketry: Studies in a Textile Art without Machinery*, London, 1905 (reprinted: Santa Barbara, 1976); Charles E. Rozaire, *Indian Basketry of Western North America*, Los Angeles, 1977; Sarah Peabody Turnbaugh and William A. Turnbaugh, *Indian Baskets*, West Chester, PA, 1986.
EAST: Ted J. Brasser, *A Basketful of Culture Change*, National Museum of Man, Canadian Ethnology Service Papers, 22, 1975; Melvin R. Gilmore, 'Arikara Basketry', *Indian Notes*, 2: 89–95, 1925; M. Lismer, *Seneca Splint Basketry*, Indian Handcraft Pamphlets, 4, 1941; Ann C. McMullen and Russell G. Handsman, *A Key into the Language of Woodsplint Baskets*, Washington, CT, 1987; Claude Medford, Jr., 'Chitimacha Split Cane Basketry Weaves and Designs', *American Indian Art Magazine*, 3, no. 1: 56–61, 101, 1977; Gaby Pelletier, *Abenaki Basketry*, National Museum of Man, Canadian Ethnology Service Papers, 85, 1982; Frank G. Speck, 'Decorative Art and Basketry of the Cherokee', *Milwaukee Public Museum, Bulletin*, 2, no. 2, 1920.
SOUTHWEST: Clara Lee Tanner, *Indian Baskets of the Southwest*, Tucson, 1983; Andrew Hunter Whiteford, *Southwestern Indian Baskets*, Santa Fe and Seattle,

1988. Anasazi: Earl H. Morris and Robert F. Burgh, *Anasazi Basketry, Basket Maker II through Pueblo III*, Carnegie Institution of Washington Publications, 533, 1941. Apache: Helen H. Roberts, 'Basketry of the San Carlos Apache Indians', *American Museum of Natural History, Anthropological Papers*, 31: 121–218, 1928 (reprinted: Glorieta, NM, 1972); Clara Lee Tanner, *Apache Indian Baskets*, Tucson, 1982. Havasupai: Barbara and Edwin McKee and Joyce Herrold, *Havasupai Baskets and their Makers 1930–1940*, Flagstaff, 1975; Herrold, 'Havasupai Basketry: Theme and Variation', *American Indian Art Magazine*, 4, no. 4: 42–53, 1979. Papago and Pima: 'Tohono O'Odham Wire Baskets', *American Indian Art Magazine*, 13, no. 4: 48–57, 1988; H. Thomas Cain, *Pima Indian Basketry*, Phoenix, 1962; Terry de Wald, *The Papago Indians and their Baskets*, Tucson, 1979; Jane M. Gogol, 'Pagago Horsehair Basketry', *American Indian Basketry*, 3, no. 11: 4–8 1983; Mary L. Kissell, 'Basketry of the Papago and Pima', *American Museum of Natural History, Anthropological Papers*, 17: 116–273, 1916.
GREAT BASIN: Craig D. Bates and Martha J. Lee, *Tradition and Innovation: A Basket History of the Indians of the Yosemite–Mono Lake Area*, Yosemite National Park, 1990; Marvin Cohodas, 'Lena Frank Dick, An Outstanding Washoe Basket Weaver', *American Indian Art Magazine*, 4, no. 4: 32–41, 1979; idem, 'Washoe Indian Basketry', *American Indian Art Magazine*, 3, no. 12, 1983; Jane Green Gigli, 'Dat So La Lee, Queen of the Washo Basket Makers', *Nevada State Museum, Anthropological Papers, 16 (Collected Papers on Aboriginal Basketry)*, pp. 1–27, 1974; G. A. Smith and R. D. Simpson, *Indian Basket Makers of San Bernardino County*, n.p., n.d.
CALIFORNIA: Samuel A. Barrett, 'Pomo Indian Basketry', *University of California Publications in American Archaeology and Ethnology* 7: 134–308, 1908; Roland B. Dixon, 'Basketry Designs of the Indians of Northern California', *Bulletin of the American Museum of Natural History*, 17, 1902; Joyce Herrold, 'Chumash Baskets from the Malaspina Collection', *American Indian Art Magazine*, 3, no. 1: 68–75, 1977; Lila M. O'Neale, 'Yurok-Karok Basket Weavers', *University of California Publications in American Archaeology and Ethnology*, 32: 1–58, 1932; Arthur M. Silva and William C. Cain, *California Indian Basketry, An Artistic Overview*, Cypress, CA, 1976.
NORTHWEST: Genevieve Baird, *Northwest Indian Basketry*, Tacoma, 1976; Carolyn J. Marr, 'Basketry Regions of Washington State', *American Indian Art Magazine*, 16, no. 2: 40–9, 1990. Aleut: Anfesia T. Shapsnikoff and Raymond L. Hudson, 'Aleut Basketry', *University of Alaska, Anthropological Papers*, 16: 14–69, 1974. Salish: Franz Boas et al., 'Coiled Basketry in British Columbia and Surrounding Region', *41st Annual Report of the Bureau of American Ethnology*, 7: 134–308, 1908; D. L. and G. E. Nord-

quist, *Twana Twined Basketry*, Ramona, CA, 1983; Marian W. Smith and D. Leadbetter, 'Salish Coiled Baskets', *Indians of the Urban Northwest*, pp. 111–31, New York, 1949. Tlingit: George T. Emmons, 'The Basketry of the Tlingit', *Memoirs of the American Museum of Natural History*, 3: 229–77, 1903; Frances Paul, *Spruce Root Basketry of the Alaska Tlingit*, Indian Handcrafts, 8, 1944. Wasco: Mary Schlick, 'A Columbia River Indian Basket Collected by Lewis and Clark in 1805', *American Indian Basketry*, 1, no. 1: 10–13, 1979.
NORTH: Molly Lee, 'Pacific Eskimo Spruce Root Baskets', *American Indian Art Magazine*, 6, no. 2: 66–73, 1981; idem, *Baleen Basketry of the North Alaskan Eskimo*, Barrow, 1983.

INTERLACING (pp. 116–17)
Ryan Brothers, 'Cowichan Knitters', *Beaver*, Summer 1965: 42–6; Kate C. Duncan, 'American Indian Lace Making', *American Indian Art Magazine*, 5, no. 3: 28–35, 80, 1980; F. Dennis Lessard, 'Instruments of Prayer: The Peyote Art of the Sioux', *American Indian Art Magazine*, 9, no. 2: 24–7, 1984; James Ostler and Marian E. Rodee, 'Zuni Beaded Dolls: from Curio to Folk Art', *American Indian Art Magazine*, 14, no. 2: 32–7, 1989.

PLAITING AND BRAIDING (pp. 117–18)
Richard Conn, 'Braided Sashes', *American Indian Tradition*, 9, no. 1: 5–14, 1963.

WOVEN QUILL- AND BEADWORK (pp. 118–22)
(See also Quill and Hair Appliqué and Bead Appliqué.) Benson L. Lanford, 'Great Lakes Woven Beadwork: An Introduction', *American Indian Art Magazine*, 11, no. 3: 62–7, 75, 1986; Dennis F. Lessard, 'Great Lakes Indian "Loom" Beadwork', *American Indian Art Magazine*, 11, no. 3: 54–61, 68–9, 1986; Ruth B. Phillips et al., *On the Border: Native American Weaving Traditions of the Great Lakes and Prairie*, Moorehead, 1990; Mary D. Schlick and Kate C. Duncan, 'Wasco-Style Woven Beadwork, Merging Artistic Traditions', *American Indian Art Magazine*, 16, no. 3: 36–45, 1991; Frank G. Speck, 'The Function of Wampum among the Eastern Algonkian', *Memoirs of the American Anthhropological Association*, 6: 3–71, 1919; U. Vincent Wilcox, 'The Manufacture and Use of Wampum in the Northeast', *The Bead Journal*, 3, no. 1: 10–19, 1976.

TWINED TEXTILES OF THE EAST (pp. 122–26)
William C. Orchard, 'Mohawk Burdenstraps', *Indian Notes*, 6: 351–9, 1929; Nora Rogers, 'Some Rush Mats with Warp Movement as Patterning', in: N. Rogers and M. Stanley (eds), *In Celebration of the Curious Mind*, pp. 9–20, Loveland, CO, 1983; Andrew

Hunter Whiteford, 'Fiber Bags of the Great Lakes Indians', *American Indian Art Magazine*, 2, no,. 3: 52–64, 85, and 3, no. 1: 40–7, 90, 1977; idem, 'Tapestry Twined Bags, Osage Bags, and Others', *American Indian Art Magazine*, 3, no. 2: 32–9, 92, 1978; Charles F. Willoughby, 'Textile Fabrics of the New England Indians', *American Anthropologist*, 7: 85–93, 1905.

TWINED TEXTILES OF THE NORTHWEST (pp. 126–30)
THE PLATEAU: John M. Gogol, 'Cornhusk Basketry of the Columbia River Plateau', *American Indian Basketry*, 1, no. 2: 4–11, 1980; Stephen D. Shawley, 'Hemp and Cornhusk Bags of the Plateau Indians', *Indian America*, 9, no. 1: 25–9, 48–9, 1975; A. Wyman, *Cornhusk Bags of the Nez Perce Indians*, Southwest Museum leaflets, 1, n.d.
SALISH: Paula Gustafson, *Traditional Salish Weaving*, Toronto and Seattle, 1980; Oliver N. Wells, *Salish Weaving: Primitive and Modern*, Sardis, 1969.
CHILKAT: George T. Emmons and Franz Boas, 'The Chilkat Blanket', *Memoirs of the American Museum of Natural History*, 3: 329–401, 1929; Cheryl Samuel, *The Chilkat Dancing Blanket*, Seattle, 1982; idem, *The Raven's Tail*, Vancouver, 1987.

TWINED TEXTILES OF THE SOUTHWEST (pp. 130–31)
Craig D. Bates, 'Feather Belts of Central California', *American Indian Art Magazine*, 7, no. 1: 46–53, 86, 1981; Charles C. Willougby, 'Feather Mantles of California', *American Anthropologist*, 24: 432–7, 1922.

WEAVING (pp. 131–38)
SOUTHWEST: Kate Peck Kent, *Prehistoric Textiles of the Southwest*, Santa Fe and Albuquerque, 1983; Marian E. Rodee, *Southwestern Weaving*, West Chester, 1987.
PUEBLO: Nancy Fox, *Pueblo Weaving and Textile Arts*, Santa Fe, 1978; Kate Peck Kent, *Pueblo Indian Textiles, A Living Tradition*, Santa Fe, 1983.
NAVAJO: Charles A. Amsden, *Navajo Weaving, Its Technic and Its History*, Santa Ana, 1934; Nancy Blomberg, *Navajo Textiles, The William Randolph Hearst Collection*, Tucson, 1988; Tyrone Campbell and Joel and Kate Kopp, *Navajo Pictorial Weaving 1880–1950*, New York, 1991; Mary Hunt Kahlenberg and Anthony Berlant, *The Navajo Blanket*, New York, 1972; idem, *Walk in Beauty: The Navajo and Their Blankets*, Boston, 1977; Alice Kaufman and Christopher Seber, *The Navajo Weaving Tradition, 1650 to Present*, New York, 1985; Kate Peck Kent, *Navajo Weaving, Three Centuries of Change*, Santa Fe, 1985; Susan McGreevy, 'Navajo Sandpainting Textiles at the Wheelwright Museum', *American Indian Art Magazine*, 7, no. 1: 55–61, 85, 1981; Harry P. Mera, *Navajo Textile Arts*, Santa Fe, 1948; Joe Ben Wheat et al., *Patterns and Sources of Navajo Weaving*, Denver, 1977.

THE EAST: William C. Sturtevant, 'The Hole-and-Slot Heddle', in: I. Emery and P. Fiske (eds), *Ethnographic Textiles of the Western Hemisphere*, pp. 325–55, Washington, 1977.

QUILL AND HAIR APPLIQUÉ (pp. 138–41)
Julia M. Bebbington, *Quillwork of the Plains*, Calgary, 1982; Norman Feder, 'Bird Quillwork', *American Indian Art Magazine*, 12, no. 3: 46–57, 1987; Carrie A. Lyford, *Quill and Beadwork of the Western Sioux*, Washington, 1940; William C. Orchard, *The Technique of Porcupine-quill Decoration among the North American Indians*, Contributions from the Museum of the American Indian, 4, no. 1, 1916 (reprinted, New York, 1971); Geoffrey Turner, *Hair Embroidery in Siberia and North America*, Occasional Papers on Technology, 7, 1955.

BEAD APPLIQUÉ (pp. 141–46)
Mike Johnson, 'Floral Beadwork in North America', *American Indian Crafts and Culture*, 7, no. 8: 2–9, no. 9: 2–7, no. 10: 2–9, 1973; William C. Orchard, *Beads and Beadwork of the American Indians*, Contributions from the Museum of the American Indian, 11, 1929.
NORTHEAST: Mike Johnson, 'Notes on Maritime Algonquin Beadwork', *American Indian Crafts and Culture*, 6, no. 8: 2–5, 1972.
GREAT LAKES: Richard E. Flanders et al., *Beads: Their Use by Upper Great Lakes Indians*, Grand Rapids, 1977; Stephen Graham (ed.), *Beadwork & Textiles ·of the Ottawa*, Harbor Springs, 1984; Robert Salzer, 'Central Algonkian Beadwork', *American Indian Tradition*, 7, no. 5: 166–78, 1961.
SOUTHEAST: Claude Medford, Jr., 'Native Clothing of the Southeastern Indian People', *Indian America*, 9, no. 1: 42–7, 1975.
PLAINS: Benson L. Lanford, 'Origins of Central Plains Beadwork', *American Indian Art Magazine*, 16, no. 1: 72–9, 1990; Dennis F. Lessard, 'Pictographic Art in Beadwork from the Cheyenne River Sioux', *American Indian Art Magazine*, 16, no. 1: 54–63, 1990; idem, 'Pictographic Sioux Beadwork, a Re-examination', *American Indian Art Magazine*, 16, no. 4: 70–4, 1991; Barbara Loeb, 'Crow Beadwork: The Resilience of Cultural Values', *Montana*, 40: 48–59, 1990; Richard A. Pohrt, 'Tribal Identification of Northern Plains Beadwork', *American Indian Art Magazine*, 15, no. 1: 72–9, 1989; William Wildschut and John C. Ewers, *Crow Indian Beadwork*, Contributions from the Museum of the American Indian, 16, 1959; John A. Woodward, 'Plains Cree Beadwork', *The Masterkey*, 43: 144–50, 1969.
PLATEAU: John M. Gogol, 'Columbia River/Plateau Indian Beadwork', *American Indian Basketry*, 5, no. 18, 1985.
SUBARCTIC: Kate C. Duncan, *Northern Athapaskan Art, A Beadwork Tradition*, Seattle and London, 1989; idem, *Some Warmer Tone, Alaska Athabaskan Bead Embroidery*, Fairbanks, 1984; Kate C. Duncan with Eunice Carney, *A Special Gift, The Kutchin Beadwork Tradition*, Seattle and London, 1988.
NORTHWEST COAST: Doreen Jensen and Polly Sargent, *Robes of Power, Totem Poles on Cloth*, Vancouver, 1986.

LEATHER, TEXTILE AND FEATHER APPLIQUE (pp. 146–51)
George P. Horse Capture (ed.), *Native American Ribbonwork; A Rainbow Tradition*, Cody, 1980.

PATCHWORK AND QUILTING (pp. 151–52)
Dorothy Downs, 'Contemporary Florida Indian Patchwork and Baskets', *American Indian Art Magazine*, 15, no. 4: 56–63, 1990; Norman Feder, 'Seminole Patchwork', *American Indian Hobbyist*, 6: 1–18, 1959; William K. Powers, 'Bessie Cornelius, Star Quilter of the Sioux', *Archiv für Völkerkunde*, 39: 117–46, 1985.

EMBROIDERY (pp. 152–57)
PUEBLO: Harry P. Mera, 'Pueblo Indian Embroidery', *Memoirs of the Laboratory of Anthropology*, 4, 1943 (reprinted: Santa Fe, 1975).
THE EAST: Stephen B. Graham (ed.), *Ottawa Quillwork on Birchbark*, Harbor Springs, 1983; Ruth Phillips, 'Glimpses of Eden: Iconographic Themes in Huron Pictorial Tourist Art', *European Review of Native American Studies*, 5, no. 2: 19–28, 1991; Turner, *Hair Embroidery*; Ruth Holmes Whitehead, *Micmac Quillwork*, Halifax, 1982.

# 6 Sculpture (pp. 159–97)

STONE SCULPTURE (pp. 158–66)
EAST: Carolyn T. Hawley, 'A New School of Iroquois Sculpture', *American Indian Art Magazine*, 15, no. 2: 48–57, 1990; J. C. H. King, *Smoking Pipes of the North American Indians*, London, 1977; Jordan Paper, *Offering Smoke, The Sacred Pipe in Native American Religion*, Moscow, ID, and Edmonton, 1989.
SOUTHWEST: E. K. Burnett, *Inlaid Stone and Bone Artifacts from Southern California*, Contributions from the Museum of the American Indian, 13, 1944; Marian E. Rodee and James Ostler, *The Fetish Carvers of Zuni*, Albuquerque, 1990.
NORTHWEST: Marius Barbeau, *Haida Carvers in Argillite*, National Museum of Canada, Bulletin 139, 1957; Leslie Drew and Doug Wilson, *Argillite – Art of the Haida*, Saanichton, B.C., 1980; Wilson Duff, *Images Stone B.C.*, Saanichton, B.C., 1975; Carol Sheehan, *Pipes that Won't Smoke; Coal that Won't Burn*, Calgary, 1981; Paul S. Wingert, *Prehistoric Stone Sculpture of the Pacific Northwest*, Portland, 1952; Robin K. Wright, 'Haida Argillite, Carved For Sale', *American Indian Art Magazine*, 8, no. 1, 48–55, 1982.

ESKIMO: Bernadette Driscoll, *Uumajut, Animal Images in Inuit Art*, Winnipeg, 1985; Charles A. Martin, 'Canadian Eskimo Carving in Historical Perspective', *Anthropos*, 59: 546–96, 1965; George Swinton, *Eskimo Sculpture*, Toronto, 1965; William E. Taylor, Jr., et al., *Sculpture/Inuit*, Toronto, 1971; Darlene Wight, *The Swinton Collection of Inuit Art*, Winnipeg, 1987.

WOODCARVING OF THE NORTHWEST COAST (pp. 166–74)
Erna Siebert and Werner Forman, *North American Indian Art*, London, 1967; Paul S. Wingert, *American Indian Sculpture: A Study of the Northwest Coast*, New York, 1940; idem, 'Tsimshian Sculpture', in: V. Garfield, *The Tsimshian*, pp. 73–94, New York, 1950.
TOTEM POLES: Marius Barbeau, *Totem Poles*, 2 vols., National Museum of Canada, Bulletin, 119, 1950; V. Garfield and L. A. Forrest, *The Wolf and the Raven, Totem Poles of Southeastern Alaska* (rev. edn), Seattle, 1961; Edward L. Keithahn, *Monuments in Cedar*, Ketchikan, 1945 (reprinted: New York, 1962); John and Carolyn Smyly, *Those Born at Koona: The Totem Poles of the Haida Village of Skedans*, Saanichton, B.C., 1976.
MASKS: J. C. H. King, *Portrait Masks from the Northwest Coast of America*, London, 1979; E. Malin, *A World of Faces*, Forest Grove, 1978; Marion J. Mochon, *Masks of the Northwest Coast*, Milwaukee Public Museum Publications in Primitive Art, 2, 1966; Wayne Suttles, 'The Halkomelem Sxwayxwey', *American Indian Art Magazine*, 8, no. 1: 56–65, 1982.
OTHER OBJECTS: Aldona Jonaitis, *Tlingit Halibut Hooks: An Analysis of the Visual Symbol of a Rite of Passage*, American Museum of Natural History, Anthropological Papers, 57, pt. 1, 1981.

ESKIMO WOOD CARVING (pp. 175–79)
Robert Gessain, 'Masques Eskimo d'Ammassalik', *Le Courier du Musée de l'Homme*, 3, 1978; Dorothy Jean Ray and Alfred A. Blaker, *Eskimo Masks: Art and Ceremony*, Seattle and London, 1975; Jean-Loup Rousselot et al., *Masques Eskimo d'Alaska*, Saint-Vit, 1991.

WOOD CARVING OF THE EAST (pp. 179–83)
M. Gilliland, *The Material Culture of Key Marco, Florida*, Gainesville, 1975; Frank G. Speck, 'Concerning Iconology and the Masking Complex in Eastern North America', *Bulletin of the University Museum*, 15, no. 1, Philadelphia, 1950.
IROQUOIS: William N. Fenton, *The False Faces of the Iroquois*, Norman and London, 1987; Robert E. Ritzenthaler, *Iroquois False-face Masks*, Milwaukee Public Museum Publications in Primitive Art, 3, 1969.
PLAINS: John C. Ewers, *Plains Indian Sculpture*, Washington, 1986.

WOOD CARVING OF THE SOUTHWEST (pp. 183–85)
PUEBLO: Horst Antes (ed.), *Kachina-Figuren der Pueblo-Indianer Nordamerikas aus der Studiensammlung Horst Antes*, Karlsruhe, 1980; Eric Bromberg, *The Hopi Approach to the Art of Kachina Doll Carving*, West Chester, 1986; Harold S. Colton, *Hopi Kachina Dolls with a Key to their Identification*, 2nd edn, Albuquerque, 1959; Jon T. Erickson, *Kachinas: An Evolving Hopi Art Form*, Phoenix, 1979; Horst Hartmann, *Kachina-Figuren der Hopi-Indianer*, Berlin, 1978; Helga Teiwes, *Kachina Dolls: The Art of the Hopi Carvers*, Tucson, 1991; Dorothy K. Washburn, *Hopi Kachina: Spirit of Life*, San Francisco, 1980; Barton Wright, *Hopi Kachinas: The Complete Guide to Collecting Kachina Dolls*, Flagstaff, 1977.
NAVAJO: Roger E. Kelly, R. W. Lang, Harry Walters, *Navaho Figurines Called Dolls*, Santa Fe, 1972.

IVORY, BONE AND HORN SCULPTURE (pp. 185–89)
ESKIMO: Heinz Israel, *Eskimo, Beinschnitzerei eines Polarvolks, Die Schatzkammer* 36, Leipzig, 1983; Dinah Larsen and Terry Dickey (eds), *Setting It Free, An Exhibition of Modern Alaskan Eskimo Ivory Carving*, Fairbanks, 1982; Eugen Philippovich, 'Eskimoskulptur aus Grönland', *EZZ*, 1977, no. 1: 91–111; J. G. E. Smith, *Arctic Art: Eskimo Ivory*, New York, 1980; Allen Wardwell, *Ancient Eskimo Ivories of the Bering Strait*, New York, 1986.
NORTHWEST COAST: Aldona Jonaitis, 'Land Otters and Shamans, Some Interpretations of Tlingit Charms', *American Indian Art Magazine*, 4, no. 1: 62–6, 1978.
EAST: Edmund Carpenter, 'Iroquois Figurines', *American Antiquity*, 8: 105–13, 1942.

CLAY SCULPTURE (pp. 189–93)
EASTERN FIGURINES: James B. Griffin et al., 'The Burial Complexes of the Knight and Norton Mounds of Illinois and Michigan', *Memoirs of the Museum of Anthropology, University of Michigan*, 2, 1970.
SOUTHWESTERN FIGURINES: Charles F. Cleland, 'Yuma Dolls', *American Indian Art Magazine*, 5, no. 3: 36–41, 71, 1980; Noel Morss, *Clay Figurines of the American Southwest*, Papers of the Peabody Museum of American Archaeology and Ethnology, 49, no. 1, 1954; Johannes Schwab, *Die Tonfiguren der Hohokam und ihr zeremonieller Kontext*, Arbeiten aus dem Seminar für Völkerkunde der Universität Frankfurt am Main, no. 20, 1989.
EFFIGY VESSELS: Charles DiPeso, 'Casas Grandes Effigy Vessels', *American Indian Art Magazine*, 2, no. 4: 32–7, 90, 1977.

OTHER THREE-DIMENSIONAL ARTS (pp. 193–95)
METALWORK: John Witthoft and F. Eyman, 'Metal-

lurgy of the Tlingit, Dene and Eskimo', *Expedition*, 11, no. 2: 12–23, 1969.
LAND ART: Thomas F. and Alice B. Kehoe, 'Boulder Effigy Monuments in the Northern Plains', *Journal of American Folklore*, 72: 115–27, 1959; William N. Morgan, *Prehistoric Architecture of the Eastern United States*, Cambridge, MA, and London, 1980; Stephen D. Peet, 'Emblematic Mounds and Animal Effigies', in his *Prehistoric America*, vol. 2, Chicago, 1890.

EPILOGUE (pp. 196–97)
Joseph Alsop, *The Rare Art Traditions: The History of Art Collecting and Its Linked Phenomena*, New York, 1982; Christian F. Feest, 'The Pervasive World of Arts', in: A. L. Josephy, Jr. (ed.), *America in 1492*, pp. 405–28, New York, 1992.

# List of illustrations

*Dimensions are given in inches and centimetres: height, width and depth*

1 Wooden figure of *Swaixwe*. Ht 46¼ (117·5). Museum für Völkerkunde, Staatliche Museen Preussischer Kulturbesitz, Berlin

3 Hide kachina mask. Ht 8⅞ (22·5). Brooklyn Museum

4 Ball-headed club. Shell and copper inlay. L. 24 (61). Skokloster Castle, Sweden

5 Double-woven cane basket. Split cane. 6⅝ × 20⅞ × 7½ (17 × 53 × 19). British Museum, London

6 Painted wooden panel. 72 × 132 (182·9 × 335·3). American Museum of Natural History, New York

7 Coiled basket made by Ana Maria Marta. Ht 6¼ (16), diam. 16 (40·5). Lowie Museum of Anthropology, University of California, Berkeley

8 *Kiowa Moving Camp*. Oil on canvas. 80 × 168 (203·2 × 426·7). Photo courtesy of U.S. Department of the Interior, Indian Arts and Crafts Board

10 *Two Men Discussing Coming Hunt*. Stencil print. 13½ × 19⅛ (34·2 × 48·5). Canadian Ethnology Service, National Museum of Man, National Museums of Canada

11 Human effigy pipe. Ht 7⅞ (20). Ohio Historical Society

12 Painted and beaded buckskin quiver with glass beads. L. 30¼ (77). Museum of Ethnography, St Petersburg

14 *The Volcano Woman*. Argillite with abalone shell and ivory inlay. 7⅞ × 7½ × 2 (19·5 × 19 × 5). Museum of Northern British Columbia, Prince Rupert. Photo Brian Gauvin (HUES)

15 Carved elk antler. 7¼ × 2 (18 × 5). Thomas Burke Memorial Washington State Museum, University of Washington

16 Carved wooden staff. Field Museum of Natural History, Chicago

17 Polychrome painted storage jar. Ht 19 (48·2), diam. 25 (63·5). School of American Research, Sante Fe

18 Pair of painted dance wands. Wood, feathers. L. 25½ (65). Museum für Völkerkunde, Staatliche Museen Preussischer Kulturbesitz, Berlin

19 Stone disc. Diam. 12¾ (31·5). Alabama Museum of Natural History, University of Alabama

20 Elk horn quirt. L. 15 (38·1). Public Library Museum, Fairfield, Iowa

21 Cut-out rawhide horse effigy. Field Museum of Natural History, Chicago

22 Leather shield. Diam. 25½ (65). Museum für Völkerkunde, Staatliche Museen Preussischer Kulturbesitz, Berlin

23 Mountain sheep horn bowl. W. 7½ (19). Museum für Völkerkunde, Staatliche Museen Preussischer Kulturbesitz, Berlin

24 Frontal headdress. Ht 7 (18). Museo de America, Madrid

25 *The White Cloud*. Oil on canvas. National Gallery of Art, Washington, Paul Mellon Collection

26 *Dance* and *Combat*. Pencil on paper. 7⅛ × 9 (18 × 23) Museum für Völkerkunde, Vienna

27 Figural beaded vest. Sinew sewn on buckskin. Ht 19 (48·3). Museum of Indian Heritage, Indianapolis

28 *Koshare Promotion Ceremony*. Ht 7 (17·8). Museum of Indian Heritage, Indianapolis, Dr Hanus Grosz Collection

29 Hide shield. Hide and feathers. Diam. of hide 20⅛ (51) Milwaukee Public Museum

30 Quilled and painted man's shirt. Deerskin decorated with quillwork and human hair. Full w. 55⅛ (140). Sheffield City Museums
31 Self-portrait by Buffalo Meat. Crayon and coloured inks on lined stationery. 6¼ × 4⅞ (16 × 11). Collection of the Oklahoma Historical Society
32 Painting on muslin. 35¾ × 98½ (91 × 250). Staatliches Museum für Völkerkunde, Munich
33 Ghost Dance dress. 62½ × 47 (158·7 × 119·4). Field Museum of Natural History, Chicago. Photo Minneapolis Institute of Arts
34 Otter tipi. Canvas, wood, horsehair, string, paint, leather. Ht 236¼ (600), diam. 413¾ (1050). Glenbow Museum, Calgary, Alberta
35 Painted bison robe. 94½ × 59 (240 × 150). Naprstkovo Muzeum, Prague
36 Parfleche. Rawhide. 21½ × 14 (54·6 × 35·6). Reproduced by permission of the University Museum, University of Pennsylvania
37 Tailored coat; Naskapi, collected 1825. Paint on leather. L. 38⅛ (97). Museum für Völkerkunde und Schweizerisches Museum für Völkerkunde, Basel
38 Painted coat. Buckskin. 53⅛ × 30¼ (135 × 77). British Museum, London
39 Painted pouch. Skin and porcupine quills. 20⅛ × 8¼ (51 × 21). Musée de l'Homme, Paris
40 Polychrome painted buckskin. After J. G. Bourke, 'The Medicine-Men of the Apache' (1892), pl. 7
41 Birch-bark container. W. 11 (28). Museum für Völkerkunde, Vienna
42 Incised birch-bark scroll. Museum für Völkerkunde, Staatliche Museen Preussischer Kulturbesitz, Berlin
43 Engraved and painted wooden cut-out board. Ht 22½ (57). Naprstkovo Muzeum, Prague
44 Portion of engraved human femur. L. 5 (12·7). Photo Field Museum of Natural History, Chicago
45 Engraved shell gorget. Diam. 4½ (11·5). Frank H. McClung Museum, University of Tennessee, Knoxville
46 Engraved pipe-tomahawk blade. L. 6¾ (17). Historisches Museum, Bern
47 Engraved pottery bottle. Ht 8 (20·3). Museum of the American Indian, Heye Foundation, New York
48 Carved redware vase. 9¾ × 8 (24·8 × 20·3). Museum of the American Indian, Heye Foundation, New York
49 Etched shell. Arizona State Museum, University of Arizona. Photo Helga Teiwes
50 Engraved walrus-ivory object. L. 5⅞ (15). Smithsonian Institution, Washington
51 Walrus-ivory arrowshaft straightener. ¾ × 7¼ × 1½

(2 × 18·5 × 4). British Museum, London
52 Walrus-ivory pipe with incised decoration. Oakland Museum
53 Embossed, cut-out copper plate. Ht 12 (30·5). Washington University Collection, St Louis, Missouri
54 Stamped openwork silver brooch. 2¼ × 2 (5·7 × 5). Albert Green Heath Collection, Logan Museum of Anthropology, Beloit College, Beloit, Wisconsin
55 Silver headstall. W. 16½ (42). Museum für Völkerkunde, Vienna
56 Silver bracelet. W. 1 (2·5). Museum für Völkerkunde, Hamburg
57 Painted copper emblem. Ht 36⅝ (93). Smithsonian Institution, Washington
58 Engraved and painted storage box. Wood, 20⅝ × 33⅛ × 19⅝ (52·5 × 84 × 50). British Museum, London
59 Engraved mountain sheep horn rattle. W. 6½ (16·5). Museum voor Land- en Volkenkunde, Rotterdam
60 Painted skin breast plate. W. 33 (84). Lomonsov State University, Moscow
61 Spruce-root hat. Diam. 19⅝ (50). Museum of Ethnography, St Petersburg
62 Plaited cedar-bark mat. 42⅛ × 85 (107 × 216). Staatliches Museum für Völkerkunde, Dresden. Photo C. F. Feest
63 Twined and painted cedar-bark blanket. 53½ × 39¾ (136 × 101). British Museum, London
64 Engraved lid of arrow box. Wood and otter teeth inlays. Ht 36⅝ (93). Museum für Völkerkunde, Vienna
65 Carved and engraved spindle whorl. 8½ × 8⅛ × ¾ (21·4 × 20·5 × 1·9). British Columbia Provincial Museum, Victoria
66 Painted board. Washington State Historical Society, Tacoma
67 Painted wooden bowl. L. 14 (35·5). Smithsonian Institution, Washington
68 Painted wooden hat. Diam. 14⅛ (36). Staatliches Museum für Völkerkunde, Munich
69 Painted bison robe. Bison skin, trade cloth appliqué. W. 82⅝ (210). Historisches Museum, Bern
70 Painted bison robe. 59⅞ × 50⅜ (152 × 128). Musée de l'Homme, Paris
71 Netted back ornament decorated with feathers. Museum of the American Indian, Heye Foundation, New York
72 Carved and painted wooden cradle board. Ht 30¾ (78), full w. 10⅝ (27). Glenbow Museum, Calgary, Alberta
73 Tularosa black-on-white painted jar. Ht 9⅜ (23·9),

209

diam. $11\frac{1}{2}$ (29·4). Field Museum of Natural History, Chicago
**74** Mimbres black-on-white painted pottery bowl. Diam. $11\frac{3}{4}$ (30). Maxwell Museum of Anthropology
**75** Sikyatki painted pottery bowl. Diam. $9\frac{7}{8}$ (25). Museum für Völkerkunde, Staatliche Museen Preussischer Kulturbesitz, Berlin
**76** Painted pottery jar. Diam. $15\frac{1}{2}$ (39·5). Museum für Völkerkunde, Vienna
**77** Polychrome painted pottery jar. $12\frac{1}{2} \times 11\frac{1}{2}$ ($31\cdot7 \times 29\cdot2$). Museum of New Mexico, Santa Fe
**78** Black-on-black painted jar. Ht $8\frac{1}{4}$ (20·9), diam. $4\frac{1}{4}$ (10·8). Dr and Mrs Ralph Reitan Collection, on permanent loan to the Museum of Indian Heritage, Indianapolis
**79** Awatovi mural painting. Photo Beckwith, courtesy Peabody Museum, Harvard University
**80** Drawing after polychrome rock painting, Emigdiano Mountains. From Campbell Grant, *The Rock Paintings of the Chumash*, University of California Press, Berkeley and Los Angeles, 1965
**81** Painted skin mask. Royal Ontario Museum, Toronto
**82** Petroglyphs at Village of the Great Kivas. Photo Etta Becker-Donner
**83** Petroglyph, known as 'Tsigaglalal'. $15 \times 15$ ($38\cdot1 \times 38\cdot1$). Photo Ray Hill
**84** Barrier Canyon style rock painting. From K.F. Wellmann, *North American Indian Rock Art*, Akademische Druck- u. Verlagsanstalt, Graz, 1979
**85** Wooden frontlet with haliotis shell inlay. Ht $7\frac{1}{8}$ (18). Oakland Museum
**86** *Navajo Man and Horse*. $15 \times 17$ ($38 \times 43$). California Academy of Sciences, San Francisco, Elkus Collection
**87** *Thunderbird, Loon Totem and Evil Fish*. From Norval Morrisseau and S. Dewdney, *Legends of my People: The Great Ojibway*. Copyright © McGraw-Hill Ryerson Limited, 1965. Reprinted by permission
**88** *Mussel*. $13\frac{3}{4} \times 11$ ($35 \times 28$). Private collection, Vienna
**89** *Whirling Logs*. Sand and charcoal. Diam. $68\frac{7}{8}$ (175). Horniman Museum, London
**90** Mosaic-encrusted flint blade. Turquoise, shell and lignite. L. $4\frac{1}{2}$ (11·5). Peabody Museum, Harvard University
**91** Profile of human head. Ht $11\frac{3}{4}$ (30). Peabody Museum, Harvard University
**92** Single-woven cane basket. Split river cane. W. $7\frac{7}{8}$ (20). College Museum, Hampton Institute, Hampton, Virginia
**93** Wood splint basket. Little Traverse, Regional Historical Society, Petoskey, MI
**94** Wicker basket. Diam. $13\frac{3}{4}$ (34). Naprstkovo Muzeum, Prague
**95** Coiled carrying basket. $19\frac{3}{4} \times 6$ ($50 \times 15$). University Museum, University of Pennsylvania. Reproduced by permission
**96** Coiled basketry bowl. Willow, devil's claw, cat tail. Diam. $14\frac{1}{8}$ (36). Museum für Völkerkunde, Vienna
**97** Coiled basket. Willow and devil's claw pods. Ht $26\frac{3}{4}$ (68). Taylor Museum, Colorado Springs Fine Arts Center
**98** Coiled basket. Ht 11 (27·9). Nevada State Museum, Carson City
**99** Twill twined basket. Diam. $11\frac{3}{4}$ (30). Oldenburg Museum
**100** Coiled feather basket with shell pendant. Field Museum of Natural History, Chicago
**101** Imbricated basket. Grass. $2\frac{3}{4} \times 3\frac{1}{8} \times 2\frac{1}{2}$ ($7 \times 8 \times 6$). British Museum, London
**102** Twined basketry cap. Natural fibres and grasses. Diam. $7\frac{1}{4}$ (18·5). Museum für Völkerkunde, Vienna
**103** Lidded basket. Ht $10\frac{5}{8}$ (27), diam. $12\frac{1}{4}$ (31). Staatliches Museum für Völkerkunde, Munich
**104** Twined bag. $5\frac{1}{2} \times 8\frac{5}{8}$ ($14 \times 22$). Staatliches Museum für Völkerkunde, Munich
**105** Sally bag. Twined hemp. Diam. $6\frac{1}{4}$ (16). Brooklyn Museum, Gift of Mrs Frederick B. Pratt
**106** Basketry-covered stoneware bottle. Vancouver Museum and Planetarium Association, Centennial Museum, Vancouver
**107** Twined basket. Devil's claw and xerophyllum. California Department of Parks and Recreation
**108** Mat with thunderbird effigies. Reeds and bark fibre. L. $100\frac{3}{8}$ (255). Museum für Völkerkunde, Vienna
**109** Sections of two fingerwoven sashes. Left: w. $4\frac{7}{8}$ (12·5). Right: w. $3\frac{7}{8}$ (10). Historisches Museum, Bern
**110** Pouch with woven quill panels. Museum für Völkerkunde, Staatliche Museen Preussischer Kulturbesitz, Berlin
**111** Wampum belt. W. $3\frac{1}{2}$ (9). Museum für Völkerkunde, Vienna
**112** Bandoleer bag with imitation wampum. Braunschweigisches Landesmuseum für Geschichte und Volkstum, Brunswick
**113** Bandoleer bag with woven beadwork. Cloth, glass beads. W. $12\frac{5}{8}$ (32). Collections of the Grand Rapids Public Museum
**114** Twined bag. State Historical Society of Wisconsin
**115** Coiled basket. Xerophyllum and redbud with

seed beads and abalone shell. Ht $2\frac{3}{4}$ (7), diam. $4\frac{3}{8}$ (11). California Department of Parks and Recreation
116 Blanket. Bark and wool. $59 \times 50$ ($150 \times 127$). Perth Museum and Art Gallery, Scotland
117 Powder horn and moosehair-embroidered strap. The Scottish United Services Museum, Edinburgh Castle. Reproduced by permission
118 Twined bag. Museum of Indian Heritage, Indianapolis, J. Morton Swango Collection
119 Twined blanket. W. 52 (132). Museum für Völkerkunde, Vienna
120 Twined blanket. W. $64\frac{1}{2}$ (164). Museum of Ethnography, St Petersburg
121 Chilkat blanket. Linden-Museum, Stuttgart. Photo Ursula Didoni
122 Blanket. Indian hemp and feathers. $50 \times 56$ ($127 \times 142.2$). Peabody Museum, Harvard University
123 Cotton yarn bag. $12\frac{1}{2} \times 6$ ($31.7 \times 15.2$). Photo Dave Roberts, courtesy U.S.
124 Third Phase 'chief's blanket'. Wool and flannel. $72\frac{7}{8} \times 54\frac{3}{8}$ ($185 \times 138$). California Academy of Sciences, San Francisco, Elkus Collection
125 Eyedazzler blanket. Germantown yarn. $54 \times 44\frac{1}{8}$ ($137 \times 112$). Museum für Völkerkunde, Vienna
126 Early dry-painting rug. Germantown yarn. $34 \times 56$ ($86.4 \times 142.2$). Museum of Indian Heritage, Indianapolis
127 Pair of moosehair-embroidered moccasins. L. $10\frac{5}{8}$ (27). Staatliches Museum für Völkerkunde, Munich
128 Quilled bandoleer bag. Cloth with quills and beads. Ht $33\frac{7}{8}$ (86), pouch $10\frac{1}{4} \times 8\frac{5}{8}$ ($26 \times 22$). Naprstkovo Muzeum, Prague
129 Quilled bag. Leather, porcupine quills, glass beads. $23\frac{5}{8} \times 13\frac{3}{4}$ ($60 \times 35$). Deutsches Ledermuseum, Offenbach
130 Quilled cuff. Buckskin. Cuff l. 10 ($25.4$), fringe $2\frac{1}{2}$ ($6.3$). Albert Green Heath Collection, Logan Museum of Anthropology, Beloit College, Beloit, Wisconsin
131 Button blanket. Wool, stroud cloth, mother-of-pearl buttons, white glass beads. $55\frac{1}{8} \times 66\frac{7}{8}$ ($140 \times 170$). Glenbow Museum, Calgary, Alberta
132 Headdress. American Museum of Natural History, New York
133 Fully beaded boy's shirt. Leather, trade cloth, glass beads. L. $16\frac{7}{8}$ (43). Museum für Völkerkunde, Vienna
134 Polychrome beaded triangular flap pouch. Rautenstrauch-Joest Museum, Cologne. Photo C.F. Feest
135 Beaded horse collar. $38\frac{1}{8} \times 16\frac{3}{8}$ ($97 \times 41.5$).

Thomas Burke Memorial Washington State Museum, University of Washington
136 Beaded bag. $12 \times 10\frac{1}{2}$ ($30.5 \times 26.7$). Cheyenne Indian Museum, St Labre Indian School, Ashland, Montana
137 Beaded dance apron. Cloth, glass beads, thimbles. $31\frac{1}{4} \times 29\frac{1}{8}$ ($79.5 \times 74$). Museum für Völkerkunde, Staatliche Museen Preussischer Kulturbesitz, Berlin
138 Folded trade cloth blanket. $60\frac{1}{2} \times 56\frac{1}{4}$ ($153.5 \times 143$). Museum für Völkerkunde, Vienna
139 Sections of two belts with leather appliqué. W. 3 (above) and $2\frac{3}{8}$ (below) ($7.5$ and 6). Museum für Völkerkunde, Vienna
140 Woman's blouse. Calico with cotton appliqué. Ht $11\frac{3}{4}$ (30). Smithsonian Institution, Washington
141 Trade cloth horse blanket. $37\frac{7}{8} \times 55\frac{1}{8}$ ($95 \times 140$). Glenbow Museum, Calgary, Alberta
142 Headband with feather appliqué. L. $25\frac{1}{2}$ (67). Museum für Völkerkunde, Staatliche Museen Preussischer Kulturbesitz, Berlin
143 Star quilt. Rayon. $81\frac{7}{8} \times 83\frac{1}{2}$ ($208 \times 212$). Private collection, Vienna
144 Coat. Buckskin with silk embroidery. $37\frac{7}{8} \times 17\frac{3}{8}$ ($95 \times 44$). Milwaukee Public Museum
145 White-American-style cradle. $27 \times 40 \times 21$ ($68.6 \times 101.6 \times 53.3$). DesBrisay Museum, Bridgewater, Nova Scotia
146 Embroidered lid of box. Birch bark with moosehair. L. $9\frac{5}{8}$ ($24.5$). Museum für Völkerkunde, Vienna
147 Diagonal twill woollen manta. $41 \times 53$ ($104.1 \times 134.6$). Field Museum of Natural History, Chicago
148 Wooden tabernacle. Ht $27\frac{1}{8}$ (69). Museum für Völkerkunde, Vienna
149 Stone pipe with bird effigy. L. $3\frac{1}{2}$ (9). British Museum, London
150 Figural catlinite pipe head. $3\frac{3}{8} \times 7\frac{3}{8}$ ($8.5 \times 18.7$). Giglioli Collection, Museo Nazionale Preistorico Etnografico 'Luigi Pigorini', Rome. Photo Soprintendenza alla Preistoria e all' Etnografia, Rome
151 Unusual figural catlinite pipe head. L. $6\frac{1}{4}$ (16). Historisches Museum, Bern
152 Whale effigy. $3\frac{5}{8} \times 4\frac{1}{2}$ ($9.2 \times 11.4$). Portland Art Museum, Portland, Oregon
153 Standing owl. Ht $22\frac{1}{4}$ ($56.5$). Oregon Historical Society, Portland
154 Figural stone bowl. Ht 10 ($25.4$). Vancouver Museums and Planetarium Association, Centennial Museum, Vancouver
155 Stone club. $2 \times 14$ ($5 \times 35.6$). British Columbia Provincial Museum, Victoria

156 Carved and engraved argillite box. Washington State Historical Society, Tacoma
157 Shaman's mask. Wood, feathers. $7\frac{7}{8} \times 16\frac{1}{2}$ (20 × 42). Thomas Burke Memorial Washington State Museum, University of Washington
158 Kachina doll representing Sip-ikne. Wood, feathers, cotton, leather, shells. Ht $15\frac{3}{8}$ (39). Museum für Völkerkunde, Vienna
159 Soapstone carving. Ht $7\frac{1}{2}$ (19). Museum für Völkerkunde, Vienna
160 Carved wooden baton. Field Museum of Natural History, Chicago
161 Carved head. Wood and human hair. $10\frac{3}{4} \times 7\frac{3}{4} \times 3\frac{3}{4}$ (27·4 × 19·7 × 9·5). South African Museum, Cape Town
162 Nulmal mask. Wood with feathers. Full ht $18\frac{1}{8}$ (46). Museum für Völkerkunde, Staatliche Museen Preussischer Kulturbesitz, Berlin
163 Carved and painted round rattle. L. 12 (30·5). Smithsonian Institution, Washington
164 Octopus mask. Wood with opercula inlay. Ht $9\frac{1}{2}$ (24). Museum für Völkerkunde, Staatliche Museen Preussischer Kulturbesitz, Berlin
165 Totem pole. Wood. Photo C.F. Feest
166 Portrait mask. Ht $9\frac{1}{8}$ (23·2). Field Museum of Natural History, Chicago
167 Wooden rattle. L. $9\frac{7}{8}$ (25). Museum für Völkerkunde, Vienna
168 Wooden ceremonial grease dish. $5\frac{1}{8} \times 10\frac{1}{4} \times 3\frac{1}{2}$ (13 × 26 × 9). British Museum, London
169 Scenic wooden sculpture. $8\frac{7}{8} \times 10\frac{1}{2} \times 4\frac{1}{8}$ (22·5 × 26·7 × 10·6). Alaska State Museum, Juneau
170 Carved tool box. Wood, shell inlay. L. $9\frac{1}{4}$ (23·5). Museum für Völkerkunde, Staatliche Museen Preussischer Kulturbesitz, Berlin
171 Painted wooden mask. L. $12\frac{1}{2}$ (32). Smithsonian Institution, Washington
172 Wooden burial mask. $8\frac{1}{4} \times 6\frac{5}{8} \times 4\frac{3}{8}$ (21 × 16·8 × 11). Museum für Völkerkunde, Hamburg
173 Wooden mask representing a woman. $14 \times 5\frac{1}{8} \times 3\frac{3}{8}$ (35·5 × 13 × 8·5). Musée de l'Homme, Paris
174 Upper part of staff with carved head of Sir Wilfred Laurier. Hickory wood, metal, stain and lacquer. L. 35 (89), diam. $1\frac{3}{4}$ (4·5). Glenbow Museum, Calgary, Alberta
175 Male effigy doll. Wood, glass beads, cotton. L. $13\frac{3}{4}$ (35). Glenbow Museum, Calgary, Alberta
176 False-face mask. Wood and animal hair, red, black and white paint. Ht 11 (28). Folkens Museetetnografiska, Stockholm
177 Meezing mask. Wood, sheet copper, horsehair. Ht 11 (28). Karl May Museum, Radebeul
178 Painted wooden mask. National Anthropological Archives, Smithsonian Institution, Washington
179 Kachina doll. Ht 11 (28). Museum für Völkerkunde, Vienna
180 Burial mask. Full w. $9\frac{1}{2}$ (24·1). American Museum of Natural History, New York
181 Walrus-ivory tupilak figure. Ht $4\frac{3}{8}$ (11). Museum für Völkerkunde, Vienna
182 Engraved club. Elk antler, leather. L. $18\frac{1}{2}$ (47). Museum of Ethnography, St Petersburg
183 Ceremonial antler club. L. $16\frac{1}{2}$ (42). Museum für Völkerkunde, Staatliche Museen Preussischer Kulturbesitz, Berlin
184 Carved mountain goat horn spoon. L. $10\frac{5}{8}$ (27). Museum of Ethnography, St Petersburg
185 Female pottery figurine. Ht $3\frac{3}{8}$ (8·5). Illinois State Museum, Springfield
186 Female clay figurine. Ht $6\frac{1}{8}$ (15·5). Peabody Museum, Harvard University
187 Female figurine. Clay, human hair, glass beads, trade cloth. Ht $8\frac{5}{8}$ (22). Staatliches Museum für Völkerkunde, Munich
188 Pottery effigy bottle. Ht $6\frac{1}{8}$ (15·5). Museum für Völkerkunde, Vienna
189 Effigy vessel. Pottery, ht $8\frac{5}{8}$ (22). Naprstkovo Muzeum, Prague
190 Mountain sheep effigy pottery sculpture. L. $10\frac{5}{8}$ (27). Museum für Völkerkunde, Vienna
191 Corn husk mask. Diam. $13\frac{3}{4}$ (34). Staatliches Museum für Völkerkunde, Munich
192 Copper mask. Ht 8 (20·3). Museum of the American Indian, New York
193 Air view of the Great Serpent Mound. Photo Ohio Historical Society

# Index